Michael Baxandall, Vision and the Work of Words

'The most important art historian of his generation' is how some scholars have described the late Michael Baxandall (1933–2007), Professor of the Classical Tradition at the Warburg Institute, University of London, and of the History of Art at the University of California, Berkeley. Baxandall's work had a transformative effect on the study of European Renaissance and eighteenth-century art, and contributed to a complex transition in the aims and methods of art history in general during the 1970s, '80s and '90s. While influential, he was also an especially subtle and independent thinker – occasionally a controversial one – and many of the implications of his work have yet to be fully understood and assimilated. This collection of 10 essays endeavors to assess the nature of Baxandall's achievement, and in particular to address the issue of the challenges it offers to the practice of art history today.

This volume provides the most comprehensive assessment of Baxandall's work to date, while drawing upon the archive of Baxandall papers recently deposited at the Cambridge University Library and the Warburg Institute.

Peter Mack is Professor of English at the University of Warwick and a Fellow of the British Academy, UK.

Robert Williams is Professor of the History of Art at the University of California, Santa Barbara, USA.

STUDIES IN ART HISTORIOGRAPHY

Series Editor: Richard Woodfield,
University of Birmingham, UK

The aim of this series is to support and promote the study of the history and practice of art historical writing focusing on its institutional and conceptual foundations, from the past to the present day in all areas and all periods. Besides addressing the major innovators of the past it also encourages re-thinking ways in which the subject may be written in the future. It ignores the disciplinary boundaries imposed by the Anglophone expression 'art history' and allows and encourages the full range of enquiry that encompasses the visual arts in its broadest sense as well as topics falling within archaeology, anthropology, ethnography and other specialist disciplines and approaches. It welcomes contributions from young and established scholars and is aimed at building an expanded audience for what has hitherto been a much specialised topic of investigation. It complements the work of the *Journal of Art Historiography*.

Michael Baxandall, Vision and the Work of Words

Edited by Peter Mack and Robert Williams

ASHGATE

Published by
Ashgate Publishing Limited
Wey Court East
Union Road
Farnham
Surrey, GU9 7PT
England

Ashgate Publishing Company
110 Cherry Street
Suite 3-1
Burlington, VT 05401-3818
USA

www.ashgate.com

British Library Cataloguing in Publication Data
A catalogue record for this book is available from the British Library

The Library of Congress has cataloged the printed edition as follows:
Michael Baxandall, vision and the work of words / Edited by Peter Mack and Robert Williams.
 pages cm. -- (Studies in art historiography)
 Includes bibliographical references and index.
 ISBN 978-1-4724-4278-9 (hardcover: alk. paper) 1. Baxandall, Michael. I. Mack, Peter, 1955– editor. II. Williams, Robert, 1955– editor. III. Potts, Alex. Visual conditions of pictorial meaning.

N7483.B34M53 2015
 709.2--dc23

 2014040728

ISBN 9781472442789 (hbk)

MIX
Paper from
responsible sources
FSC® C013985

Printed in the United Kingdom by Henry Ling Limited, at the Dorset Press, Dorchester, DT1 1HD

Contents

List of Illustrations

Color Plates

1 Piero della Francesca, *The Resurrection of Christ*, before 1474, fresco and other media, c. 225 x 200 cm, Museo Civico, Sansepolcro

2 Jean Dubuffet, *Joë Bousquet in Bed*, 1947, oil emulsion in water on canvas, 146.3 x 114 cm, Museum of Modern Art, New York. © 2015 Artists Rights Society (ARS), New York/ADAGP, Paris

3 Ben Nicholson, *Feb. 28–53 (vertical seconds)*, 1953, oil on canvas, 75.6 x 41.9 cm, Tate, London. © 2015 Angela Verren Taunt/All rights reserved/ARS, NY/DACS, London

4 Georg Baselitz, *Women of Dresden – The Heath*, 1990, limewood and yellow tempera, 155 x 70 x 56 cm, Louisiana Museum of Modern Art, Humlebaek. © 2013 Georg Baselitz

5 Georges Braque, *Violin and Pitcher*, 1910, oil on canvas, 117 x 73 cm, Kunstmuseum, Basel. © 2015 Artists Rights Society (ARS), New York/ADAGP, Paris

6 Jean-Baptiste-Siméon Chardin, *A Lady Taking Tea*, 1735, oil on canvas, 80 x 101 cm, Hunterian Art Gallery, University of Glasgow. Courtesy Bridgeman Art Library Ltd.

7 Cover of Michael Baxandall's *Shadows and Enlightenment* (1995), with illustration of Pierre Subleyras, *Charon*, c. 1735–1740, oil on canvas, 135 x 83 cm, Musée du Louvre, Paris. Courtesy Yale University Press

8 Cover of Michael Baxandall's *Patterns of Intention* (1985), with detail from Jean-Baptiste-Siméon Chardin, *Lady Taking Tea*, 1735, oil on canvas, 80 x 101 cm, Hunterian Art Gallery, University of Glasgow. Courtesy Yale University Press

9 Cover of Michael Baxandall's *Words for Pictures* (2003), with detail from Piero della Francesca, *The Resurrection of Christ*, before 1474, fresco and other media, c. 225 x 200 cm, Museo Civico, Sansepolcro. Courtesy Yale University Press

10 Veit Stoss, *Virgin and Child*, c. 1510–1520, © Victoria and Albert Museum, London (*The Limewood Sculptors of Renaissance Germany*, plate 45)

11 Michael Erhart, *Virgin of Mercy*, c. 1480–1490, Staatliche Museen, Berlin (*The Limewood Sculptors of Renaissance Germany*, colour plate 3)

12 Michel Erhart, *Retable of the High Altar*, c. 1493–1494, Klosterkirche, Blaubeuren (*The Limewood Sculptors of Renaissance Germany*, plate 19)

13 Riemenschneider, *St Barbara*, detail, c. 1410–1420, Bayerisches Nationalmuseum, Munich (*The Limewood Sculptors of Renaissance Germany*, plate 23)

14 Antonello da Messina, *Virgin Annunciate*, oil on panel, 45 x 34.5 cm, mid-1470s, Palermo, Galleria Regionale della Sicilia di Palazzo Abatellis (inv. 47). © Archivio fotografico Galleria Regionale della Sicilia di Palazzo Abatellis. Photo: Gero Cordaro

15 Giorgione, *La Vecchia*, tempera and walnut oil on canvas, 68 x 59 cm, Accademia Gallery, Venice. Photo © Scala, Florence, courtesy of the Ministero Beni e Att. Culturali

16 Titian, *Supper at Emmaus*, oil on canvas, 169 x 244 cm, Louvre, Paris, INV. 746. © White Images/Scala, Florence

Black and White Figures

7.1 Michael Baxandall, typewritten syllabus for HA 162, taught at University of California, Berkeley, Spring 1989

7.2 Michael Baxandall, typewritten midterm exam questions for HA 162, Spring 1989

7.3 'A Ground Plott of Westminster Hall, Shewing the Position and Dimensions of the Severall Tables, Seats, Cupboards, Galleries, &s, on the day of their Majesties Coronation 23 April 1685'. In Francis Sandford (1630–1694), *The history of the coronation of … James II … and of his royal consort Queen Mary … 23 of April … 1685. With an exact account of the several preparations in order thereunto … By his Majesties especial command …* (London: In the Savoy: printed by T. Newcomb, 1687), 200. Anne S.K. Brown Military Collection, Brown University Library

7.4 Michele Sorellò, etcher, after a design by Giuseppe Silici, *Prospettivo della Seconda Macchina con cui vengano rappresentati Orti Pensili …* (Rome, 1747). Collection of Vincent J. Buonanno

7.5 Giuseppe Vasi, etcher, after Giuseppe Palazzi, draftsman, and Paolo Posi, architect. *Prima macchina, 1759. Castel Sant'Angelo*, etching, 1759. Collection of Vincent J. Buonanno

7.6 Giuseppe Vasi, etcher, after Giuseppe Palazzi, draftsman, and Paolo Posi, architect. *Seconda macchina, 1761, Un Magnifico Teatro*, etching, 1761. Collection of Vincent J. Buonanno

7.7 Jacques Blondel, *Veue général des décorations, illuminations, et feux d'artifice …*, etching, in *Description des festes données par la ville de Paris : à l'occasion du mariage de madame Louise-Elisabeth de France, et de dom Philippe, infant & grand amiral d'Espagne, les vingt-neuviéme & trentiéme août mil sept cent trente-neuf* (Paris: P.G. Le Mercier, 1740), n.p. Anne S.K. Brown Military Collection, Brown University Library

Notes on Contributors

Elizabeth Cook is a poet, fiction writer, and scholar. She was a pupil of Michael Baxandall at the Warburg Institute and was formerly Lecturer in English at the University of Leeds. Her books include *Seeing through Words: The Scope of Late Renaissance Poetry* (1986), *John Keats: The Major Works* (editor), *Achilles* (2002), and *Bowl* (2006). She wrote the libretto for Francis Grier's *The Passion of Jesus of Nazareth* and is currently working on *Lux*, a fiction.

Whitney Davis is George C. and Helen Pardee Professor of History of Art at the University of California, Berkeley, where he teaches ancient and modern art and theory. His books include *The Canonical Tradition in Ancient Egyptian Art* (1989), *Replications: Archaeology, Art History, Psychoanalysis* (1996), *Queer Beauty: Sexuality and Aesthetics from Winckelmann to Freud and Beyond* (2010), and *A General Theory of Visual Culture* (2010). He is working on a new book, *Visuality and Virtuality: Images and Pictures from Ancient Egypt to New Media*.

Alberto Frigo is a post-doctoral research fellow at the University of Lyon. He specializes in early modern philosophy and theology, the history of religion, and aesthetics. His publications include *L'esprit du corps. Morale et ecclésiologie dans les Pensées de Pascal* (2015) and, as editor, Montaigne, *Lettere* (2010) and Montaigne-Sebond, *Theologia naturalis* (2016). He is currently preparing a book on the philosophy of connoisseurship.

Paul Hills is Professor Emeritus of History of Art at the Courtauld Institute, University of London. He has researched widely on colour and light, language, and perception in Florentine and Venetian art. His books include *David Jones* (1981), *The Light of Early Italian Painting* (1987), and *Venetian Colour Marble,*

Mosaic, Painting and Glass, 1250–1550 (1999). He is currently completing *Material and Metaphor: Veils and Drapery in Italian Renaissance Art*.

Evelyn Lincoln is Professor of the History of Art and Architecture and Italian Studies at Brown University. She studied with Michael Baxandall at Berkeley. She specializes in early modern Italian art and print culture and is the author of *The Invention of the Italian Renaissance Printmaker* (2000) and *Brilliant Discourse: Pictures and Readers in Early Modern Rome* (2014).

Jules Lubbock is Professor Emeritus of Art History at the University of Essex. He specializes in architecture and urbanism and in Italian Renaissance art. His books include *The Tyranny of Taste: The Politics of Architecture and Design in Britain, 1550–1960* (1995) and *Storytelling in Christian Art from Giotto to Donatello* (2006).

Peter Mack is Professor of English at the University of Warwick and was until recently Director of the Warburg Institute, University of London. He was a pupil of Michael Baxandall and specializes in the history of Renaissance rhetoric and dialectic. His books include *Renaissance Argument: Valla and Agricola in the Traditions of Rhetoric and Dialectic* (1993), *Elizabethan Rhetoric* (2002), *Reading and Rhetoric in Montaigne and Shakespeare* (2010), and *A History of Renaissance Rhetoric 1380–1620* (2011).

Alex Potts is Max Loehr Collegiate Professor and Professor of Art History at the University of Michigan. He specializes in sculpture, aesthetics, and artistic theory. His books include *Flesh and the Ideal. Winckelmann and the Origins of Art History* (1994), *The Sculptural Imagination: Figurative, Modernist, Minimalist* (2000), and *Experiments in Modern Realism: World Making, Politics and the Everyday in Postwar European and American Art* (2013).

Robert Williams is Professor of the History of Art at the University of California, Santa Barbara. He specializes in Italian Renaissance art and art theory. His books include *Art, Theory and Culture in Sixteenth-Century Italy: From Techne to Metatechne* (1997) and *Art Theory: An Historical Introduction* (2004; second edition 2008). He has recently completed a book manuscript, *Raphael's Modernity: Italian Renaissance Art and the Systematicity of Representation*.

Introduction: Of Tact and Moral Urgency

A striking and much-remarked moment in Michael Baxandall's work is found at the very end of the chapter on Chardin's *Lady Taking Tea* in *Patterns of Intention*. There, having analyzed the picture so exactingly in relation to eighteenth-century optical theory, he pauses to say of the woman depicted that she is 'probably Chardin's first wife a few weeks before her death'. The effect of this abrupt aside is complex. On the one hand, it signals a potential aspect of the picture's interest that Baxandall himself has chosen not to pursue; it draws attention to the limited, circumscribed nature of the argument he is making. By treating such personal information almost as if it were an afterthought, moreover, he seems to be challenging us, daring us, to think him so preoccupied with his preferred mode of analysis, so callous, that he has forgotten about the human content of the image. At the same time, it feels as though he is scolding us for our prurience, our misplaced curiosity. Is his purpose thus to dismiss a clumsy kind of art-historical contextualism, a vulgar social history of art? Or is he is confessing to his own inadequacy, a lack of psychological and emotional sensitivity sufficient to deal with those aspects of the picture in an appropriate way? Perhaps, he is saying, pictures deserve a measure of privacy.

The more extended discussion of Chardin in *Shadows and Enlightenment* features a similar moment, though not nearly so dramatic: having situated Chardin's interest in shadows in relation to optics, he briefly pauses to acknowledge some of the qualities associated with shadows that might also condition the way in which artists address them or viewers experience them:

> The shaped and often grotesquely imitative mobility of a shadow, like some parasitical animal, can also be experienced as uncanny. Even in the cool sort of lexicon the eighteenth-century Enlightenment used, established extended senses of *ombre* include ghost, of course, and chimera; unreal appearance, diminished trace; secret, pretext, concealment, the domination of a destructive presence; threat.

Here again, just before the end of his text, Baxandall stops to acknowledge something of all that he has left out. The effect is to point up the highly focused, even obsessive concentration of his own inquiry, but also to indicate the potential scope and depth of the issue he has raised, the richness of its implications for future study. For his own part, he will not presume to decide for the viewer what the metaphorical expressivity of the shadow language at work in Chardin's still-lifes may be. People who look at pictures also deserve a measure of privacy.

Both passages are demonstrations of what Baxandall called 'tact'. In one of the interviews he gave toward the end of his career, he insisted that 'tact is more important than method'.[1] Although his attitude is sometimes thought to imply a rejection of method, it should rather be understood to involve a recognition of the need for sensitivity to the built-in limitations of our various analytical procedures, of language, and of our faculties in general. Since his entire approach to the study of art was governed by this idea and by the constraints it imposes on the kinds of claims we might legitimately make, it could be regarded as itself a methodological principle. Yet it might also be understood to involve something more than constraint: an active element indicated more clearly by the word 'tactical'. His teacher, F.R. Leavis, suggested such an idea when he declared that 'the problem of critical method is largely tactical'.[2] Baxandall's emphasis on tact testifies to a sense of critical practice having to be governed by a self-regulating order or protocol of some kind, structured by an inherent decorum. His lifelong project could be described as an effort to fashion the best possible mode of engagement with art: the most comprehensive, penetrating, and empirically rigorous, but also the most flexible and receptive to what may always elude our conceptual and linguistic equipment.

That ambition, and the skill with which he pursued it, justifies the claim that he 'was probably the most important art historian of his generation'.[3] In a sequence of brilliant books, each an important contribution, not only to the understanding of its specific subject, but to art-historical method in general, he helped to bring about a redefinition of the discipline. In some ways, his professional *iter* was unlikely. Trained in classics at school and in English at Cambridge, he spent a couple of years on the Continent, in Italy, Switzerland, and Germany, originally intending to write a novel but slowly drifting into the serious study of Renaissance history and art. After working in the Photographic Collection of the Warburg Institute and the Sculpture Department of the Victoria and Albert Museum, he was appointed in 1965 to lecture at the Warburg, not on art history but on rhetoric and dialectic. He began a dissertation under the supervision of E.H. Gombrich but did not finish it, though his research provided him with material for several important articles as well as his first two books. *Giotto and the Orators* (1971) examined the

relationship between Renaissance pictures and the conventions of humanist Latin while demonstrating the necessity of an attentiveness to language in any self-conscious approach to visual art. The suggestive and highly influential *Painting and Experience in Fifteenth-Century Italy* (1972), still his most widely read book, considers the ways in which pictures are informed by the visual, conceptual, and linguistic skills of the people by and for whom they were made. *The Limewood Sculptors of Renaissance Germany* (1980) attempts a more ambitiously comprehensive and systematic historical contextualization, examining everything from the cellular structure of limewood to the dynamics of commerce to the relation between religion and emergent humanism. As in *Painting and Experience*, the author quarried a refreshingly varied array of primary sources while also structuring the argument in such a way as to offer a methodological model.

Having thus established his credentials as an exceptionally innovative art historian – and at a moment when the discipline of art history was eagerly in search of new perspectives – he was appointed Professor of Art History at the University of California, Berkeley, in 1986, at first combining the post with a Chair in the History of the Classical Tradition at the Warburg. *Patterns of Intention* (1985), with its chapters on Picasso, Chardin, and Piero della Francesca, testifies to a growing range of interests as well as a more rigorous and finely tuned interrogation of analytical language and procedure. *Tiepolo and the Pictorial Intelligence* (1994), written with Svetlana Alpers, and *Shadows and Enlightenment* (1995) are both devoted to eighteenth-century topics: the first addresses the practical challenges of large-scale decorative painting, the second, the relation between the intimate work of artists like Chardin and the optical theory both of their time and ours.

Baxandall's dissertation was to have been about the principle of 'restraint' in Renaissance culture, and in the interviews he admitted that his interest in restraint had developed early on.[4] His attraction to the principle as an object of historical inquiry thus overlay his sense of its importance to any mode of historical inquiry. The result was a fastidiousness that sometimes irritated even his admirers, a refusal either to rush heedlessly into unsustainable conjecture or to bully readers into accepting apodictic assertions. 'The job of art criticism is to stop short at a certain point', he insisted, 'to establish a platform from which people can do the last stage themselves'.[5]

> If one's taking a painting and talking about its meaning, the last stage of its meaning is liable to be differently plotted by different people according to their own experience and urgencies, and I don't like art criticism which spells out directly what the narrative feelings of a picture are. One sets up a frame for it; that is how I see it. Not as a theoretical point, but simply as a practical matter of what one can do well, or well enough, and partly as a matter of good manners.[6]

Tact is something conditioned by the ambition to methodological consistency on the one hand and by human sensitivity on the other, a sensitivity to the human context in which any engagement with art occurs.

This commitment would seem to explain Baxandall's determination to evolve an approach to the study of art that is, as he says at the end of *Patterns of Intention*, both 'scientific' and 'sociable'. It also enables us to recognize that his desire to fashion the best possible approach to art is the product of moral as well as methodological deliberation. The theme of 'moral urgency' emerges in the interviews as well; it is, again, something associated with Leavis[7] and the atmosphere of Cambridge during the 1950s, remembered as 'urgent, scientific, moralistic'.[8] Although he suggested that Leavis is not an example to follow in every respect – that one might want to do some things differently – the way in which 'the moral and the literary were interfused'[9] in Leavis's teaching had a profound effect on Baxandall's work. It even figures in his novel, *A Grasp of Kaspar*, a story that revolves around the dilemma of an engineer with moral misgivings.[10] Apparently antithetical as they may seem, tact and moral urgency should not be understood as opposed to one another but as two aspects of the same fundamental principle, two sides of the same coin: an expression of human sensitivity, tact is a sign of alertness to the dynamic of human concerns that ground and motivate our interest in art in the first place, and is thus a direct expression of what is most pressingly at stake in it.

Like tact, moral urgency occasionally also makes itself strikingly felt. One of the most memorable instances occurs in the chapter on Piero's *Resurrection* in *Words for Pictures*, which features a passage from the Old Testament that Baxandall could have summarized or paraphrased, but chose to cite verbatim: 'Wherefore art thou red in thine apparel, and thy garments like him that treadeth in the winevat? I have trodden the winepress alone; and of the people there was none with me: for I will tread them in my anger, and trample them in my fury.'[11] Thus baldly presented, not at the climactic point in the argument, as any half-clever graduate student would know to do, but at the beginning of the relevant section, the words of Scripture are allowed to pre-empt the argument Baxandall then advances, that the colour of Christ's robe helps to superimpose the theme of the Last Judgment onto that of the Resurrection, and thus endow what is normally a joyous scene with a frisson of dread. By simply placing the quotation in relation to Piero's picture, Baxandall enables us to arrive at his thesis ourselves.

An even more powerful example, although relying rather on a slow build-up to its climax, is a passage in the autobiographical sketch, *Episodes*, the story of the eccentric hermit, whom young Michael encountered in the Welsh village where he spent a summer as a child. While playing with some of his friends, he watches this pathetic character approach and pass by. One of the boys throws a stone: 'It hit the man harmlessly on the back. But he stopped

and half turned round to look, stooped with one arm raised to shield his head. He stayed twisted in that posture for a moment as if he were performing a mime of fear or abjection, then shuffled on off to the shop.' The boys explain that the man's name is Godwin, and that he is the local 'loony' who lives alone, like a hermit, in a big house on the edge of town. Michael becomes fascinated:

> I was curious about Godwin. What did he do all day in and around that big house? Did he spend time in his father's library? Did he miss his parents? Was it necessarily sad to be a hermit? But what would become of Godwin in the end? That kind of question. There must have been some self-projection.

He finally sneaks onto Godwin's property and wanders around the run-down garden. Nothing happens, but he fantasizes about talking with Godwin and entering the house. He concludes: 'In fact I did not see Godwin again before we left the village, but he continued to come to mind sometimes, partly because an image of him attached itself to my sense of the words "poor in spirit" – a phrase heard quite often in a puzzling context.'[12] If Baxandall is best known for the elaborate care with which he connected words to the images that impressed him, this haunting epiphany – Godwin as messenger of God – shows how deep and morally driven that impulse was.

The essays presented here were, for the most part, given in lecture form at a conference at the Warburg Institute in May 2012. They testify to the range of Baxandall's achievement, as well as to the range of ways in which it is understood, which has so far been the object of only one collection of essays.[13] Most are concerned with his art-historical scholarship, but several – those of Alberto Frigo, Paul Hills, Peter Mack, and Elizabeth Cook – take up aspects of his personal memoir and his novel, and emphasize the way in which those posthumously published texts have enabled us to situate his scholarly work within a more broad-ranging literary ambition. If he was as much a 'writer' as a 'scholar', it would also explain his preference for characterizing his approach to art as 'criticism', as well as his fundamentally linguistic outlook on the problem of interpretation. Another group of essays – including Frigo's but also those of Jules Lubbock, Whitney Davis, and Robert Williams – explore what might be called the intellectual-historical sources of Baxandall's methodological orientation, and emphasize just how responsive he was to the critical and philosophical life of his time, even though his connections to figures like Leavis, Collingwood, Gramsci, or Wittgenstein might vary greatly in depth, extent, and degree of directness. Lubbock avails himself of the unpublished papers now in the collection of Cambridge University Library and the Warburg Institute. The essay of Alex Potts assesses Baxandall's debt to Gombrich, Podro, and Wollheim, but also executes a sensitive analysis of his relation to the aesthetic convictions present in a certain kind of modernist painting to illuminate his special sense of the way pictorial meaning is produced. The essays of Lubbock, Hills, Mack, and Evelyn Lincoln emphasize

Baxandall's impact as a scholar and teacher, and exemplify the way it lives on in the practice of contemporary art history.

Yet Baxandall's receptivity to the intellectual currents around him is only one side of the story: the other is represented by his equally impressive selectivity, and most of all, perhaps, by his outright resistance to many trends that went on to become fashionable. At the same time, his work met with resistance of its own, both on general methodological grounds and from scholars into whose areas of specialty he had trespassed. The fact that while receptive he was also sceptical, and while highly influential also controversial, is part of what makes him interesting and possibly even more important than we can now clearly assess: it is, one senses, a lesson not yet fully understood. His position, in other words, while subject to critical evaluation, also constitutes an implicit critique of the field, including many of the assumptions that now go unexamined. In what ways he may simply have become obsolete, or may prove rather to have been ahead of his time, are not yet possible to determine.

Taken together, these essays thus faithfully capture the feeling registered by many participants in the original conference, that the process of coming to grips with Baxandall's intellectual legacy has only just begun. While this volume may go some way toward staking out the dimensions of his achievement, it is provisional. There are also aspects of his work that are not represented as fully as they might have been. Some readers may be surprised by the relatively little space given over to studies of Italian and Northern Renaissance or eighteenth-century art that take their point of departure directly from Baxandall's contribution to those fields. His influence so deeply pervades so much current scholarship, especially in Renaissance art, that direct reference to him has become superfluous. On the other hand, much recent work has moved on to the consideration of issues for which he does not seem to provide particular help. That most of the essays here emphasize general methodological considerations accurately reflects the fact that interest in Baxandall's achievement now concentrates on that aspect of it, nor should such a development come as a surprise: even his ventures into specialized territory were undertaken with a belief in the validity of general inquiry, in the necessity, one might say, of implicating the particular in the general and the general in the particular. What may become clearer with the passage of time is that this approach was a way to reclaim the ground of the possibility of art history as a coherent practice. The terms of our engagement with his achievement may shift, but such engagement is likely to remain central to any practice that calls itself art history.

Baxandall's dissertation, as has already been said, was to have been about 'restraint' in Renaissance art and culture; in his last interview he described his current project, also never completed, as a study of the role of inattention in our response to art with the working title *Three Levels of Inquietude*. His lifelong preoccupation with the visible, with what seems to be self-evident,

and which yielded analytical formulations of unrivalled precision and acuity, was framed by a lifelong preoccupation with the invisible, with what is so latent, rarefied, and elusive – but at the same time so pervasive, urgent, and profound – as to defy all our power to objectify and articulate it. Perhaps there is one more lesson here: that the vitality of art history depends upon those who continually reach for what seems lie beyond it – but in fact does not – and whose heroic ambition, structuring their practice as a whole, redefines the discipline for the rest of us.

Notes

1 'Substance, Sensation, and Perception: Michael Baxandall Interviewed by Richard Cándida Smith', Getty Research Institute, 1998 (http://archives.getty.edu:30008/getty_images/digitalresources/spcoll/gri_940109_baxandall_transcript.pdf; hereafter Smith, 'Interview'), 65.

2 F.R. Leavis, *The Living Principle: 'English' as a Discipline of Thought* (Oxford and New York: Oxford University Press, 1975), 173. Baxandall expressed his understanding of Leavis's position in one of the interviews (Smith, 'Interview', 19): 'Leavis's position was, the only way that you could talk about method was to do a particular job. He always refused to make methodical statements or write methodical books. The only way you could do method was by doing exemplary performance.' For a consideration of Leavis's anti-philosophical or anti-theoretical stance, see Barry Cullen, '"I thought I had provided something better" – F.R. Leavis, Literary Criticism and Anti-Philosophy', in Gary Day (ed.), *The British Critical Tradition: A Re-evaluation* (New York: St. Martin's Press, 1993). For a more comprehensive overview of Leavis's ideas: Gary Day, *Re-reading Leavis* (New York: St. Martin's Press, 1996).

3 John Onians, 'Michael David Kighley Baxandall 1933–2008', *Proceedings of the British Academy*, 166 (2010): 27.

4 Smith, 'Interview', 29, also 52–3, on his early reading of Elias and the influence of Gombrich's essay 'Metaphors of Value in Art'.

5 Smith, 'Interview', 112.

6 Smith, 'Interview', 138–9.

7 Allan Langdale, 'Interview with Michael Baxandall', *Journal of Art Historiography*, 2009 (http://arthistoriography.wordpress.com/number-1-december-2009/1-AL/1; hereafter Langdale, 'Interview') 1–2: '[T]here was a moral urgency about his approach … he had a strong sense of the relationship between technique and morality.' See also Smith, 'Interview', 11–14.

8 Smith, 'Interview', 11.

9 Smith, 'Interview', 14.

10 Michael Baxandall, *A Grasp of Kaspar* (London: Francis Lincoln, 2010), esp. 143–4:

> To make or mend an engine can at first seem a neutral matter, technical not moral. No moral dimension in metallurgy. But of course Kaspar had

long moved beyond this. Engines function. A bomb is an instrument to an end with a moral dimension. To make or mend it is to participate as an enabling agent towards that end.

11 Isaiah 63:2–3.

12 Presumably in church or in the course of other religious instruction. The phrase is from the opening words of the Sermon on the Mount (Matthew 5:3), the foundation of Christian moral doctrine.

13 Adrian Rifkin (ed.), *About Michael Baxandall* (Oxford: Blackwell, 1999), first published as a special issue of *Art History* 21:4 (December, 1998).

The Visual Conditions of Pictorial Meaning

Alex Potts

When Michael Baxandall described the analysis he offered of Piero della Francesca's *Resurrection* (Plate 1) as 'an attempt to establish an instance of the visual conditions of a pictorial meaning',[1] he summed up an ambition evident in several of the more important studies he published towards the latter part of his career. At issue in his preoccupation with painting at this juncture was an apparent paradox – how does an attentiveness to subtleties of visual apprehension that viewing a painting brings into play not only constitute the first order interest it has but also inform an understanding of its larger meaning? To put this another way, how can one address questions of pictorial meaning so that the visual and painterly qualities of a work are not being reduced to symbolic or expressive ciphers? Such concerns come to the fore in a particularly telling way in his studies of Braque's *Violin and Pitcher*, Chardin's *A Lady Taking Tea*, and Piero della Francesca's *Resurrection*, the three works that form the focus of this analysis of Baxandall's subtle and intriguing explorations of pictorial depiction.[2] Taking a cue from his own interest in the historical circumstances informing artistic practices and ways of writing about art, I shall also say something, necessarily very speculative, about how these concerns of his relate to and differ from preoccupations with problems of picturing that were circulating in the contemporary art world at the time when his outlook on art and writing about art was being formed in the 1950s and 1960s.

This aspect of Michael Baxandall's scholarship has received considerably less attention than his exploration of the language of art-critical and art-historical analysis – succinctly referenced in the title of his final volume of collected essays, *Words for Pictures* – or his study of sculptural aesthetics and the materiality of sculpture, or his often misunderstood reflections on the notion of the period eye.[3] However, his later thoughts on painting are in their

own way just as significant and searching as these more widely discussed and influential dimensions of his wide-ranging work as an art historian.

At issue for him was a very basic question having to do with the nature of pictorial depiction. How does attending closely to the internal processes and subtleties of a painterly depiction prompt one to see something in a painting – whether meaning or affect or some sense of the larger culture – that is not literally there? This in part has to do with very basic processes of seeing a motif or scenario emerge from the forms created by the marks on the surface of a painting. However, it is much more than the mere recognition of what is being depicted. It involves apprehending in the minutiae of the picturing something that brings the depicted motif to life and gives it its larger meaning. Modernists have short-circuited this issue as much as innocent eye naturalists. For committed modernists, there is an ineluctable disparity between properly seeing the formal and visual aspects of a work and seeing it as representing or depicting something – leading them to the supposedly intellectually rigorous decision to discount representation as irrelevant to painting properly conceived of as a self-defining and autonomous art. For the naive naturalist, in contrast, the pictorial subtleties that mattered were those that served the interests of representational verisimilitude. Painterly process should be largely invisible, and the depicted motif and its meanings shine through without visible interference. Baxandall directs attention to something more complicated and apparently paradoxical than either of these alternatives, namely how focusing on the distinctive effects created by pictorial mark making and on the technical details of pictorial depiction gives one a sense of the work's significance that goes beyond the purely visual or pictorial. While this has in some form or other been a fairly widespread concern of modern art historical analysis, Baxandall addresses the issues involved with an unusual combination of directness and intellectual rigour, and with a particularly keen awareness of the complexities of visual perception and cognition.

There is a repeated insistence in Baxandall's discussion of the distinctive kind of looking that painting invites on the interplay between focal and peripheral vision, and more generally between attentiveness and inattentiveness. Attending closely to a painting is generally envisaged in terms of an exactingly focused looking. Baxandall, in contrast, stresses the key role of the moments when one's attention wanders, when focused perception relaxes and gives way to free-wheeling global apprehension, and when the effects of peripheral vision kick in so that many of the disparate visual phenomena one has picked out blur together. In an interview published shortly before his death, he talked about how his recent work for a study of attention had led him to the conclusion that 'what was more interesting than attention was inattention and what is happening outside of attention'.[4] There is what one could characterize as a principle of indirection at work here that also informs his reflections on the 'visual conditions of pictorial

meaning'. He was loath to talk directly about the more resonant aspects of pictorial meaning, and his analyzes where such meaning is brought into play most compellingly are those where it does so peripherally or tangentially. In his view pictorial interpretation should proceed, not by focusing on a work's larger significance, but rather by having this significance emerge while attending to pictorial peculiarities that are not in themselves signs or bearers of some larger meaning but intriguing or puzzling effects in their own right. This brings with it a reciprocal hypothesis that the same holds for the painter, whose work gains in resonance through his or her focus on technicalities of picture making, technicalities whose relation to any larger meaning might seem at first sight to be incidental or even inconsequential. Meaning of this kind may have been there in the mind of the artist, but at the moment of conceiving and fashioning, the work is likely to have been very much at the back of the mind, out of view as it were. The process whereby significant meaning gets into the painting, according to Baxandall, has little to do with conventional iconographical or representational subtleties, the nuts and bolts of the hermeneutic interpretation that have dominated art historical analysis.

There were tendencies in the broader art historical and artistic culture of Baxandall's time that gave the often technical-seeming concerns preoccupying him a particular urgency, but these came to a head, not when he was formulating his late thoughts on problems of picturing in the 1980s and 1990s – Baxandall was no postmodernist – but earlier on, in the more immediate post-war period when his intellectual outlook was being formed. Baxandall's thinking on pictoriality closely paralleled Michael Podro's, whose ideas on the subject were similarly formed in the 1950s and early 1960s, but whose book *Depiction* only appeared rather later, in 1998,[5] at approximately the same time as Baxandall's more intensive reflections on the subject. Both had very much been formed by Ernst Gombrich's systematic rethinking of pictorial representation, and in Baxandall's case by Gombrich's close engagement with recent scientific studies of visual cognition and perception, and both were students of Gombrich's in the late 1950s at the moment when he came out with his hugely influential *Art and Illusion*.[6] Both also soon allied themselves with Wollheim's critique of Gombrich's reliance on ideas of illusion and insistence on the incompatibility between seeing a painting 'as marks on a plane surface'[7] and seeing it as a convincing representation of a three-dimensional phenomenon. While they were formed by Gombrich's intellectually precise approach to analyzing issues of visual representation, they moved on to focus on issues of pictorial depiction which were not amenable to Gombrich's basic model. For both, such a model in which the visual effects created by pictorial mark making were envisaged as approximately matching, and so giving the illusion of seeing, a phenomenon in the real world seemed inadequate to accounting for the more complex and resonant aspects of pictorial depiction.

How then do Baxandall's distinctive concerns with painting relate to those circulating in the contemporary art world at the time when in the 1950s and the earlier 1960s his ideas on pictorial depiction were first being worked out? The moment was certainly one of intensive preoccupation with painting and painterly process. However, the most influential painters of the period, such as Jackson Pollock, either worked in a more or less purely abstract, non-representational mode, or experimented with highly abstracted forms of figuration in which the free-wheeling painterliness rendered redundant the kinds of depictive subtlety that preoccupied Baxandall. While the new abstract expressionist or 'informel' painting was not necessarily entirely abstract and retained certain representational elements, it was, generally speaking, antithetical to traditional conceptions of pictorial depiction – ones in which an artist was seen as seeking to delineate with some degree of accuracy an observed or remembered visual phenomenon. A number of experimentally minded painters were fascinated with the possibilities of an approach to painting carried out without regard to fashioning recognizable motifs, with largely unintended representational shapes somehow emerging out of the mark making and the application of paint to a flat surface.[8] Baxandall may have been intrigued by lapses from or disruptions of naturalistic depiction, but these only made sense for him in relation to an artist's broader commitment to nuances of visual depiction. Like a number of art historians working in the period, he may at one level have been in tune with the premium placed by contemporary artists on the self-generating aspects of pictorial process, at the same time that his interest in painting worked against the grain of a broader disregard for and rejection of naturalistic forms of visual representation, particularly as codified in the increasingly influential dogmas of high modernist formalism.

The new painting of the post-war period often exploited a persistent tension in modern conceptions of painting between the privileging of a relatively autonomous way of working driven by imperatives internal to the art of painting and the possibility of representational effect – such that the viewer would be faced with a disparity between the immediate impact made by the vividly painted surface of a work and the look of the depicted phenomena seen to emerge from the painterly mark making. Dubuffet was probably the best-known artist working in such a mode, and also one who spoke particularly eloquently about such an engagement with painterly process that characterized much art of the period. In his discussion of painterly depiction (see Plate 2), he insisted that the intention to depict something actively got in the way of representing it convincingly, and that by committing to the internal imperatives of painterly process the artist would render it more compellingly than by deliberately focusing on delineating its shape:

This brutal manifestation, in the picture, of the material means employed by the painter to conjure up the objects being represented, and which seem to prevent them … from taking shape, function in reality for me in the opposite way; on the contrary, to me it seems, paradoxically, to give these objects a heightened presence, or rather, to put it better, to render this presence more surprising, more impressive.[9]

Such an outlook would seem to be at odds with Baxandall's insistence in his book *Patterns of Intention* on the key role played by our sense of an artist's intentionality in any more searching analysis we offer of his or her work, but only superficially so. Dubuffet was in fact talking about a quite deliberate approach to painting, one in which the artist made 'marks on a plane surface in such a way that their visual interest is directed to an end', to quote Baxandall.[10] The intention in this case was to fashion a compelling image that emerged from a close engagement with painterly mark making. This was in contrast to a way of working which Dubuffet felt deflected from the ends of painting because it submitted the artist's immersion in material process and medium to the constraints of consciously directed naturalistic representation.

Dubuffet, incidentally, was someone who, like Baxandall, was preoccupied by inattentiveness. 'It seems to me', he wrote in an account he gave of his work in 1957,

that too much consciousness, deliberately burdening the look that I direct at an object, falsifies the normal mechanisms of looking, and I think that the painter should pay great attention to forbidding himself this excess of consciousness, and should essentially apply himself (and this is a difficult gymnastic feat) to examining and representing things without ever doing violence to that distracted, confused state of mind, that kind of hazy consciousness perpetually in motion which is man's normal condition when the things around him strike his attention.[11]

It was, he claimed, 'a matter then of paying great attention to inattention, of being very attentive to transcribing as skilfully and as faithfully as possible what happens when an object is viewed without great attentiveness'.[12]

The affinity here with Baxandall's ideas on attention and inattention is not a direct one. I imagine that Baxandall would have had a deep distaste both for the kind of art Dubuffet produced and for the way in which he articulated his views on painting, in particular his loud-voiced, edgy insistence on the ironies of pictorial depiction. Even so, Baxandall might have found something to bemuse him in the demotic cast of Dubuffet's insistence on the importance of attentive inattentiveness. Baxandall's own artistic tastes would probably have been more in tune with work such as Frank Auerbach's, which sought to retain elements of depictive subtlety in a very materially orientated and often non-representationally focused engagement with painterly process[13] – an artist whom his close friend Michael Podro greatly admired. If anything,

his preferences in modern art were for the relatively refined painterly abstractions of artists such as Jean Hélion and Ben Nicholson (Plate 3), these being amongst the few more recent artists singled out in his published writing about painting.[14]

Baxandall did, however, write an intriguing short essay on the sculpture of Georg Baselitz for an exhibition that took place in 2004, in which he talked about the interplay between coarse-grained and fine-grained perception in a way that could be seen as pertinent to the work of a painter such as Dubuffet. He commented how, standing back from one of Baselitz's rough-hewn sculptures (Plate 4), so that one's perception of 'the harassed wood surfaces and finer structures of light and shade' were blurred, it often happens 'that the vivid form of a person bursts through'. 'This sort of perception', he went on to explain, 'we can then take back to the perception of the sculpture seen properly clear and sharp'. What was being activated here in his view was a distinctive process of apprehension whereby

> the tension between (one the one hand) such optically low-definition personality and (on the other) the strange high-definition realm of ripping and chipping and notching – the energy this relation can demand and generate in us … becomes available to animate and charge these compelling figures.[15]

Viewing Dubuffet's figurative paintings (Plate 2), there often is such an enlivening tension and interplay between one's fine-grained perceptions of the lively paint work, its intricate markings and smearings and spottings and amalgamations, and one's coarse-grained apprehension of the roughly depicted figure as a vividly characterized persona. The animated and densely textured substance of the painting has its own impetus that operates quite independently of the depicted motif. At the same time it gives life and a material particularity to the figural apparition one momentarily senses as one desists from looking closely at the painterly marks and opens out to a coarse-grained kind of viewing – one in which a striking figural motif comes into view that is radically different in its visual form from the mêlée of painterly marks, but with which somehow it seems to share certain qualities.

The one form of twentieth-century art Baxandall discussed at any length was the analytic cubism of Braque and Picasso, starting with his extended analysis of Picasso's portrait of the art dealer Daniel Henri Kahnweiler in *Patterns of Intention*.[16] One can see why this kind of painting fascinated him with its play on the standard devices used to achieve definition of three-dimensional shape and surface – shading and delineation of edges. In the more radical versions of analytic cubism, the faceted surfaces, the localized depictions as it were, decompose the motif to an extent that one's attempts to see a relatively coherent three-dimensional motif in the painting are almost blocked (see Plate 5). The internally directed, painterly process of generating an interlocking array of surfaces and edges spread out over a flat surface

clearly has its own momentum, quite distinct from, but never entirely separate from, fashioning a recognizable three-dimensional image. As Baxandall put it, such work is a particularly vivid demonstration of how 'the painter's complex problem of good picture-making becomes a serial and continually self-redefining operation, permanent problem–reformulation, as soon as he enters the process of actually painting'.[17] This, Baxandall explained, brings into play an 'encounter with medium', 'the sense of a dimension of process, of re-formulation and discovery and response to contingency going on as the painter is actually disposing his pigments'[18] that might equally well describe what was happening in the work of painters more contemporary to Michael Baxandall, such as Jackson Pollock.

The pictorial problems Picasso was toying with in his portrait of Kahnweiler, Baxandall insisted, were at one level given to Picasso in that they enjoyed public currency in the artistic culture of his time: analytic exploration of the interplay between the two-dimensional plane of the canvas and the representation of a three-dimensional world, experimenting with the form-making potential of drawing and shading, without recourse to colouristic effects, and highlighting the tensions between an instantaneous visual apprehension of a painting or a phenomenon in the real world, and the many different apprehensions one has of a motif over a period of time, fixating on this or that detail, or this or that aspect of its shape.[19] The seriousness with which Picasso tackled these problems, in Baxandall's view, had to do with the fact that he could assume that they would be seen by his audience as having considerable traction.[20] They had a certain cultural grounding. But this in the end remains a little dry and academic. One is given little or no idea of how more broadly shared cultural concerns were somehow at stake in the art world's preoccupations with the ambivalences and problematics of pictorial depiction with which Picasso was dealing. In part this was because such problematics would not have been strange enough to a mid- or later-century viewer such as Baxandall. They would have been so taken for granted as part of the common sense of modern artistic culture that their larger cultural motivations would not have required the suggestive speculation which he brought to bear so effectively on the less familiar pictorial problems of earlier periods, as in his analysis of Chardin's *Lady Taking Tea* (Plate 6), which follows directly after his discussion of Picasso's analytic cubism in *Patterns of Intention*.

What Baxandall characterized as Chardin's capacity to tell a 'story of perceptual experience masquerading lightly as a moment or two of perception'[21] is seen to matter because Baxandall in this instance showed how such a focus on matters of visual sensation and perception was central to Enlightenment thinking more generally. The painting was characterized by him as a pictorial exploration of issues of Lockean epistemology. It had to do with how people at the time thought one built up an idea of the material world from a shifting array of visual sensations, sensations that were subject

to vagaries of indistinctness in the peripheral zones of one's field of vision as one's viewing drifted from one focus of attention to another.[22] In the context of Enlightenment culture, much more was at stake than a purely pictorial problem – at work was a fascination with an activating interplay between attention and inattention that Baxandall suggestively characterized as 'inquietude'.[23] At the same time he insisted that Chardin was not working as a neo-Lockean philosopher, but rather playing out concerns circulating in his culture at an everyday level, which philosophers and painters each addressed in their own highly specialized and very different ways. Chardin was engaged in fashioning a 'sensational-perceptual' form of depiction as distinct from one that sought to render substance, drawing the viewer into an acute awareness of the interplay between sensations of distinctness and indistinctness central to notions of perceptual process that formed part of a broader 'eighteenth-century a web of preoccupation' and were embedded in 'eighteenth-century behaviour'.[24]

Baxandall's subsequent examination of the pictorial resources of analytic cubist painting in a later article, '*Fixation and Distraction: The Nail in Braque's Violin and Pitcher (1910)*' (Plate 5), is rather more suggestive than his discussion of Picasso's portrait Kahnweiler in *Patterns of Attention*, partly because it is less constrained by a concern to clarify issues of art-historical methodology. Another factor too is his empathy with Braque's more low-key and ostensibly reticent approach and with Braque's evident fascination with the vagaries of perceptual process. As in his discussion of Chardin's painting, he engages here with larger issues of viewing and perception, even if these are not given the same grounding in broader cultural terms. His analysis is built around a very basic question about the significance of what appears to be an incidental detail, the nail with its cast shadow at the top centre of the painting. Distancing himself this time from modernist preoccupations with the tension between pictorial flatness and depicted depth that this detail would seem to lay bare, Baxandall shifts the terms of reference. He sets in play a much more productive question about how this eye-catching detail compels one to move the focus of one's viewing away from the main motifs, the pitcher and the violin, such that these motifs are seen with the hazy indeterminacy of peripheral vision. Seen peripherally, one's awareness of the disruptive faceting of detail recedes and one has a much stronger sense of the motifs as whole, integral things.[25] In other words, the violin and the pitcher momentarily look much more like a violin and a pitcher as one fixates on the nail. At the same time, Baxandall points out, there are areas, such as that on the lower left, where the interlocked planes are so arrayed that they never become a depiction of something recognizable – unlike the area on the right that eventually coalesces into the image of a vertical wall articulated by a horizontal band of moulding, against which the flat top of a piano, seen from above, is placed.[26]

Baxandall's argument is that the painting makes one aware, in a way one is not in one's everyday apprehensions, of an interplay between focal and peripheral viewing, between fine and coarse visual registration. The painting engages one in a process of viewing that highlights the formative role of inattentiveness in visual perception. In this case, the process is potentially disturbing, and also enlivening, because it never quite resolves itself into a consistent picturing of a world of three-dimensional spaces and things. As Baxandall put it, the 'general experience of *Violin and Pitcher* is a violent sort of cognitive scintillance'.[27] He concludes with a comment which is revealing as to his commitment to indirection in dealing with questions about how some sense of resonantly charged significance might enter into one's engagement with the complexities of visual depiction and perception that painting invites:

> The picture is bracing, therefore, and in some moods one is anxious to insist that its narrative theme is the intrinsically moral one of the complexity and excitement of seeking true knowledge [this is Baxandall at his most Podro-like]. However, the fabric of the performance is visual representation of visual knowledge, and that is a sign not transparent through to some paraphraseable semantic object somehow inside.[28]

The intrinsically moral theme that Baxandall brings into play and also partly brackets out is not informed by any serious consideration of the 'what' as distinct from the 'how' of representation – in contrast to his treatment of a work such as Chardin's *Lady Taking Tea* where the figural presence, a certain attitude on the figure's part turning obliquely away or receding from the viewer, absorbed in a state of attentive distraction, are clearly in evidence. Still Baxandall's analysis of the Braque gives one a little more sense of the possible resonances of what is being represented than does his study of Picasso's portrait of Kahnweiler. In the latter, the reflexivity of Picasso's playing out pictorial problems that were also articulated in the dealer Kahnweiler's critical analysis of Picasso's cubism seems a little mechanical. Featured in Braque's complexly articulated still life are various objects of fixation that are also objects of a kind of distraction, including the gratuitously ordinary yet also faintly intriguing pitcher, violin, and nail. The painting is redolent in a very muted way of something significant about how we see largely insignificant things in our immediate world and how they nevertheless matter to us and command our attention.

While the meaning of the Braque is characterized in terms which to some degree reach beyond the purely scopic, Baxandall's interpretation does not engage with distinctive features of the larger culture the artist inhabited and beliefs and values circulating in it in the way that some of his more densely articulated discussions of issues of picture making and pictorial depiction do. A particularly fine instance of the latter is his late article on Piero della Francesca's *Resurrection of Christ* (Plate 1). In this case Baxandall proceeds

to take one through a close analysis of the work's visual particularities and apparent awkwardnesses, which he then envisages as making visually present, in a very indirect way, certain larger Christian thematics of resurrection which would have had a powerful resonance in the painter's immediate cultural environment. Such details include the curiously 'taught', almost 'fissile' Christ, his left side that of a 'militant standing figure' and his right of a 'majestically sitting figure'. The distinctive rendering of this split and tense figure, Baxandall suggests, creates an effect whereby it both seems to rise up before one in a manifestation of redemptive force and loom over one as the seated Christ of the Last Judgement.[29]

One other such detail Baxandall singles out is a slight confusion in the arrangement of the soldiers at the foot of the sarcophagus – the soldier holding a lance seems to be missing his legs. Such depictive ambiguity creates an instability in his view that makes way for thoughts about the ambiguous role played by the soldiers guarding the tomb in Matthew's account of the Resurrection – both asleep and uncognizant of Christ's rising, and becoming as 'dead men' faced with the frightening apparition of the angel that rolled back the stone closing the tomb.[30] In both the instances detailed here, the visual peculiarities do not in any way directly represent resonant features of the Resurrection story or theological conceptions current at the time concerning its doctrinal significance. These particularities are interruptions to a straightforward visualizing of the scene, creating a space in the mind of the viewer for larger considerations to come into play while looking closely at the picture.

According to Baxandall the painting engages one in a process of viewing, particularly charged for someone living within the theologically informed culture of the time, that moves from thoughtful consideration of the pictorial ambiguities, such as the inconsistent perspectival rendering of different parts of the picture and the highly fragmented and radically incomplete representation of the side of the sarcophagus, to envisaging the totality of the scene as presenting a singularly compelling and resonant rendering of the significance of Christ's Resurrection:

> Part of the power of this picture comes from a match between, on the one hand, pictorial vision being so much a discussion about how far one really knows and, on the other hand, the Resurrection of Christ raising an issue of faith that has rather the same shape. There is a formal affinity between thoughtful depiction and thoughtful belief.

He goes on to insist that any such manifestation of larger meaning, any such compelling affinity between thoughtful painting and thoughtful belief, must remain implicit in a detailed analysis of the kind he has been offering: 'It would be a pity to reduce this pictorial universe, reverberating in sympathy

with the Resurrection of Christ, to a level of questions about whether or not, yes or no, this particular thing stood for that.'[31]

There follows a particularly suggestive passage about how one might imagine the broader connotations of the scene of Resurrection entering into the painting while the artist was immersed in the process of realizing it, a process which in Baxandall's view would have entailed a focus on pictorial technicalities of depiction rather than a direct engagement with representing or expressing its symbolic meaning:

> One must suppose that in the course of its making the subject of the Resurrection of Christ would have been a constant part of the ambience of the painter, not in the sense that he had to be thinking about it at the time – rather than about the lime drying too quickly again … . but because it had been the frame and premise of his activity at and from the start; and was now implicit in any developing situation of his work, however secularly and materially addressed at any moment.[32]

As interpreters of the painting, we go through a similar process: 'Since the structure of the picture is not and cannot be homologous with the interesting matters or their structures, we cannot expect to read them off. We cannot describe pictorial meaning directly, which is quite all right as long as we acknowledge it.'[33]

Baxandall adopted a somewhat similar approach in his earlier discussion of Piero's *Baptism of Christ* in *Patterns of Intention*, but the interpretation offered there does not have the same resonance.[34] This is in part because he was constrained by the somewhat didactic agenda of the book in which this critical analysis was incorporated. His overriding concern was to offer a demonstration of intellectually rigorous inferential criticism that clearly differentiated itself both from the elaborate symbolic decodings of traditional iconographical interpretation and from the then recently fashionable social historical and political readings of works of art, whether Marxist or New Historicist. He was also reacting against schematic applications of the notion of the period eye he had adumbrated in his *Painting and Experience in Fifteenth-Century Italy* and an all too ready eagerness to which this had given rise to match cultural meanings with visual or formal configurations. His sensitivity on this score is evident in a late interview where he made the point that his conception of the period eye had 'caused a lot of misunderstanding', adding rather disingenuously: 'I think period eye is a very a modest, limited claim … The period eye is constituted by the skills of discrimination one acquires by living in a culture, including perceiving the art in that culture, but it is totally different from zeitgeist and has none of the theoretical substructure.'[35] In his discussion of Piero's *Baptism* in *Patterns of Intention*, he went so far as to hedge his own observations on the possible cultural significance of the pictorial peculiarities he singled out for mention, cautioning that 'Falling back into the

habit of looking for "meaning" one sought "signs" and of course immediately found them'.[36] All he allowed himself with regard to seeing any larger meaning in the painting was by way of indirectly associating the work's more purely pictorial and visual realization of *commensurazione* with the possible ethical and religious resonances of the term. Informing this take on the picture was a rather sparely articulated abstract point that 'Behind a superior picture one supposes a superior organization – perceptual, emotional, constructive'.[37]

In his later analysis of Piero's *Resurrection*, he had moved beyond the somewhat self-denying ordinance he had set himself earlier of refusing any assigning of cultural or social historical meaning to the work. Rather than downplaying as he did in *Patterns of Intention* the status of the broader cultural meanings that might have been associated with the subject depicted by designating these as circumstances framing the artist's fashioning of the work, he was open here to reflecting on the ways in which some such possible meaning might, however indirectly, shape and give resonance to the work's pictorial subtleties and idiosyncrasies. He did this by way of a careful detailing of these subtleties and idiosyncrasies, as he did in his earlier analysis of Piero's *Baptism*, but now with rather fewer inhibitions – and with a new insistence that these particularities somehow coalesced and issued in a sense of the picture being imbued with a very real and powerful significance. Characteristically, he made this point by way of a guarded qualification to his painstaking examination of the work's more distinctive visual features: 'The trouble is that piecemeal placing in this fashion short-circuits the more systemic force of the picture in which these individually described things interact. It thwarts a possible transcending pictorial super-event.'[38] Still, this was a back-handed invitation to the reader to see in his carefully ordered constellation of observations some indication of the 'transcending pictorial super-event' that Piero had realized in the painting.

Baxandall's way of engaging in detailed critical analysis of paintings might be characterized as acrobatic deadpanness. There is a strategic indirectness, with comments about larger meanings presented as tangential afterthoughts, but which then, nevertheless, seem to resonate retrospectively in his punctiliously deliberate analysis of pictorial detail and his matter of fact narration of the cultural realities that might have been at play in the conception of a work. A classic case is the way he slips in a comment at the end of his careful parsing of the perceptual subtleties, such as the sharply focused depiction of hand and arm and hat, and the more blurred, peripheral-seeming rendering of the figure's head, in Chardin's *The Lady Taking Tea* (Plate 6):

> I shall say that we have here a sort of Lockean *Apollo and Daphne*, a re-enactment of bafflement by the elusiveness and sheer separateness of the woman – who is, I can by now say without colouring your perception too much, probably Chardin's first wife a few week before her death.[39]

Still he was careful immediately to qualify this with a matter of fact insistence on pictorial and perceptual priorities. 'Lockean pictures', such as this, he wrote, 'represent in the guise of sensation, perception or complex ideas of substance, not substance itself'.

Something of this indirect, covertly charged approach is evident in the choice of covers for his last three books. *Shadows and Enlightenment* features what at first appears to be an academic study of a backwards-facing, carefully posed male nude handling a large pole, but is, on closer inspection a representation of Charon ferrying dead souls – the shades of the title – across the river Styx towards Hades, taken from a painting by the eighteenth-century French artist Sublyeras (Plate 7). The live flesh of Charon's body stands out vividly from the drained and shrouded bodies of the shades of the dead. In the detail of Chardin's *Lady Taking Tea* on the cover of *Patterns of Intention* (Plate 8), the glimpsed, brightly lit woman's hand contrasts with the inorganic quiddity and stolidly shadowed presence of the teapot. On the cover of *Words for Pictures*, there is the frozen and slumped form of a soldier from Piero's *Resurrection* (Plate 9), either sunk in deep sleep or one who 'became as dead men' faced by the terrifying display of immortal power in the wake of the Resurrection – either way, presaging the inertness of death to which the mortal body is subject, in contrast to the ever-living body of the divine Christ. These narratives of life and death are a subtext, both there and not there, the more powerfully present for being displaced by less resonant matters that are amenable to conceptual analysis. The latter have to do with complexities of interpretative inference and artistic intentionality, with how shadows, the gaps in the visual field, can make perceptions of shape more vivid, and finally and not least, with the attentive inattentiveness, the deliberate indirectness, with which one has to approach any worthwhile understanding of 'the visual conditions of pictorial meaning', and perhaps also those of living and dying.

Notes

1 Michael Baxandall, *Words for Pictures* (New Haven and London: Yale University Press, 2003), ix.

2 Michael Baxandall, 'Fixation and Distraction: The Nail in Braque's *Violin and Pitcher* (1910)', in John Onians (ed.), *Sight & Insight: Essays on Art and Culture in Honour of E.H. Gombrich at 85* (London: Phaidon Press, 1994), 398–415; Baxandall, 'Pictures and Ideas: Chardin's *A Lady Taking Tea*', in *Patterns of Intention. On the Historical Explanation of Pictures* (New Haven and London: Yale University Press, 1985), 74–104; and 'Piero dell Francesca's *The Resurrection of Christ*', Baxandall, *Words for Pictures*, 119–64.

3 See Adrian Rifkin (ed.), *About Michael Baxandall* (Oxford; Malden, MA: Blackwell Publishers, 1999).

4 Michael Baxandall and Hans Ulrich Obrist, 'Interview with Michael Baxandall', *RES*, 42 (May 2008): 52.

5 Michael Podro, *Depiction* (New Haven and London: Yale University Press, 1998).

6 Ernst Hans Gombrich, *Art and Illusion: A Study in the Psychology of Pictorial Representation* (New York: Pantheon Books, 1960).

7 The phrase comes from Baxandall, *Patterns of Intention*, 43. Wollheim's critical take on Gombrich's model achieved its fullest expression in his conception of the twofold nature of viewing a pictorial representations, with the latter understood as a process of 'seeing in' rather than 'seeing as' (Richard Wollheim, *Painting as an Art* [London: Thames and Hudson, 1987], 46–7 and 360, note 6).

8 For a discussion of these tendencies, see Alex Potts, *Experiments in Modern Realism: World Making, Politics and the Everyday in Postwar European and American Art* (New Haven and London: Yale University Press, 2013), 31–2, 70–77.

9 Jean Dubuffet, *Prospectus et tous écrits suivants* (Paris: Gallimard, 1967), vol. II, 75 (from a text first published in 1953). On Dubuffet's understanding of painterly process, see Potts, *Experiments*, 137–40.

10 Baxandall, *Patterns of Intention*, 43.

11 Dubuffet, *Prospectus*, vol. I, 103. This statement comes from an essay titled 'Cows, Grass and Foliage' in a text written in 1957.

12 Dubuffet, *Prospectus*, vol. II, 104.

13 See for example Frank Auerbach, *Primrose Hill*, oil on board, 1967–1968, Tate, London, illustrated in the catalogue on the gallery website (under Art and Artists), http://www.tate.org.uk/art/artworks/auerbach-primrose-hill-t01270.

14 Baxandall, 'Interview', 53.

15 Michael Baxandall, 'Foreword', in *Georg Baselitz Recent Sculptures* (New York: Gagosian Gallery, 2004), unpaged.

16 Michael Baxandall, 'Intentional Visual Interest: Picasso's *Portrait of Kahnweiler*', Baxandall, *Patterns of Intention*, 41–73, illustration plate I. The portrait dated 1910 is in the Art Institute of Chicago.

17 Baxandall, *Patterns of Intention*, 73.

18 Baxandall, *Patterns of Intention*, 63.

19 Baxandall, *Patterns of Intention*, 44–5.

20 Baxandall, *Patterns of Intention*, 61, 71.

21 Baxandall, *Patterns of Intention*, 102.

22 Baxandall, *Patterns of Intention*, 77–102.

23 Baxandall, 'Interview', 52.

24 Baxandall, *Patterns of Intention*, 103.

25 Baxandall, 'Fixation', 401–6.

26 Baxandall, 'Fixation', 409–10.

27 Baxandall, 'Fixation', 414.

28 Baxandall, 'Fixation', 414.

29 Baxandall, *Words for Pictures*, 118.

30 Baxandall, *Words for Pictures*, 126, 141–3.

31 Baxandall, *Words for Pictures*, 159.

32 Baxandall, *Words for Pictures*, 160.

33 Baxandall, *Words for Pictures*, 160.

34 'Truth and Other Cultures: Piero della Francesca's *Baptism of Christ*', Baxandall, *Patterns of Intention*, 105–37, illustration plate IV. The painting is in the National Gallery, London.

35 Baxandall, 'Interview', 44.

36 Baxandall, *Patterns of Intention*, 125.

37 Baxandall, *Patterns of Intention*, 135.

38 Baxandall, *Words for Pictures*, 146.

39 Baxandall, *Patterns of Intention*, 103.

'To Do a Leavis on Visual Art': The Place of F.R. Leavis in Michael Baxandall's Intellectual Formation

Jules Lubbock

'Anachronistic' was a word I remember Michael using quite often when he was teaching me in the late 1960s. He might say, 'That's anachronistic; they wouldn't have thought like that'.[1] He was not, of course, a dry-as-dust art historian; just because 'they', fifteenth-century spectators, may not have articulated their responses to a work of art in the way I had naively suggested, did not mean that my formulation was wrong.[2] Michael's profound understanding of the key terms and procedures of fifteenth-century art criticism and theory did not entail his own uncritical espousal; in fact, he considered them to be in many ways inadequate, as we shall see, sometimes even when deployed by Alberti himself. Nor did he consider it desirable, let alone possible, to respond only as a beholder contemporary to the work of art would have done. Nonetheless, much of his career was devoted to the study and teaching of what he called 'art and its circumstances'[3] and even if he did not consider that a grasp of the latter was a sufficient condition for understanding of the former, he did regard it a necessary one.[4]

Here I will examine the 'circumstances' of Michael's own development as a student of art. He has given his own account in *Episodes* in which he refers to his papers, most of them now housed in the Department of Manuscripts at Cambridge University Library; but reading those documents themselves provides a richer understanding of how the disciple of F.R. Leavis who graduated with an upper second in the English Tripos at Downing College, Cambridge, in 1954, became the Warburg lecturer who from 1965 was already teaching the material to be published in 1971 as *Giotto and the Orators* and, a year later, as *Painting and Experience*, books which gained him international fame. I shall concentrate upon a limited period, from his Cambridge years up to the early 1970s, and upon a single topic, namely his enduring admiration for Leavis and how his ambition 'to do a Leavis on visual art' manifested

itself.[5] I shall argue that Baxandall's approach to the study of works of art was essentially critical and interpretative, deriving from his education with Leavis. Like his close friend Michael Podro, who also studied English at Cambridge, though not in Downing, he was critical of British art history, 'Courtauld stuff' as he called it.[6] He wanted to develop an art history which combined the vigour of Leavis's approach to literature with the rigour of German scholarship. He was not a social historian; he did not aim to write an improved social history of art.[7] One of his key terms was 'relevance', and social facts were relevant only when they helped bring the work of art into clearer focus.[8] Furthermore, as we shall see, the spectator's initial experience was a very important starting point, however mistaken or anachronistic it might turn out to be in the light of subsequent study and reflection. This essay is a sketch, riddled no doubt with anachronisms and inaccuracies, but I hope it might inspire others to explore the riches of Michael's papers, perhaps in the form of an intellectual biography of this remarkable writer, teacher, and scholar.

ಎ ಎ ಎ

In *Episodes*, Baxandall describes how excited he was by Leavis's practice of literary criticism, particularly by his seminars in practical criticism held four mornings a week in Downing, 'not having realized at all that one could read so actively'.[9] But Baxandall points out that '"close reading" was not what was specific to Leavis ... What were ... were a temperament and a set of stances and a set of values.'[10] The values were 'established in exemplary pieces of literature ... read in his way'. Baxandall says that it took him some 'time to adjust to Leavis's unwillingness to describe procedures and criteria in general terms: I would have liked an explicit method with precepts and procédés', a 'sort of neat driver's manual'.[11] He came to accept that Leavis could not and should not produce such a thing, but not before making his own 'brief glossary' of some of Leavis's terms in an 'illegitimate document', part of which he quotes.[12] The original document, 'Leavis on Critical Theory', survives [Appendix]. Four key terms are examined.[13] Here I shall focus upon 'standards'.

The gist is that a *dictionary* definition of 'standards' is not possible. That doesn't mean that literary standards do not exist and cannot be discussed. They are, however, complex and interdependent upon other concepts and activities denoted by other key terms. For a start, literary standards are not objective like weights and measures; one cannot weigh a poem like a bag of potatoes. A poem doesn't exist in the same way as a physical object. It only exists once it has been 'established' (another key term) in the minds of its readers. Even this is not a simple matter of reading the words but is something to be accomplished through the exercise of 'literary criticism', whereby

the experience of the poem is recreated in the minds of readers and shared through collaborative discussion. This in turn depends upon an intelligent and informed 'reading public'. Literary criticism, therefore, was not quite the same thing as passing judgement on a poem. Each term entails others. Literary 'standards', therefore, require the creative act of 'establishing' the poem as a shared experience from which a 'judgement' will emerge.

This somewhat tortuous attempt to make sense of Leavis is of great importance within Baxandall's development. Much of his work over the next twenty years was devoted to disinterring and understanding the key terms of Renaissance art criticism and theory. In addition, the complexity of Leavis's practice of literary criticism set Baxandall a standard by which to judge Alberti and his contemporaries, if not always favourably. Maybe in applying Leavis's standards and procedures to those of a very different era Baxandall himself was guilty of anachronism, but he was no pedant and believed that even the most scholarly historian of art is 'unavoidably limited more than he realizes by responses anachronistic with the picture he is looking at'.[14]

There was another less intellectual side to Leavis, what Baxandall called his 'histrionic energy, his play-acting',[15] which not only played its part in his embattled public persona as the upholder of literary standards against the shallowness of the metropolitan literary world, but also played an intrinsic 'creative part in his criticism'. Baxandall observes that at his best Leavis was like 'an extraordinary actor' acting out not simply the text but also the 'author, reader, sometimes also character'. More significant, however, was Baxandall's insight that 'the intensity of Leavis's moral response to literature also arose from this: If you act out text, character, author and reader you are going to find yourself having to inhabit people you will have strong feelings about having had to *be*'.[16]

One implication of this was to be central to Baxandall's lifelong attempt to do a Leavis on visual art.[17] Baxandall considered that the dramatizing approach of the literary critic was not possible for the art critic, because in the visual arts there was no natural progression between the 'language' of the work and that of criticism.[18] Leavis's dramatic dialogue between 'text, character, author and reader' could not be transferred directly to the visual arts because three of those components were in different mediums to the fourth – the words used by the spectator and critic. This also has an important bearing upon what is often seen as Baxandall's distinctive contribution to art history, his attempt to develop a more subtle approach to the relationship between art and its social background than that of Antal or Hauser. Sometime in the late 1960s, perhaps while he was working on *Painting and Experience*, he reflected upon the brilliance of Leavis's own 'equations' between literature and the community, particularly in his essay 'Literature and Society' in *The Common Pursuit*.[19] As an example, this is how Leavis characterized the Augustan tradition in eighteenth-century England, manifested above all in

The Spectator:[20] 'The characteristic movements and dictions of the eighteenth century, in verse as well as prose, convey a suggestion of social deportment and company manners.'[21] Leavis is pointing to the way that literature is embedded in its 'milieu' through diction and social mores. The task Baxandall set himself was to find some equivalent within the visual arts for Leavis's social equations.

Baxandall admired others in Leavis's circle who had tackled this issue, particularly L.C. Knights and H.A. (Harold) Mason. The first half of Knights's *Drama and Society in the Age of Jonson* describes the economic and social issues of the reign of Elizabeth I.[22] The second provides literary criticism of the drama of Ben Jonson and his contemporaries. It is, however, an account of literature *and* society, not literature *in* society.

H.A. Mason was Baxandall's supervisor in Downing, for whom he wrote his essays. Baxandall pays tribute to him for arousing his interest in Renaissance humanism, for starting him on the path of learning Italian through his famous Dante evenings,[23] and for having shared a classical education.[24] Mason's *Humanism and Poetry of the Early Tudor Period*,[25] published five years after Baxandall graduated, is marred by polemical digressions and prolixity, but there are pointers to Baxandall's later approach. Mason, for example, quotes T.S. Eliot: 'It is fairly certain that "interpretation" is only legitimate when it is not interpretation at all, but merely putting the reader in possession of facts which he would otherwise have missed ... to present [the reader] with a selection of the simpler kinds of fact about a work – its conditions, its setting, its genesis.'[26] Mason recommends Burckhardt's *Civilisation of the Renaissance in Italy*,[27] always top of Baxandall's own short reading lists.[28] Mason is critical of the notion of a zeitgeist.[29] He sees the fifteenth-century humanist-led fashion to write 'imitation-Cicero' (later at the centre of *Giotto and the Orators*) as a dangerous tendency which led to vacuous 'fine writing', or belles lettres, anathema to Leavisites.[30] Baxandall too was critical of some aspects of humanist Ciceronian Latin.

By the end of his time at Cambridge, Baxandall was growing disenchanted with the literary criticism of Leavisite epigones, 'dishing out dismissals in the late *Scrutiny*'.[31] His professional interests were turning to the visual arts, so much a part of his own background;[32] he read Ruskin's *Seven Lamps of Architecture* and the third part of Wölfflin's *Classic Art*.[33] His first surviving work in the field is an unpublished 4,500-word review of *The Changing Forms of Art* (1955) by the painter Patrick Heron.[34] The book is a jumble, although an illuminating period document. The interest of Baxandall's review lies in his sense of Heron's 'limited conception of [art] criticism', in particular his avowed aim of simply providing 'an accurate description of the appearance of contemporary works, rather than hazard their "interpretation"'.[35] Baxandall's conclusion broaches the major issue of the language and procedures of art criticism: 'But if anything is to grow out of the present condition of English

art criticism, the critic … must proceed with flexibility and awareness of the complexity of feeling greater than Mr Heron seems to think necessary.'

Five years later, Baxandall, while having published nothing, had established his own characteristic procedures. We can trace this development. In 1955 he enrolled at the Courtauld Institute for an external BA, immediately setting out on three *Wanderjahre* in the course of which he acquired some necessary skills. The first year, 1955–1956, was spent at the Collegio Borromeo in Pavia learning Italian and touring the art centres of Italy. The second he taught English in Switzerland while learning German in preparation for the next year at the University of Munich studying art history.[36] At Pavia he was beginning to realize the need to establish a framework of theory, historical circumstances, observation, criticism, and evaluation.

> But these encounters [with works of art] either set or met problems that engaged me for years after. Did one need to think, to conceptualise about the character of these objects in order to get a grasp of them? Probably, but with what concepts? Their concepts? Was knowledge of the historical frame – art history but also cultural history – properly to be sought as a condition for understanding? Surely: their strangeness was hair-raising and insisted on questions about their circumstances. What then was the standing of the raw visual feel of the pictures and the immediate sense of human quality and mood? And could one evaluate the objects, relatively? One was doing so anyway; but then what was one's status?[37]

In Munich we glimpse the mature art historian. He has vividly sketched his encounter with the sinister Hans Sedlmayr, who unlike Leavis, 'had provided a driver's manual of how to analyze a picture'.[38] This was not what Baxandall was looking for. Instead he wrote his paper for Ludwig Heydenreich's classes on the use of source material for the study of the Ducal Palace in Urbino, 'the best formal teaching' Baxandall ever had in art history.[39]

One sheet of observations and several sheets of notes is all that survives of his paper on Federigo da Montefeltro's studiolo. But Baxandall lectured and conducted classes on Federigo and Urbino until he retired from teaching, although he never published on the topic[40] – it was a key case study for 'Renaissance Art and Its Circumstances' bringing together the social and political circumstances, the patron, humanism, Alberti, painting, and above all architecture.[41] From his later lecture notes on Urbino and from other papers, it is possible to hazard a reconstruction of where Baxandall stood when he entered the Warburg Institute shortly after leaving Munich in 1958.

First, Baxandall provides a brief biography of Federigo, the illegitimate son of the Count of Urbino who received a humanist education at Vittorino da Feltre's famous school in Mantua, before becoming a highly paid condottiere. Succeeding to the title after his legitimate brother's deposition and murder by the citizens of Urbino for sexual misdeeds, Federigo became, in effect, a constitutional monarch, installed by the commune on condition that he paid

for free education and social services out of his immense military income.[42] Baxandall surmised that this accounted for the architectural character of the ducal palace, designed by Luciano Laurana:

> To the town the palace present [sic] a low domestic front of three modest stories ... But in the other direction looking out from the town the palace is a huge massif, bristling with non-functional turrets, defying the outsider. This two-faced quality makes it a huge and unmistakeable emblem of the benevolent ruler, mild to his own, fiercely protective against foreign. It's a quite new and completely renaissance-movement effect.[43]

This brilliant architectural criticism,[44] Ruskinian in its vivid language if not in its brevity, is based upon personal observation and the deft use of Alberti's distinction between the palace of a just ruler and that of a tyrant:

> A good king (such as this) takes care to have his city strongly fortified in those parts which are most liable to be assaulted by a foreign enemy. A tyrant (on the other hand), having no less danger to fear from his subjects than from foreigners, has to fortify his city against his own people than against foreigners.[45]

A single sheet of observations on the studiolo, relating to Baxandall's 1958 paper, shows comparable architectural insight:

> The use of the room. Baldi – 'destinata alla studio'. Already in Bisticci 'il suo studio'. But the smallness and odd shape/proportions; the heaviness and jarringness of (without trying to give an aesth analys semimonochrome tarsien under chromatic worthies under v. heavily decorated & coloured ceiling; the 3 doors; wall shelves or furniture rule out by [Baldi descrv] tarsien; the oblique and limited light. One couldn't study there.

> Thus the room as receiving vestibule (between bedroom guardaroba and audience room) and, as prestige symbol & backcloth for 'humanist' prince – the propaganda of 2 figures of duke; the lifemanship of the negligently left appurtenances of war, study, and state; studio as a genre (cp others).[46]

This visceral response is an example of that 'raw visual feel of the pictures [mostly architecture in this case] and the immediate sense of human quality and mood'. He claims that the 'main critical conviction' that he 'had developed independently at Cambridge was the very general one that it was no use denying or excluding elements in your response to a work, as inappropriate or improper. They were intrinsic to one's energy ... The thing to do was to ... ride their energy and ... above all simply to know them for what they are'.[47] This point of view certainly marks him out from 'Courtauld stuff' and seems to relate to Leavis's performances of practical criticism where he would often read a passage, then express his dissatisfaction with his reading, reflecting upon what features of the piece were impeding his ability fully to enter into

it, using those reflections to open up his critical commentary, before reading it aloud once more.[48]

Baxandall's ambition to do a Leavis on visual art was clearly manifest in Munich. I would argue that it persisted throughout his career. He explains his views about the relationship between criticism and social history most fully in *Patterns of Intention*, though he alludes to them earlier in *Painting and Experience*.[49] Criticism should be one's focus and only historical facts which 'contribute to sharper perception of the pictorial order and character' should be adduced.[50] For example, the fact that Piero della Francesca owned farmland similar to that portrayed in the background of the *Baptism* would not be 'relevant' – another of Baxandall's key terms taken from Leavis.

Another significant feature of Baxandall's work on Federigo is its affinity to Burckhardt, whom he read at Cambridge. Indeed his account is based upon Burckhardt.[51] Baxandall's way of studying a subject was also similar to Burckhardt's; he would compile quotations from original sources on half-quarto index cards and then shuffle them around in patterns on a table before editing his material into the selective case studies of *Painting and Experience* and other publications.

Alberti's *De re aedificatoria* relates to the focus of Baxandall's studies at the Warburg – his efforts to puzzle out the meanings of the key terms in Renaissance art theory and criticism. *De re* was a central text for his uncompleted PhD, although its role is superseded by *De pictura* in his publications. At Munich he was beginning to analyze the language of Vasari's *Lives*, particularly that of Ghiberti as well as of Ghiberti's own *Commentaries*.[52] At the Munich Staatsbibliotek he read Ficino, Bartolommeo Facius, and Arnoldo della Torre's history of the Platonic Academy in Florence, and much else.[53] In short, Heydenreich seems to have directed Baxandall to some of the key issues of the next 15 years and beyond. But Heydenreich's own publications on Urbino, which presumably derive from his seminar, are far more straightforward than Baxandall's unpublished work. Heydenreich refers to the two facades of the palace but not to their contrasting characters. The seminar provided the scholarly underpinning for Baxandall's brilliantly worded perceptions.[54] In addition, Heydenreich, who had been a student of Panofsky in Hamburg in the 1920s, appears to have introduced Baxandall to Gertrud Bing, then director of the Warburg Institute, the second of Baxandall's three major mentors.[55]

Baxandall was at the Warburg for three years, from autumn 1958 to 1961, the first assisting in the photographic collection, the second two as a junior fellow studying for a PhD on restraint in Renaissance behaviour and its bearing upon the visual arts, theory, and criticism.[56] One of Heydenreich's observations about the Ducal Palace, that its 'decoration is characterised by a temperance in profusion', suggests the further possibility that his seminar may also have assisted Baxandall to formulate the topic of his doctoral studies, although he claims that it was prompted by the last part of Wölfflin's *Classic Art*.[57]

As he remarks, he read a lot in those two years, took many notes on 'half-quarto slips of any sort of paper', hundreds of which survive, but 'wrote practically nothing'. In fact some 60 pages of typescript, 20,000 words relating to the thesis, survive in addition to handwritten drafts.[58] Amongst the typescripts are 13 pages on 'Decorum in Alberti' which is almost certainly the piece upon which Bing commented 'in the frugal Institute manner on the back of galley-proof of the British Museum Library supplementary catalogue for 1949', which Baxandall came across when he was writing *Episodes*, though he believed that he had lost his own text. In fact he had only mislaid it.[59]

Baxandall is highly critical of Alberti's framework of architectural theory and criticism, which he considers 'to have been too tidy and inflexible' to do justice to the complexities both of the experience of architecture and the job of designing a building.[60] He identifies four components in Alberti's conception of architectural decorum: a scale of magnificence, the appropriateness of ornament to the building's place in that hierarchy, certain exemptions from the strict application of these rules, and, finally, an appeal to the mean.

The relationships between magnificence and ornament were 'the most obvious and the most recurrent. The amount of ornament the building is to carry is based on its position in a hierarchy of social importance descending from the temple to at least the houses of modest citizens.' While this scale is softened and moderated by the exemptions and by the mean, Baxandall describes it as the 'most rigid of the standards ... fundamentally so simple and so consistently explicit that it doesn't seem to lead very far in any very interesting way'. Indeed the second section of his paper is entitled 'The inadequacy of this'.[61] Here he attacks Alberti's view of architectural decorum not only for being too tidy but also for being too directly related to classical treatises on rhetoric. In his handwritten notes he is even more critical:

> Its limitations are clear enough. Yet, however much clarity he has gained by making use of the accessible model offered by rhetorical theory the structure appears to omit much. The very clarity of the system seems to give it a certain unreality.[62]

He also comments on Alberti's 'oddly dispassionate, cerebral handling of decorum'[63] which he contrasts unfavourably with the 'more enthusiastic aspects' and the 'less guarded tone'[64] of Alberti's response to actual buildings[65] exemplified by his only description of a contemporary building, the Florence Duomo, in the dialogue *Profugiorum*[66] which Baxandall quotes at length:

> And certainly this temple has in itself grace and majesty; and, as I have often thought, I delight to see joined together here a charming slenderness with a robust and full solidity so that, on the one hand, each of its parts seems designed for pleasure, while on the other, one understands that it has all been built for perpetuity. I would add that here is the constant home of temperateness, as of springtime: outside, wind, ice and frost; here inside one is protected from the

wind, here mild air and quiet. Outside, the heat of summer and autumn; inside, coolness. And if, as they say, delight is felt when our senses perceive what, and how much, they require by nature, who could hesitate to call this temple the nest of delights? Here, wherever you look, you see the expression of happiness and gaiety; here it is always fragrant; and, that which I prize above all, here you listen to the voices during mass, during that which the ancients called the mysteries, with their marvellous beauty.[67]

Baxandall comments with approval:

> The building has become more than a brick-and-mortar correlative of the theme of the dialogue; it is a means towards this very state of mind. The agency is complex, depending on utility, direct physical impressions and associations. It is only partly comprehensible within the scales of ornamental decorum. For what is missing from the system is the whole basis of transference. It presupposes a straight convertibility between formal elements and moral values ...

Once again, we encounter Baxandall's hostility to the 'driving manual' and his admiration for writing which is less systematic and more spontaneous, more direct and enthusiastic, in a word, more visceral.[68]

In conversation Baxandall could be even more forthright, and a trace of this survives in a letter to me about 1970 shortly before the publication of *Giotto and the Orators*:

> What did you find out about the art historians' distinction between appreciation and real study? I should be very interested to know as it worries me too. I think the trouble is that the existence of art history or, earlier, art criticism has created a situation where even children and innocent adults find themselves in a condition of anxiety in front of a picture, anxiety about 'proper' response, 'understanding' and so on. This began in the renaissance, above all with Alberti, who inhibited people through the difficulty of his equipment. I think one can only provide a few non-destructive categories they can try out – Wölfflin's for instance – almost purely as a means of giving them confidence, warming up, and showing there is no mystery. A banal point of view.[69]

Baxandall never published his work on *De re*,[70] but the chapter on *De pictura* in *Giotto and the Orators* derives from it, although in that book his account of the shortcomings of the rhetorical model is more balanced and judicious.

He argues that the language we use strongly affects the ways in which we attend to things, both in the world and in the visual arts.[71] He provides a detailed account of how the humanists had aimed to re-establish the language and the 'institutions of art criticism'.[72] Humanist neo-Ciceronian Latin, however, was not a language learned from infancy nor used in everyday life, but a reconstructed supplementary language. The result was that 'the ascendancy of language over experience inevitable in any critical discourse' was compounded by the humanists' obsession with the forms and structures of classical Latin: 'Relatively little of their energy need be spent on brutalizing

the beautiful patterns of language to make a workable fit with experience; relatively more could be spent on playing on these patterns correctly and stylistically'[73] But although he praises as 'triumphantly vernacular' Galli's epitomization of Pisanello derived partly from the Italian vernacular language of dance manuals – to be discussed later – he argues nonetheless that humanist Latin did make it 'easier to talk about some things'.[74] The major example of this is Alberti in *De pictura*, where his application of the classical rhetoricians' composition of the periodic sentence and of antithesis is 'creatively used'.[75] Alberti, he says, was 'much more serious' than other humanist writers on art because unlike them he also had practical experience of painting, and was a serious writer in vernacular Italian as well being a good humanist. Thus, 'out of the litter of humanist cliché and habit he made something with very long-term consequences for European attitudes to painting', even though those consequences were not entirely benign.[76] In a passage of virtuoso writing, Baxandall demonstrates how Alberti's system influenced the composition of Mantegna's engraving of *The Lamentation over the Dead Christ*, which he describes as 'the proper visual appendix to *De pictura* II', while also using Alberti's categories to write a compelling piece of practical criticism of the engraving as well as providing exemplary literary criticism of Alberti's text itself.[77]

By the time of the publication of *Giotto and the Orators*, Baxandall had moved beyond his crudely polarized admiration for the vernacular and condemnation of revived latinity of 'Alberti and Decorum'. Instead of regarding the two languages as mutually exclusive, he saw them as mutually enriching, particularly in Alberti's writings, even though Baxandall was frustrated by the 'difficulty of his equipment'. His manuscripts enable one to penetrate the poised scholarly style of the published work to his personal hostility to some aspects of the language of art criticism and history, both Renaissance and contemporary.

The ambition behind *Painting and Experience* was to provide an answer to the problems of neo-classical art criticism aired in *Giotto and the Orators*. I think that his adoption of the word 'experience' in the title relates to his use of the word in *Giotto and the Orators*, where he sets it against the generalizing and categorizing nature of language in general and of humanist Latin in particular: 'Any language, not only humanist Latin, is a conspiracy against experience in the sense of being a collective attempt to simplify and arrange experience in manageable parcels.'[78] The two books are really two parts of the same argument. What we have, in effect, is a dispute between the Orators and Experience. In the second book he aims to reconstruct the kind of more flexible, complex, and less rule-based critical vocabulary which he found in Alberti's Duomo passage in *Profugiorum*, as well as to find some equivalent in art criticism to Leavis's procedures. Incidentally, the original titles were *Pisanello and the Orators*[79] and *Painting and Perception*.[80]

Amongst the typescripts from the early 1960s is one on dancing, annotated by Bing. It is important for being the earliest evidence of Baxandall's interest in vernacular visual skills and their bearing upon art criticism, central to *Painting and Experience* and *German Limewood Sculpture*. Much of this paper was used in a 1965 BBC Third Programme talk, 'Botticelli and the Bassa Danza', which was recycled in *Painting and Experience*.[81]

His identification of dancing as the key vernacular visual skill of the quattrocento was an imaginative leap, whose precise trajectory I have not been able to reconstruct. Much of his Warburg work was concerned with the language Alberti used to discuss architecture and decorum. The hundreds of index cards were largely concerned with decorum and restraint not only in the visual arts but also in everyday life – clothing, fashion, sumptuary regulation, music – but I have found no cards on dancing. It may have been the serendipity of the Warburg Library, where dance is located on the shelves close to cookery, household management, festivals, and the conduct of courtly life, where he may have been looking for material on decorum.[82] At DCA 1540 he would have found an offprint of an article entitled 'The Earliest Dance Manuals', by Artur Michel. He made a photocopy of the article.[83] Of course there remains the possibility that he was following up on a suggestion of Warburg or a tip from Bing, Gombrich, or the Warburg's polymathic librarian Otto Kurz. Albeit, the paper begins with an analysis of a passage from Angiolo Galli's 1442 sonnet to Pisanello subsequently quoted in both *Giotto and the Orators* and in *Painting and Experience*.

Art, *mesura, aere* and draughtsmanship, *Maniera,* perspective and a natural quality – Heaven miraculously gave him these gifts.[84]

Baxandall criticizes Panofsky's[85] definitions of *mesura, aere,* and *maniera,* the three terms which did not belong to the Renaissance language of art criticism, 'for depending so much on rather later preoccupations'.[86] He is taken to task for interpreting *aere* as 'the air of the figures' in the modern usage of the word meaning simply appearance or manner,[87] 'a more or less neutral mount for the adjectives they are carrying' as when one talks of a graceful air. Baxandall rejects this as 'surely quite anachronistic'.[88] The three words have specialized meanings deriving from fifteenth-century manuals on dancing the earliest of which, Domenico da Piacenza's *De Arte saltandi*[89] of around 1445, defines *aere* as 'the art of an elegant alternation between motion and repose, conforming to the demands of the musical rhythms'.[90] He also explains the precise meaning of *mesura* and *maniera* in the manuals.

Baxandall's account of the relationship between the dance manuals and the visual arts is famous.[91] I wish to make two points. First, dance provided him with trace evidence of key terms in the Italian language, in the vernacular, which Galli and others were applying in their discussion of the visual arts.

Baxandall considered that this corresponded to Alberti's 'enthusiastic' and flexibly expressed account of Florence cathedral that Baxandall preferred to the formal, rhetorical, neo-classical humanist Latin of *De re*. He also found the Italian vernacular in Cristoforo Landino's observations on fifteenth-century Florentine painters and in Ghiberti's commentaries as well.[92]

Second, I think that dancing, more than the other vernacular visual skills such as pious meditation, listening to sermons, gauging quantities, or the Rule of Three, provided Baxandall with the kind of shortcut between social life and the visual arts that he found in Leavis, and which he considered to be less problematic for literary than for art criticism. Dancing was popular at all social levels; it also involved bodily movement and deportment that could also be employed as models for pictorial composition, particularly for the new mythological subjects where there were no traditional compositional formulae as existed for religious images. Through the language and practice of dance, the twentieth-century spectator of such pictures could infer a sense of the distinctive culture of the fifteenth century, just as Leavis had done for the Augustan period.

Earlier I referred to some notes about Leavis which Baxandall probably jotted down in the late 1960s while working on *Painting and Experience*. They bear quoting at length:

> Some years ago FRL [FR Leavis] … L&S ['Literature and Society'] CP [*The Common Pursuit*]. Brilliant statement how can/not set about stating equations between litt/ community. Particularly brilliant for *examples*. One, of a way a man writes being closely connected community, Bunyan PP. [*Pilgrim's Progress*], and its [*sic*] stayed in mind as warning to a.h. [art historian] what he himself cannot do.
>
> Strength of B's language recognisably related milieu raciness, concreteness, marvellous control of rhythm and tone, colloquialism idiom of directly relatable small town, south midlands, small craftsman, bible-reader, non-conf. [nonconformist] preacher. Within a given sentence. Rel. can be made with precision and detail. Exactly this one would like p & s [painting and sculpture?]
>
> Medium of litt is language: of v.as [visual arts] not. Language one of 2 or 3 central social skills We all talk … We all have very highly developed common collective ling. skills, with distinctive individual and sectional variations: This is not so v.a's Putting pigment on flat plane surface … . This the problem – that, though painting just as social – in sense of being a thing done by one person with a view to others responses – its medium is a matter of specialist skills and much of its history is private to itself. It follows that one cannot do what one does with Bunyan for Giotto or … .[93]

Through his invention of the notion of vernacular visual skills, Baxandall was able to find in the 'church-going business man, with a taste for dancing' the Italian Renaissance equivalent to Leavis's account of the south Midlands, Bible-reading small craftsman with a taste for non-conformist sermons which constituted Bunyan's cultural milieu and informed his art.[94]

æ æ æ

At first glance Michael Baxandall's work seems quite unlike that of F.R. Leavis.[95] Leavis is polemical, passionate, and confrontational; Baxandall appears scholarly, cool, and judicious. Baxandall didn't like polemics.[96] His own circumstances and temperament were not those of Leavis. His family were deeply involved in the visual arts, particularly in the St Ives group of artists. He liked Raymond Chandler novels, Citroën cars, and the cool jazz of Miles Davis. Both of them, however, were steeped in the Arts and Crafts movement.[97] Both studied Latin and Greek at secondary school. Leavis studied history before changing to English literature. What Baxandall found so exciting about Leavis's literary criticism was the intensity of his engagement with writing and his ability to communicate partly through quotation (in class by reading aloud), partly through close reading and, more often than one might think, by adducing the historical, social and ideological circumstances.[98] A critic of the visual arts cannot read a painting aloud, but Baxandall used the other two methods to sharpen our perceptions of a work of art. He had no desire, however, to impose his own interpretations upon students or readers, as Leavis was notorious for doing.[99] But Baxandall was just as passionate as Leavis about the individual work and the oeuvre, starting with the 'raw visual feel' of his first encounter, subsequently refined through the effort of entering into the circumstances such as the language of dance manuals, Alberti's humanist concept of pictorial composition, gauging, or the economy of German cities. He wanted to avoid anachronism, but what drove him was his passion for the visual arts and his irritation with the language of art criticism and the procedures of art history when they erected barriers between the spectator and the work. This was the radical, creative, open-ended, even anarchic ambition behind his work, which is perhaps even more evident in his sometimes fiercely worded manuscript drafts and jottings than in his finely polished publications.

Appendix

Cambridge University Library, Department of Manuscripts and University Archives, Add. Mss. 9843/7/2/5/1.

Leavis on Critical Theory

Standards

This problem can come up in a number of guises. One may abstain from the metaphysical angles. The matter cannot be separated from critical method. One must assume ignorance apart from the two Eliot essays – 'Use of Poetry' and 'Tradition and the individual talent' Standards are not like weights and measures; nor can they be imposed. They only exist by being *recognized*; and so they cannot be discussed apart from method. Standards only exist in an intelligent and interested public. You cannot define them; nor is the term safe. Talk about 'judgement' instead; related to 'perception'. Which two cannot really be separated. Value and valuation are very complex ideas; you cannot put a price on literature. 'Judge ment' suggests application of standards, which is impossible; so use 'perception' in its related quality as a prophylactic against this error. The type undertaking of criticism is not valuation but the establishment of say the poem as an existing thing; and of course the valuation is a part of this – you cannot take possession of a poem in a neutral way or in a critical vacuum, re-creative analysis cannot exist without implied value judgement.

Analysis. 'Practical criticism' is not a part but an illustration of criticism. In analysis we are not dealing with an inert object. Analysis is a process of *re-creation*. Involving discipline in relevance.

So the form of a critical judgement, though in the first place inevitably personal or nothing, cannot be merely personal. It must mean to be more than that; one cannot mean a serious judgement to be merely personal as Empson would claim, we must want confirmation.

For we must assume that since there is *a* poem there must be *a* content, *a* meaning; that there is a total coherent meaning. The poem does not consist in the marks on the paper, but in the effects of the marks on the mind, in the response of the reader. It is thus neither purely public nor purely private. But if you could not establish from the print on the page something over which minds could meet literature would be pointless. (Invoke instance of Jules Lemaitre and Anatole France for insignificance of scepticism and impressionism – Irving Babbitt. They held the purely personal ejaculation as all criticism could do – 'You cannot get outside yourself', 'Adventures of one's soul in masterpieces'. Of course you cannot confine this scepticism to

criticism.) Language exists only as something apprehended or conceived. But in spite of this a judgement cannot seek to impose itself upon the reader; it must be an appeal for agreement. Thus – 'This is so ...', then appeal '... is it not?' We do not get complete agreement – 'Yes, but ...'. At best we can only expect qualified agreement; but we try to get enough to make differences profitable. And in this re-creative and co-operative process evaluation is implied and inevitable.

Criticism is almost impossible in an age when it is crippled by social form. Standards are not weights and measures, nor are they purely personal: standards are absent now because a collaborative intelligent public are absent with their common sensibility. (For the problem of public sensibility, and the necessity for such a public and its criticism for the writer see Arnold 'Function of criticism') The contemporary sensibility has assumptions. The critic must recognize these assumptions, or 'standards', but need not justify them.

Moral Judgements

The criteria of a value judgement: One cannot distinguish between moral and critical considerations. The critic should not necessarily base his moral-critical judgements on any particular ethic; he offers them with the same appeal for agreement as in other critical judgements, an appeal to the moral-critical sense-response of the reader. Moral as a word is used in criticism for emphasis on relevance to 'criticism of life'. Significant art challenges (moral) habit and with acquaintance changes it. Failure to change or challenge it implies pejorative judgement. So all significant art is in a sense 'immoral'.

(Then the points of reference, the standards by which we judge, are nothing more than our sense of life, the contemporary sensibility.)

Art and Morality

Start by way of the aesthetic fallacy: 'Art for art's sake' means nothing but only stands for an attitude. The nearest approach to an intellectual statement is in Clive Bell. It started with Gautier – 'L'art pour l'art'. In his poems in fact he transcended it. Keats not of it, as 'art' in Gautier's sense had not then been thought of. Then Pater, who does in fact allow for moral judgement and comparison (essay on Style). But he only admits the distinction between 'perfection' and greatness theoretically; all the emphasis is on 'art'. Wilde does not count. Whistler is one of the most lively.

In fact, Aestheticism was partly an answer to a phase in civilization when the arts were on the defensive and thought unnecessary. And partly reaction against the moralistic fallacy of Ruskin.

The moralistic fallacy: Ruskin shows one side of it in the didactic (which in itself is not one) fallacy – the idea that moral content must be explicit (Johnson on Shakespeare for classic statement) not just enacted. This leads to poetic

justice and the rest. Didacticism in itself is not necessarily wrong – in Dante and Bunyan it is the vitalizing element – but must be watched, for work with a didactic intention is inclined not to come from the whole psyche, just the moral side of it.

There is also Tolstoi, who is the moralistic fallacy and in whom the word 'directly' is the key. See Richards Principles Chaps. 9 and 10. The answer to Tolstoi's 'directly' is in Shelley: 'The chief agent of moral good is the imagination, and poetry ministers to the end by acting on the cause.'

See also James on Flaubert, Balzac and Maupassant.

Impersonality

Impersonal: not direct address from the poet; self effacement, disinterestedness, detachment. But only in certain circumstances does one talk about it (Wordsworth, Keats). See Leavis on Hyperion for his treatment. Related to the question of form – necessity for living rhythm not to be stifled by it (Lawrence on Mann). Locae: Eliot's Tradition and the Individual Talent (reaction against Romantic confusion of autobiography and art); Sturge Moore for Flaubert tags (who first used the term impersonality); Richards Principles pp. 245 ff.; Coleridge Chap 15 on Venus and Adonis. A big question is whether Lawrence lacked impersonality in Women in love; and whether it matters.

Notes

1 The Papers of Michael Baxandall, Department of Manuscripts, Cambridge University Library, Additional Mss 9843/7/2/1/1 [2/2]; Baxandall Papers, CUL, Add. Mss., 9843/8/14; Baxandall Papers, Social dancing paper, CUL, Add. Mss., 9843/8/16; Michael Baxandall, *Patterns of Intention: On the Historical Explanation of Pictures* (New Haven and London: Yale University Press, 1985), 120. I wish to acknowledge the generous help and direction that I have received from Kay and Lucy Baxandall family and from Svetlana Alpers in writing this essay. Dr Patrick Zutshi, Keeper of Manuscripts and Archives at Cambridge University Library; Karen Davies, who catalogued the Baxandall papers; and all the staff of the department made my visits there a very great pleasure.

2 Baxandall Papers, CUL, Add. Mss., 9843/7/2/1/1 [2/2].

3 Slade Lectures, University of Oxford, 1974, 'Art and Circumstances: High German Renaissance Sculpture'; Baxandall Papers, CUL, Add. Mss., 9843/5/11: AH162, University of California, Berkeley, 'Italian Renaissance Art and Its Circumstances, 1400–1527'; Michael Baxandall, *Episodes: A Memory Book* (London: Frances Lincoln, 2010) 86, quoted below.

4 Baxandall, *Patterns of Intention*, 120.

5 He expresses his feelings about Leavis in *Episodes*, pages 71 and 107; see also Ian MacKillop, *F.R. Leavis: A Life in Criticism* (London: Allen Lane, 1995), 8–9. The whole passage is illuminating. Of course there were many other scholars and writers whom he admired such as Burckhardt, Wölfflin, Panofsky, Gramsci, Bing, and Gombrich but the contention here is that Leavis was fundamental to Baxandall's development, as he himself says.

6 Glyn Allan Langdale, 'Art History and Intellectual History: Michael Baxandall's Work between 1963 and 1985', (PhD diss., University of California, Santa Barbara, 1995), UMI Microform, 1995, 377, interview with Baxandall, who describes university art history in the 1950s and 1960s as 'old-fashioned – I withdraw that word – tended to be art history as we knew it. Courtauld stuff'. He preferred the way the subject was being taught in the art schools, such as Camberwell under Michael Podro, as much more varied and more free. He has interesting observations on the differences between German and English art history and criticism on pages 364–6.

7 There are references in his papers to both Arnold Hauser and Frederick Antal amongst others, but he wasn't interested in social history of art on such a level of generality.

8 In *Painting and Experience*, 151, he observes that 'much of the book has been given up to noting bits of social practice or convention that *may sharpen our perception of the pictures*' [my italics]. This was a formulation he also uses in *Patterns of Intention* where he talks on 136 about the irrelevance to one's understanding of Piero della Francesca's *Baptism* that the artist owned farmland similar to that in the background: 'it would not contribute to sharper perception of the pictorial order and character'. He uses the phrase in several other places.

9 Baxandall, *Episodes*, 63. For seminars held four times a week see MacKillop, *Leavis*, 10.

10 *Episodes*, 65.

11 Baxandall enjoyed driving and cars. In *Episodes*, 86 he refers to a summer vacation at Cambridge driving a Land Rover around the sites of Italy with a couple of friends, and he took great pleasure in the design of his Citroën GS in the early 1970s.

12 *Episodes*, 66.

13 *Episodes*, 65–7; 'Leavis on Critical Theory', Baxandall Papers, CUL Add. Mss. 9843/7/2/5/1. There are two quarto pages typewritten on both sides. Standards takes up half the text, art and morality a quarter, and moral judgements and impersonality an eighth each. It probably dates from about 1953 and seems to be the earliest surviving piece of Baxandall's writing. None of his student essays seem to have survived.

14 Baxandall Papers, CUL Add. Mss. 9843/7/2/1/1 [2/2] written on cream coloured paper 8x8" dating from the summer of 1970, in which he compares two approaches to writing about works of art, that of the art critic with little scholarly knowledge of the period and that of the art historian who tries to avoid anachronism. He says that both approaches are valid.

15 *Episodes*, 68.

16 *Episodes*, 69.

17 *Episodes*, 71. In Baxandall's letter to MacKillop, *Leavis*, 9, he writes that 'I set out partly to do a Leavis … '

18 *Episodes*, 71–2.

19 Baxandall Papers, CUL Add. Mss. 9843/7/2/1/1 [1/2].

20 The title of Leavis's PhD thesis was *The Relationship of Journalism to Literature: Studied in the Rise and Early Development of the Press in England*, University of Cambridge, 1924. This is a very scholarly account with excellent chapters on Addison and Steele's *Tatler* and *Spectator*. Leavis started out as a historian, taking the two-year Part 1 Tripos in History, for which he got a 2ii, before going on to the one-year Part 2 in the new English Tripos where he got a First. See MacKillop, *Leavis*, 37–8, 48–51. For the circumstances surrounding his thesis see pages 68–72.

21 F.R. Leavis, *The Common Pursuit* (Harmondsworth: Penguin,1962) [1st edition 1952], 186.

22 L.C. Knights, *Drama and Society in the Age of Jonson* (London: Chatto and Windus, 1937).

23 According to David Ekserdjian these were still flourishing in the 1970s.

24 Baxandall, *Episodes*, 64. Baxandall argues that by virtue of that shared background, Mason showed greater sensitivity to his frame of mind than Leavis himself, whose first report on Baxandall's progress described him as 'crippled for life by a classical education'. In fact, Leavis himself had an extremely rigorous classical education at the Perse School in Cambridge, where lessons were conducted in Latin and Greek, see MacKillop, *Leavis*, 33–5.

25 H.A. Mason, *Humanism and Poetry of the Early Tudor Period* (London: Routledge and Kegan Paul, 1959).

26 Mason, *Humanism*, 2. Mason left out Eliot's parenthesis following "interpretation" – '(I am not touching upon the acrostic element in literature)'. See 'The Function of Criticism' of 1923 in T.S. Eliot, *Selected Essays* (London: Faber and Faber, 1961) [1st edn. 1932], 32.

27 Mason, *Humanism*, 20.

28 Baxandall Papers, CUL, Add. Mss. 9843/5/1. His course on the Italian Renaissance for the University Board of Studies in History, 1972–1973, provides a list of Burckhardt, Brucker on Florence, Dennis Hay on the Italian Renaissance in its historical background, Panofsky's Renaissance and Renascences, and Vasari's Lives. Later booklists at Berkeley are similar.

29 Mason, *Humanism*, 23. On page 30 he also refers to the first great Northern European humanist, Rudolph Agricola, about whom Baxandall was to write.

30 Mason, *Humanism*, 31.

31 *Episodes*, 70.

32 *Episodes*, 71–2.

33 *Episodes*, 72. There is no third part of *Classic Art*. He is probably referring to the second part – the New Ideal, the New Beauty, and the New Pictorial Form.

34 Baxandall Papers, CUL Add. Mss. 9843/7/2/5/2; *Episodes*, 72.

35 Michael Baxandall, *Giotto and the Orators: Humanist Observers of Painting in Italy and the Discovery of Pictorial Composition, 1340–1450* (Oxford: Clarendon Press, 1971), 46: 'At any time very little is said about paintings in direct descriptive terms.'

36 *Episodes*, 75–110; Baxandall Papers, CUL Add. Mss. 9843/1/12 for his CV.

37 *Episodes*, 86. He also mentions on page 86 'notes of observations' he took on these visits as being 'pale and useless', but these do not seem to have survived.

38 *Episodes*, 104.

39 *Episodes*, 108; Baxandall Papers, CUL, Add. Mss. 9843/1/7, Calendar of courses for the Summer Semester, p. 168; CUL, Add. Mss. 9843/1/6 Baxandall's Studienbuch, Summer Semester 1958.

40 He refers to Urbino on page 133 of *Giotto and the Orators*.

41 Baxandall Papers, CUL Add. Mss. 9843/5/11.

42 First draft of first Slade Lecture, 26, Baxandall Papers, CUL. Add. Mss. 9843/5/7.

43 Lectures on the Italian Renaissance, handwritten 96-page mss. on cream 8x8" paper, 62, Baxandall Papers, CUL. Add. Mss. 9843/5/17. On the basis of internal evidence, this was probably written in the summer of 1970.

44 There is some remarkable architectural criticism in a long 42-page essay on Michelangiolo [sic] which may have been written in 1958–1959 when he was preparing to take the exams for his external Courtauld B.A. Particularly striking is his account of the vestibule of the Laurentian Library on 24–5. Baxandall Papers, CUL. Add. Mss. 9843/8/9.

45 Baxandall Papers, CUL Add. Mss 9843/5/6, foolscap page of what appears to be Baxandall's own translation of Alberti, *De re aedificatoria*, Vi. It is written on Victoria and Albert Museum drafting paper with the royal crest and hence dates from after autumn 1961 when he joined the Museum. For the drafting paper see *Episodes*, 132. See also Baxandall Papers, CUL Add. Mss. 9843/8/11, index card with quote from *De re*, Viii on the adornment of the palace of a king.

46 Baxandall Papers, CUL Add. Mss. 9843/5/6. Single sheet of paper 20x20.5 cm written in pencil with a large capital P in red ink in top left-hand corner. On the evidence of available manuscripts Baxandall seems only to have used red ink during his period in Munich.

47 *Episodes*, 86–7. Lucy Baxandall in a conversation in September 2012 used the word *visceral* to describe her father's strong and instantaneous reactions to things.

48 Personal recollection. Of course this too was a staged performance since he used the same passages, indeed the same well-thumbed cyclostyled sheets year after year, but it sounded spontaneous.

49 *Patterns of Intention*, vii, viii, 116, 136–7. For *Painting and Experience* see note 8 above.

50 To return to the earlier quote from T.S. Eliot, '"interpretation" is only legitimate when it is … merely putting the reader in possession of facts.'

51 Jacob Burckhardt, *The Civilisation of the Renaissance in Italy* (London: Phaidon, 1965 [1860]), 29–30 and 135. Maybe he read Burckhardt on Mason's recommendation.

52 Baxandall Papers, CUL. Add. Mss. 9843/8/13; CUL, Add. Mss. 9843/8/9, seven pages in red ink, therefore dating from Munich, on Ghiberti's Commentaries.

53 Baxandall Papers, CUL Add. Mss. 9843/5/6.

54 Ludwig H. Heydenreich, 'Federigo da Montefeltro as a Building Patron: Some Remarks on the Ducal Palace of Urbino', in Michael Kitson and John Shearman (eds), *Studies in Renaissance and Baroque Art Presented to Anthony Blunt* (London and New York: Phaidon, 1967), 1–6. Baxandall set this essay as reading for his own classes; Ludwig Heydenreich and Wolfgang Lotz, *Architecture in Italy, 1400–1600* (Harmondsworth: Penguin, 1974), 71–9.

55 *Episodes*, 112; MacKillop, *Leavis*, 9, mentions three. Leavis was obviously the first and Bing the second; my guess is that Gombrich was the third.

56 *Episodes*, 112; Baxandall Papers, CUL, Add. Mss. 9843/1/12 for Baxandall's 1980 CV.

57 Heydenreich and Lotz, *Architecture in Italy*, 76; *Episodes*, 118.

58 *Episodes*, 123. Some of the handwritten drafts are written on Victoria and Albert Museum paper with the royal crest, 'the slick, signeted, yellowish foolscap used in the Museum for informal drafts', *Episodes*, 132, so they must date from between autumn 1961 when he started working at the V&A and Bing's death in 1964. Baxandall Papers, CUL, Add. Mss., 9843/5/4, 9843/89, 9843/8/5, 9843/8/4, 9843/8/14, 9843/8/16, 9843/7/2/1/1 [1/2] and [2/2], 9843/8/11.

59 Baxandall Papers, CUL, Add. Mss. 9843/8/16, 9843/8/1, 9843/1/10. Another such piece of 1949 galley proof with a bibliographic reference is in CUL, Add. Mss. 9843/8/11.

60 Baxandall Papers, CUL, Add. Mss. 9843/8/14.

61 Baxandall Papers, CUL, Add. Mss. 9843/8/14, 3.

62 Baxandall Papers, CUL, Add. Mss. 9843/8/1 folio 5r II on V&A paper.

63 Baxandall Papers, CUL, Add. Mss. 9843/8/14; CUL, Add. Mss. 9843/8/1 folio 5r II on V&A paper, 5.

64 Baxandall Papers, CUL, Add. Mss. 9843/8/14.

65 Baxandall Papers, CUL, Add. Mss. 9843/8/1.

66 Also known as *Della Tranquillità dell'Animo*.

67 Translation by Christine Smith, *Architecture in the Culture of Early Humanism: Ethics, Aesthetics, and Eloquence 1400–1470* (New York and Oxford: Oxford University Press, 1992), 5–6.

E certo questo tempio ha in sè grazia e maiestà: e quello ch'io spesso considerai, mi diletta ch'eo veggo in questo tempio iunto insieme una gracilità vezzosa con

una sodezza robusta e piena, tale che da una parte ogni suo membro pare posto ad amenità, e dall'altra parte compreendo che ogni cosa qui è fatta e offirmata a perpetuità. Aggiungni che qui abita continuo la temperie, si può dire, della primavera: fuori vento, gelo, brina; qui entro temperatissimo refrigerio. E s'egl'è, come è dicono che le delizie sono quando a' nostril sensi s'aggiungono le cose quanto e quali le richiede la natura, chi dubiterà appellare questo tempio nido delle delizie? Qui dovunque tu miri, vedi ogni parte esposte a giocondità e letizia; qui sempre odoratissimo; e, quell ch'io sopra tutto stimo, qui senti in queste voci al sacrificio, e in questi quali gli antichi chiamano misteri, una soavità maravigliosa.

68 Baxandall Papers, CUL, Add. Mss. 9843/8/9, seven pages of notes on small paper sheets in red ink (Munich 1957–1958) on Ghiberti's Commentaries. He talks of Ghiberti's 'pretension to be a humanist' which he dismisses, but clearly admires his writing on art: 'enthusiasm for Ambrogio Lorenzetti'; 'He is very much the *romantic* enthusiast over antiquity'; 'His strength is in his non-humanist side – vitality of description particularly.' He compares him with Alberti 'who was never an artist among artists'. Enthusiasm seems to have been a key term of approval for Baxandall at this time. Section 4, 'Interpenetration of values', of the Alberti and Decorum paper, 10–11, identifies far more complex relationships between 'art and life' in *De re*.

69 The letter is in Baxandall Papers, CUL but will remain closed until 2045. The final sentence is a typical example of Baxandallian self-deprecation. In his notes for the paper on 'Art, Society, and the Bouguer Principle' (later published in *Representations*, 12 [Fall 1985]: 32–43) he writes 'To do yet: Cut by 2 ¾ minutes … Insert 3 charming ironies, 1 real joke, 1 (suggestions welcome) self-deprecation'. Baxandall Papers, CUL, Add. Mss. 9843/6/2. There is a summary by Baxandall of Wölfflin's five pairs of principles in CUL, Add. Mss. 9843/8/9.

70 He refers to *De re* in his important but infrequently cited 1972 paper 'Alberti and Cristoforo Landino: The Practical Criticism of Painting', in *Accademia Nazionale dei Lincei, Anno CCCLXXI – 1974, Convegno Internazionale Indetto nel V Centenario di Leon Battista Alberti,* (Rome: Accademia Nazionale dei Lincei, 1974), 143–56.

71 Based upon a modified version of the Whorf Sapir hypothesis, see Roger Brown, *Words and Things* (New York: Free Press of Glencoe, 1958), 238, a copy of which Baxandall owned. A receipt from the university bookshop in Malet Street indicates that he bought the book in May 1966. There are several index cards which relate to Whorf Sapir in Baxandall Papers, CUL, Add. Mss., 9843/8/17.

72 Baxandall, *Giotto and the Orators*, 50.

73 Baxandall, *Giotto and the Orators*, 46.

74 Baxandall, *Giotto and the Orators*, 13.

75 Baxandall, *Giotto and the Orators*, 50 and 129–35.

76 Baxandall, *Giotto and the Orators*, 50.

77 Baxandall, *Giotto and the Orators*, 133. In his 1972 conference paper on Alberti and Cristoforo Landino he argues that Landino's observations were in effect an appendix to *De pictura*. See note 70 above.

78 *Giotto and the Orators*, 44. One is reminded of T.S. Eliot's observation about Henry
James in the *Little Review*, 5, no. 4 (August 1918): 46. 'James's critical genius
comes out most tellingly in his mastery over, his baffling escape from ideas; a
mastery and an escape which are perhaps the last test of a superior intelligence.
He had a mind so fine that no idea could violate it.' This passage would certainly
have been familiar to people in Leavis's circle.

79 Baxandall Papers, CUL Add. Mss. 9843/7/2/1/1 [2/2]. An A4 ruled page providing
the title and subtitle – *a review of the art criticism of the earlier Italian Humanists*. A
synopsis follows in three sections: I Humanists' opinions and humanist points
of view, II Pisanello and the humanists, III The failure of humanist art criticism.
It is significant that the first section of part III was titled 'Alberti against the
humanists'. 'Pisanello' makes much more sense of the contents of the book than
'Giotto' since part of Baxandall's aim is to challenge the dominant art historical
lineage of Giotto, Masaccio, Donatello, and Michelangelo and to give greater
emphasis to such artists as Ambrogio Lorenzetti, Fra Angelico, Filippo Lippi, the
Netherlandish painters, and Botticelli.

80 Warburg Institute archives, not catalogued at date of publication, typescript
of the book with many revisions. The title page reads PAINTING AND
PERCEPTION. PERCEPTION has been crossed out and EXPERIENCE written in
by hand.

81 Baxandall Papers, CUL, Add. Mss. 9843/7/3/2.

82 Baxandall Papers, CUL, Add. Mss. 9843/7/3/2. He mentions in the typescript that
two of the dancing manuals were written by people associated with the culture
of princely courts.

83 Artur Michel, 'The Earliest Dance Manuals', *Medievalia et humanistica*, 3 (1945):
117–31. Offprint in Warburg Institute Library at DCA 1540. Baxandall's
photocopy is in Baxandall Papers, CUL. Add. Mss. 9843/7/2/1. It seems to
have been made from the journal itself and not from the offprint. Baxandall
acknowledges Michel's article in his references on page 157 of *Painting and
Experience* and in the text quotes almost directly from him.

84 *Giotto and the Orators*, 11; *Painting and Experience*, 77:

> Arte, mesura, aere et desegno
> Manera, prospectiva et natural
> Gli ha dato cello per mirabil dono.

Baxandall's italics for the dancing terms.

85 Erwin Panofsky, *Renaissance and Renascences in Western Art* (London: Paladin,
1970 [1965]), 27, n.3: 'Another problem posed by Galli's sonnet is the significance
of *aere*. Taken to mean something like atmosphere, the term would be somewhat
anachronistic and, if so interpreted, would appear more natural in combination
with *prospectiva* than *desegno*. I am inclined to interpret it, as in our "airs", as
referring to the postures, gestures and general deportment of Pisanello's figures.'

86 Baxandall Papers, CUL, Add. Mss. 9843/7/3/2.

87 Baxandall Papers, CUL, Add. Mss. 9843/7/3/2.

88 Baxandall Papers, CUL, Add. Mss. 9843/7/3/2.

89 The manuscript in B.N.Ms.it.972, transcribed more recently in A William Smith, *Fifteenth-Century Dance and Music: The Complete Transcribed Treatises and Collections in the Domenico Piacenza Tradition*, 2 vols (Stuyvesant, New York: Pendragon Press, 1996). The manuscript is also available online at http:www. pbm.com/-lindahl/pnd/all.pdf, accessed 28 November 2012. Giugliemo Ebreo's *De Practica seu arte tripudii*, also referred to by Baxandall, has been edited and translated with a commentary by Barbara Sparti and published by Oxford University Press in 1999.

90 Baxandall Papers, CUL, Add. Mss. 9843/7/3/2; CUL, Add. Mss. 9843/7/3/2 .

91 *Painting and Experience*, 60, 77–81.

92 See notes 68 and 70 above.

93 Baxandall Papers, CUL Add. Mss. 9843/7/2/1/1 [1/2]. I would date it to the late 1960s. Baxandall then mentions Ambrogio Lorenzetti's *Good and Bad Government in Siena* as a possible case study, so this is the germ of the abortive paper to which he refers in the Bouguer Principle of 1985–1986. His observations on Good and Bad government appear in three pages of what is almost certainly a draft for his introductory Slade lecture on 1974. This 26-page typescript is now in the Baxandall Papers at CUL which I consulted before it was deposited there. At the time of writing there is no pressmark. A carbon copy of one of those three pages is to be found in the Bouguer principle file Baxandall Papers, CUL, Add. Mss. 9843/6/2, so this is certainly the abortive paper, although he may have lectured about the Lorenzetti frescoes earlier. I recollect that Michael Podro in the early 1970s mentioned Baxandall's interest in the Sala della Pace frescoes; Podro said that Baxandall considered that Ambrogio to have been the chief author of the programme.

94 For Leavis on Bunyan see 'Literature and Society' in *The Common Pursuit*, 189–91; 'Bunyan through Modern Eyes', also *Common Pursuit*, 204–10. For a fuller treatment see John Bunyan, *The Pilgrim's Progress, With an Afterword by F.R. Leavis* (New York: Signet Classic, 1964), 284–300. I don't believe that Baxandall is referring to the 1964 Leavis Afterword.

95 As he himself observed, MacKillop, *Leavis*, 9.

96 He did, however, keep a cutting from an account in a national newspaper [*The Observer*?] of Leavis's famous attack in the Richmond Lectures of February 1962 on C.P. Snow's discussion of the Two Cultures. Baxandall Papers, CUL, Add. Mss. 9843/8/11: '… stiletto-tongued Frank Raymond Leavis, 66, set off the biggest explosion to rock Britain's literary Establishment in a decade …'

97 For Leavis see MacKillop, *Leavis*, 31–2, on the Arts and Crafts family home designed and built by his father, and Tanya Harrod, *The Last Sane Man: Michael Cardew: Modern Pots, Colonialism, and Counterculture* (New Haven and London: Yale University Press, 2012), 101, 119, for the purchase in 1929–30 by the Leavises of pots by Cardew, from whom Baxandall's parents also bought.

98 A good example of this is in his essay on Gerard Manley Hopkins in *The Common Pursuit*, 44–58.

99 MacKillop, *Leavis*, 4–5, quotes an amusing account by the artist Peter Greenham, who painted the portrait of Leavis for Downing, of how he refused to accept Greenham's statement that he liked Arnold Bennett's novels.

Baxandall and Gramsci: Pictorial Intelligence and Organic Intellectuals

Alberto Frigo

'Gramsci is a hero for me.'[1] This was how, in 2008, Michael Baxandall replied to a question from Hans Ulrich Obrist about the role of the political in his art history. Such an enthusiastic declaration can come as a surprise to those who have some knowledge of Baxandall's work. His style as a writer was, as Svetlana Alpers put it, 'to be discreet, almost stealthy, about his deep intellectual commitments'. The intentional absence of an index of names at the end of *Patterns of Intention* is almost emblematic of such discretion.

Gramsci, however, seems to be an exception. Baxandall's interest in the Italian philosopher is not just a matter of curiosity or intellectual esteem, but perhaps something more like an elective affinity, something deeper and more intimate than a simple sharing of theories and concepts. In another interview, in 1998, Baxandall said: 'Gramsci's fine for me, and in spite of everything, I still feel this... . It's just sort of an emotional attitude.'[2] This emotional connection found its way into Baxandall's teaching: 'I still teach all my students Gramsci', he declared, 'because apart from anything else he's a marvelous tool for the historian of Italy'.[3] The sustained engagement that arose from this elective affinity is really fascinating. Again, in the interview with Obrist, Baxandall affirmed, 'I think I am content to stay with Gramsci'.[4] The formula is simple but profound: 'staying with Gramsci' does not just mean reading the *Prison Notebooks*, agreeing with its ideas, or even taking a specific position in debates over the modern forms of Marxism. Primarily it means getting pleasure from engagement in a kind of dialogue with an intelligence that is at once sympathetic to our own and sufficiently different to enrich our thinking. To examine how this 'staying with Gramsci' manifested itself in Baxandall's work is a challenging task and requires great prudence, yet we are encouraged to it by Baxandall himself, who admitted to Allan Langdale that 'in a sense I would think of myself as Gramscian'.[5]

❧ ❧ ❧

The fact that Gramsci's name appears just once in Baxandall's published writings – in one of the endnotes to *Tiepolo and the Pictorial Intelligence*[6] – is no argument against the claims we are making. Indeed, it would seem to suggest that the Italian thinker's presence in Baxandall's works is so constant and deep that it does not need to be made explicit. Baxandall himself supports this view, stating that 'anybody who knew Gramsci would see that Gramsci was a very strong influence on me'.[7] The challenge is to determine what he means by *influence*. In *Patterns of Intention*, of course, Baxandall famously argues against the notion of influence, 'a stumbling-block or scandal', that originates from a misunderstanding 'of the active/passive relation', and proposes to replace it with the idea of a productive relation to tradition. 'Arts are positional games', he writes, 'and each time an artist is influenced, he rewrites his art's history a little'. The question is not how Cézanne 'influenced' Picasso but rather how Picasso 'acted on' Cézanne, changing forever the way we can see Cézanne, 'whom we must see partly diffracted through Picasso's idiosyncratic reading'.[8] If we try to apply such instructions to our investigation, the question is: how did Baxandall make use of or assimilate himself to Gramsci? What kind of 'intentional selection' has he made from the array of themes, ideas, and critical positions contained in the *Prison Notebooks*?

❧ ❧ ❧

In order to understand the way in which Baxandall approaches and *acts* on Gramsci, it may be useful to remember the circumstances surrounding his first encounter with the Italian philosopher. Having left Cambridge in 1955 intent upon spending an 'untidy exploratory year'[9] in Italy, he was given a research grant to the Collegio Borromeo in Pavia, where he spent the entire winter. He attended some lectures and conferences and made friends with several Italian and foreign students. In his 'memory book', *Episodes*, he remembers, among these friends, Giovanni Emmanuele Colombo, 'an ascetic lawyer whose passion was left-wing politics from a Nenni-Socialist position. From him I first learned about the dazzling Gramsci.'[10] Elsewhere Baxandall says: 'I got to Italy and discovered Gramsci, or had Gramsci laid out for me because Gramsci was very much in the air.'[11] Indeed, Gramsci was the principal figure in Italian cultural debates of the mid-1950s. The first partial edition, in six volumes, of the *Prison Notebooks*, had recently been released (1948 to 1951)[12] making his work known to a larger public for the first time. When Baxandall says that the discovery of Gramsci 'was the main general intellectual revelation of that year', he expresses an enthusiasm shared by many scholars and students at the time.

This is certainly not enough to define the nature of Baxandall's approach to Gramsci. One wonders whether, in addition to the conversations with his friend Colombo, his classes at the Collegio Borromeo provided further exposure. In *Episodes*, Baxandall remembers having attended the lectures of Lanfranco Caretti[13] on Tasso's *Gerusalemme Liberata*. Caretti was one of the greatest Italianists of the twentieth century and the substance of his teaching in Pavia is contained in his book, *Ariosto e Tasso*, published in 1957. Caretti was a keen and careful reader of Gramsci. He reviewed the *Notebooks* soon after their publication[14] and he often used Gramscian concepts in his analysis of the history of Italian literature. The way in which he sets the two poets, Ariosto and Tasso, in contrast to one another seems to have been inspired by Gramsci's ideas about the nature and development of the Italian Renaissance. In an article entitled 'Debt to Gramsci', Caretti even recognized his having been involved in a kind of continuous dialogue with the philosopher all his life.[15] It is likely that Baxandall often heard mention of Gramsci during Caretti's lectures at Collegio Borromeo.

<p style="text-align:center">෨ ෨ ෨</p>

Soon after recalling his conversations with Colombo, Baxandall writes: 'Other sites of my education were the billiard room and a couple of cheap little bars south of the river in Borgo Ticino where the serious drinking was done.'[16] These bars are vividly described in Baxandall's posthumously published novel *A Grasp of Kaspar*, set partly in Pavia in October 1956. Halfway through the story we read the following:

> There were not enough chairs and several Young Communists were sitting against the wall, on the floor. Briggs used to join these and listened. His grasp of the Lombard idiom was not of a kind to let him follow the discussion fully. It seemed to be about Gramsci's analysis of 'common sense' but also about Mussolini's 1938 prohibition of shaking hands in salutation, and presumably about some relation between these. He let voices flow over him and just looked around and enjoyed the atmosphere. It was cheering.[17]

Here we get a hint of something more concrete and straightforward about exactly what Baxandall may have heard and remembered about Gramsci: the idea of 'common sense' and a discussion of its potential application to Mussolini's prohibition of shaking hands. In another passage of *A Grasp of Kaspar*, Baxandall describes 'a thin young man with a priestly look about him sitting at the table' in the same café, 'reading one of the books of Gramsci. He made a dismissive remark about Gramsci as he handed it over: how, he tediously asked, could the man claim to transcend his own moment?'[18] While this is obviously literary fiction, is it so improbable to imagine

Baxandall recording actual discussions he had while in Pavia? After all, some of the characters of the novel have real names, the names of the friends, and the colleagues that Baxandall met during his stay. *A Grasp of Kaspar* relates to real places and circumstances in a different way than does *Episodes*, in which their exact coordinates are often given. This possibility deserves further consideration.

ॐ ॐ ॐ

In his novel, Baxandall writes that the talk of the young communists in the bar 'seemed to be about Gramsci's analysis of 'common sense'. The concept of common sense is the centre of Gramsci's political and philosophical project in the *Prison Notebooks*. One might even say that it lies at the heart of all Gramscian thought. Soon after his arrest, in a letter to his sister-in-law, Tatiana Schucht, Gramsci writes (19 March 1927):

> I would like to concentrate intensely and systematically on some subject that would absorb and provide a center to my inner life. Up until now I've thought of four subjects, … they are (1) a study of the formation of the public spirit in Italy during the past century; in other words, a study of Italian intellectuals, their origins, their groupings … . (2) A study of comparative linguistics! … . (3) A study of Pirandello's theatre and of the transformations of Italian theatrical taste that Pirandello represented and helped to form … . (4) An essay on the serial novel and popular taste in literature.

After having provided this outline of the project that would occupy him for the next 10 years, until his death in 1937, he adds: 'At the bottom, if you examine them thoroughly, there is a certain homogeneity among these four subjects: the creative spirit of the people in its diverse stages and degrees of development is in equal measure at their base.'[19] The main issue is that of the 'public spirit'. He wonders about the forces that oppose the formation of a common way of feeling and of thinking, especially in Italy, one that might be shared by the intellectuals and the common people and thus allow for real national unity. His entire project is based on a recognition of the disparity between intellectuals and common people, but also on the belief that this gap can be reduced. As he says: 'The principle must first be established that all men are "philosophers", that is, that between the professional or "technical"philosophers and the rest of mankind, the difference is not one of "quality" but only of "quantity."'[20] People are not passive participants in the formation of a 'public spirit' or a shared taste. Intellectuals have an important role – a hegemonic function, as he will later say – but their influence is exerted over a popular spirit that is creative in itself and that finds expression in autonomous forms of thought and art. In order to explain this creative spirit

systematically, he elaborates the notion of common sense. Gramsci defines it as the 'philosophy of non-philosophers', or 'in other words the conception of the world which is uncritically absorbed by the various social and cultural environments in which the moral individuality of the average man is developed'.[21]

Four characteristics allow for a better articulation of the nature of this concept.[22] First, common sense presents itself in a great many forms. 'Every social stratum', Gramsci writes, 'has its own "common sense" and its own "good sense", which are basically the most widespread conception of life and of man'.[23] There is not just one common sense but always and at the same time a plurality of common senses, at times in disagreement among themselves. Gramsci clearly distinguishes common sense from the *Zeitgeist* or from the *Volkgeist* of German Idealism. 'Common sense is not a single unique conception, identical in time and space. It is the "folklore" of philosophy, and, like folklore, it takes countless different forms.'[24] Different social groups develop different forms of common sense. We can thus speak of a common sense of philosophers and of intellectuals, 'because every philosophy has a tendency to become the common sense of a fairly limited environment',[25] just as we can speak of the common sense of the people that, on the contrary, has its origins 'in the parish and the "intellectual activity" of the local priest or aging patriarch whose wisdom is law, or in the little old woman who has inherited the lore of the witches'.[26]

Second, common sense has different degrees of generality. Gramsci analyzes two extreme cases: on the one hand, there is an almost universal common sense that is religion[27] which is able to adapt into infinite forms. Catholicism, for instance, assures itself universal status thanks to its adaptability. Behind the apparent unity of the faith there exists, in fact, a 'Catholicism for the peasants, one for the petits-bourgeois and town workers, one for women, and one for intellectuals'.[28] On the other side, there are the so-called 'subaltern classes',[29] the marginal groups that each have an autonomous common sense and speak a kind of 'cultural dialect' that is incomprehensible to those who do not belong to the group itself.[30]

A third characteristic of common sense, perhaps the most important, it that it is 'not something rigid and immobile, but it is continually transforming itself, enriching itself with scientific ideas and with philosophical opinions which have entered ordinary life'.[31] Common sense is not something like the spirit of the time that floats over the men of any particular epoch. It is more like a base or a set of knowledge and skills that belong to a single individual and that everyone can use, correct, or integrate. Common sense is always already given, but everyone must appropriate and modify it, introducing original features and shaping a new form of it. The inner mobility of common sense is the consequence of its composite nature, linking passive and active elements, perpetuating the past and trying, at the same time, to elaborate a

new synthesis: 'The personality of most men', Gramsci writes, 'is strangely composite: it contains Stone Age elements and principles of a more advanced science, prejudices from all past phases of history at the local level, and intuitions of a future philosophy which will be that of a human race united the world over'.[32]

The last characteristic is that common sense finds its primary mode of expression in language. 'Every language contains the elements of a conception of the world and of a culture.'[33] Language is not simply a medium but the concrete form of any individual's or historical group's conception of the world, 'a totality of determined notions and concepts and not just of words grammatically devoid of content'.[34] 'Language also means culture and philosophy (if only at the level of common sense). The fact of "language" is in reality a multiplicity of facts more or less organically coherent and co-ordinated.'[35] This is why, in the *Notebooks*, we find several passages under the title 'encyclopedic notions', in which Gramsci discusses commonly used terms or expressions and tries to expose the concepts and cultural values encoded in them. 'Language equals thought, a way of talking indicates a way of thinking.'[36] At the same time, language is also 'a living thing and a museum of fossils of life and civilisations'.[37] If language and common sense are indeed inseparable, Gramsci reasons, it should be possible to 'sketch a picture of the "normative grammar" that spontaneously operates in every given society, as it tends to unify itself both as territory and culture'.[38]

<p style="text-align:center">ℝ ℝ ℝ</p>

Let us set Gramsci aside for a moment, and return to Baxandall. There is more than one good reason to believe that the concept of common sense, evoked in *A Grasp of Kaspar*, had inspired the author of *Giotto and the Orators* and *Painting and Experience*. Let us start with the last characteristic listed above: the unity of language and representations of the world and the idea of language as a museum of fossils of life and civilizations. Here one clearly recognizes an affinity with the assumptions that underlie Baxandall's analysis of the 'humanist observers of paintings'. 'The words were the system', we read in *Giotto and the Orators*. 'Any language, not only humanist Latin, is a conspiracy against experience in the sense of being a collective attempt to simplify and arrange experience into manageable parcels.'[39] While Baxandall's principal source here it is not Gramsci, but rather the classics of American and French anthropology – and his own adaptation of them is driven by his determination to propose a less paradoxical version of Whorfian linguistic determinism and by a deep interest in the idea of restraint[40] – yet, when he describes language and syntax as being selective sharpeners of attention, one immediately thinks of Gramsci and especially of the several pages where the Italian philosopher

analyzes the 'history of terminology and metaphors'[41] as a tool to show how 'a concept or a newly discovered relationship' is understood, 'brought back to the cultural world, historically determined', and finally integrated into common sense.

The connection to Gramsci can be seen even more clearly in the preface that Baxandall wrote for the Italian edition of *Giotto and the Orators*. The ultimate concerns of the book, he points out, are not 'a matter of linguistic determinism', nor of 'cultural structures'. Rather, 'the subject is the integrity both of the historical cultures that we study and of our individual psyche. I cannot tolerate the thought that the Italian Renaissance ... is nothing but a casual aggregation of fragmentary inclinations.'[42] This emphasis on the integrity of a culture is achieved by choosing to 'follow the thread of speech'. The same notion of integrity returns in *Patterns of Intention*, especially when Baxandall justifies the necessity of 'thinking about relations between the visual interest of pictures', (here Chardin's paintings), 'and the systematic thought, science or philosophy, of the culture they come from' (Newtonian-Lockean science). One of his motivations, he explains, is the desire to see 'human cultures and human minds as wholes rather than fractured and fortuitous'.[43] *Shadows and Enlightenment* attempts to describe a 'Rococo-Empiricist shadow-watching community' that is characterized by a real 'cultural coherence'.[44] Baxandall's belief in the integrity of cultural formations, sustained throughout his career, relates directly to Gramsci's concept of common sense.

Part of what would have made the idea of common sense appealing to Baxandall is its ability to assimilate the expressions and structures of both 'popular' and 'high' culture. According to Gramsci, common sense can include, for instance, 'Stone Age elements', such as elementary perceptual skills, united and coordinated with 'principles of a more advanced science', as in the case of the 'Lockean culture' that Baxandall identifies as an aspect of the eighteenth-century mind. At the same time, the various members of a community participate in common sense to different degrees. The concept allows for the 'high points' achieved by 'single particularly gifted individuals', in a manner that suits Baxandall's determination to relate such achievements to their cultural circumstances. An example is found in *The Limewood Sculptors*: Paracelsus, Baxandall writes, 'is not a mainstream figure in either the craftsman's or the intellectual's culture', but something of his 'very personal nature philosophy' introduces us to 'a general period sense of the Sign'.[45]

The idea of common sense also suits Baxandall's tendency to downplay the theoretical in his approach. Gramsci emphasizes its concreteness: it is a complex mix of 'opinions, convictions, criteria of discrimination, standards of conduct'[46] that are recognizable, within which you can easily move and that are often used even though they are not – or cannot be – verbalized. Baxandall seems to have something very similar in mind when, defending himself from

the claim of having revived the idea of zeitgeist in *Painting and Experience*, he says: 'The period eye is constituted by the skills of discrimination one acquires by living in a culture, including perceiving the art in that culture, but it is totally different from zeitgeist and has none of the theoretical substructure.'[47]

Finally, Gramsci's concept of common sense economically pairs two qualities that seem to belong together when, like Baxandall, we try to think of the integrity of a culture as a whole: stability and flexibility. Common sense designates a *stable* network of knowledge and practices within which the thoughts and actions of any individual are always positioned. 'We are all conformists of some conformism or other, always man-in-the-mass or collective man',[48] Gramsci writes. It is difficult, even impossible, to describe this conformism, the structure of common sense at a given time, in detail. There are a few guidelines we can use – found in sources as diverse as popular melodramas, papal encyclicals, political newspapers, and *feuilletons* – that allow for the reconstruction of common features that remain stable despite individual differences. A similar awareness of the inherent conformism in every human action lies behind Baxandall's disingenuously simple claim that 'A Quattrocento man handled affairs, went to church, led a social life.'[49] At the same time, common sense is *flexible* enough not to determine the specific shape that it will take in the individual. Gramsci has beautiful and difficult pages on the notion of originality, on the relationship between ordinary people and the avant-garde, and on the function of philosophers and artists in creating new common senses. One of his favourite touchstones is Dante, a character central to Italian political and cultural identity. According to Gramsci, Dante could not be reduced to the historical context in which he operated: he is the voice of his time but he is also the prophet of another time, of another common sense. Baxandall makes a similar point when, in *Words for Pictures*, he invokes 'Alberti's cast of mind' and suggests that 'the extraordinary *De pictura* was not just an outcome of the cultural moment'. 'Perspective and neoclassicism were of the time, and motifs of balance and mean were certainly of neoclassicism; but the drive that imposed systematic order on painting, sometimes unsustainably, and the radically selective bent of the order were his and were eccentric.'[50] In *Giotto and Orators*, Alberti had been recognized as a spokesman of the humanistic point of view on paintings, or rather, of the 'authentically humanistic, because periodic point of view'.[51] Nevertheless, this humanistic common sense, so to speak, is not enough to explain *De pictura*. One has need of the 'hypertrophy of a particular mental muscle that lies behind the conceptual algebra, the balancing and compensating habit of the mind' peculiar to Alberti.[52] Common sense structures a culture but it is differently appropriated by every individual. As Baxandall succinctly says in *The Limewood Sculptors*, 'Forms may manifest circumstances, but circumstances do not coerce forms.'[53]

ॐ ॐ ॐ

What has been said so far offers little more than a general and schematic image of the relationship between Gramsci and Baxandall. The task is now to add details that illuminate the relationship in a more nuanced and probing way. Let us return to Gramsci. As has already been shown, common sense is a cluster of 'opinions, convictions, criteria of discrimination and standards of conduct' which belong to a certain social group or to a certain culture. It finds its legitimacy in the principle that 'all men are philosophers'. It is worth considering this principle in order to show that it allows, or even compels us, to reconsider the figure of the intellectual in a new way. As Gramsci says: 'Although one can speak of intellectuals, one cannot speak of non-intellectuals, because non-intellectuals do not exist.' The distinction between non-philosophers and professional philosophers, non-intellectuals and intellectuals, is a matter of degree, not of essence. As we read in *Notebook 12*, devoted entirely to a 'history of the intellectuals',

> [T]here is no human activity from which every form of intellectual participation can be excluded: *homo faber* cannot be separated from homo sapiens. Each man, finally, outside his professional activity, carries on some form of intellectual activity, that is, he is a 'philosopher', an artist, a man of taste, he participates in a particular conception of the world, has a conscious line of moral conduct, and therefore contributes to sustain a conception of the world or to modify it, that is, to bring into being new modes of thought.[54]

This inherent intellectual content belongs to every human activity and it is the corollary, on one side, of the identity of theory and practice that is at the base of Gramsci's philosophy of praxis. But it is also the consequence of a specific way of conceiving of thought and its functions. Gramsci habitually describes intellectual activities, even the more abstract ones, as a mix of 'intellectual-cerebral elaboration and muscular-nervous effort'. Whoever makes a comparison between an intellectual and a labourer ignores 'that studying too is a job, and a very tiring one, with its own particular apprenticeship – involving muscles and nerves as well as intellect. It is a process of adaptation, a habit acquired with effort, tedium and even suffering.'[55]

In such a view of things, what could be said to distinguish the real intellectual? As has already been said, it is a matter of 'quantity', not 'quality', 'the term "quantity" being used here', Gramsci adds, 'in a special sense, which is not to be confused with its meaning in arithmetic, since what it indicates is a greater or lesser degree of "homogeneity", "coherence", "logicality"'.[56] The intellectual is he who brings common sense to a superior level of coherence and unity, eventually both critiquing and renewing it. Being an intellectual involves making explicit and unitary the conception of the world that each man contributes to creating or perpetrating in his actions and existence as a

whole. Combining theory and practice, the intellectual finds thought implicit in every act and arrives at the point of thinking, or of making thinkable, new acts. An intellectual is a person who achieves a

> critical elaboration of the intellectual activity that exists in everyone at a certain degree of development, modifying its relationship with the muscular-nervous effort towards a new equilibrium, and ensuring that the muscular-nervous effort itself, in so far as it is an element of a general practical activity, which is perpetually innovating the physical and social world, becomes the foundation of a new and integral conception of the world.[57]

This definition offers a serious critique of the romantic notion of the life of the mind, art, and culture, as *otium et non negotium*. In *Notebook 6* we read: 'The intellectual function cannot be divided from the general productive work not even when we speak of artists: that can be done only when they show that they are really artistically productive.'[58]

From this general definition of intellectual activity, Gramsci deduces a famous distinction between 'traditional' and 'organic' intellectuals. The first can be described as 'an autonomous and independent social group', identified by the literary, pedagogical, generally non-physical nature of the work they do. Examples would be the clergy, the men of letters, the philosophers, and the professors. On the other hand, Gramsci writes, 'Every social group, coming into existence on the original terrain of an essential function in the world of economic production, creates together with itself, organically, one or more strata of intellectuals which give it homogeneity and an awareness of its own function not only in the economic but also in the social and political fields.' This group includes 'capitalist entrepreneurs', 'industrial technicians', 'specialists in political economy', and 'the organizers of a new culture, of a new legal system'[59] but also journalists, especially those 'ready to comprehend and analyze the organic life of a big town'.[60] Some years ago, Edward Said also proposed to include 'today's advertising or public relations experts, who devise techniques for winning a detergent or airline company a larger share of the market' or anyone else who 'in a democratic society tries to gain the consent of potential customers, win approval, marshal consumer or voter opinion'.[61] It is worth remembering, however, that Gramsci himself was primarily concerned with the ways in which organic intellectuals operate in relation to political parties.

Extensive analysis of this concept, or of the whole issue of the relationship between organic intellectuals and the hegemony of the ruling class, is not necessary here. We need only emphasize that 'these organic intellectuals are distinguished less by their profession, which may be any job characteristic of their class, than by their function in directing the ideas and aspirations of the class to which they organically belong'.[62] The definition is purely functional: it is not a matter of mental qualities or the explication of theories

or visions of the world, but considers only the role of awareness, organization, and direction that organic intellectuals assume in relation to groups within society or society as a whole. The term 'intellectual' thus applies to a range of figures – artists, journalists, clergy members, professors and teachers, but also managers, civil servants, technicians and scientists, lawyers, and doctors – who share the ability to bring to a higher level of articulation the relationship 'between efforts of intellectual-cerebral elaboration and muscular-nervous effort'. In modern industrial society, the intellectual is often a specialized technician or an engineer who, 'by comparison with the unskilled labourer', 'not only knows the trade from the practical angle, but knows it theoretically and historically'.[63] 'This way of posing the problem results in a considerable extension of the concept of intellectual', Gramsci concludes, 'but it is the only way which enables one to reach a concrete approximation of reality'.[64]

ھ ھ ھ

If we may seem to have left Baxandall dangerously far behind with this second foray into Gramsci's work, two quotations will show this distance to be illusory. Answering two of his interviewers, Langdale and Obrist, about his relationship to the Italian philosopher, Baxandall invokes 'the concept of the intellectual' and identifies painters as intellectuals. 'Gramsci's notion of the intellectual has been very important for me. I think of artists as Gramscian intellectuals.'[65] What remains to be shown, then, is how Piero della Francesca, Picasso, Chardin, or Tiepolo can be considered Gramscian intellectuals. The first and most natural hypothesis is connected with the idea that works of art are also historical documents and that artists are witnesses to their culture. Baxandall writes in the first pages of *The Limewood Sculptors* that works of art can sometimes be 'addressed as lenses bearing on their circumstances'.[66] Understood in such terms, some artists seem to show traits that link them to the intellectuals described by Gramsci. At least some works of art offer a sophisticated synthesis of the totality of the needs that have contributed to their making and in which they participate. Great artists, Baxandall affirms more than once, unite in a coherent and ordinate way the elements coming from a number of heterogeneous circumstances imposed by the society and culture with which they interact. Gramsci says that while all men participate in a conception of the world, only some of them bring it to a sufficient degree of homogeneity and coherence. In the same way it is important to distinguish the great painter from the painter of 'common sense'. 'Only very good works of art, the performances of exceptionally organized men', Baxandall in fact writes in *The Limewood Sculptors*, 'are complex and co-ordinated enough to register in their forms the kind of cultural circumstance sought here; second-rate art will be little use to us'.[67] What allows Florid Sculpture to 'offer a

fresh focus on the cultural history of Renaissance Germany',[68] is the organic character of its artistic synthesis, a characteristic which is symmetrical to the organic totality of circumstances.[69] So for Baxandall, artists – great artists – are intellectuals because they produce a synthesis characterized by what Gramsci called 'homogeneity', 'coherence', and 'logic'. Rather than singling out qualities like sensitivity, taste, or originality in the painters he studied, Baxandall emphasizes their 'high degree of organisation'.[70] It is this quality that makes painters Gramscian intellectuals: 'A superior craftsman, and only the superior one', Baxandall writes, 'is so organized that he can register within his medium an individual awareness of a period predicament'.[71]

For Baxandall, 'Gramscian intellectuals' seems to mean primarily – perhaps exclusively – 'organic intellectuals'. Three elements of this notion seem to be particularly relevant: the expanded application of the term *intellectual* that it allows, the fusion of theory and technique – the 'intellectual-cerebral elaboration and muscular-nervous effort', on which it is based, and the idea that such intellectuals practice '"specialisations" of partial aspects of the primitive activity of the new social type which the new class has brought into prominence'.[72] At the end of *Tiepolo and the Pictorial Intelligence*, Baxandall and Svetlana Alpers show what this means in art-historical terms.[73] In the context of a meditation on the 'tart sort of moral after-taste' that characterizes the painting of the Treppenhaus, the two authors strongly 'decline the view of Tiepolo as the artist of fading aristocracy, the exponent of a petty absolutist dream-world'. They see the true and, so to speak 'final' cause of the Residenz not to be the Von Schönborns family but rather, the 'other men who shaped, made and used the Residenz': 'These men ... were specialists, technicians of a sort, mainly with origins in the craftsman class.' The purest example of this class of technicians was the architect of the building itself, Balthasar Neumann. In order to describe Neumann's 'intellectual physiognomy', Baxandall and Alpers quickly trace back the history of the 'culture of the central European copper industry' between the Middle Ages and the Renaissance. 'This culture had first produced a substantial new technical professional class of experts – mineral surveyors, salaried mine and foundry managers, assayers and metallurgists This was the highly self-conscious culture synthesized by Agricola's *De Re metallica*, a culture of generalized and also aestheticized technique adaptable to varied particular cases.' Here is an effort to define a type of organic intellectual that arose alongside a new social group and a specific productive activity. Neumann is a late example of this 'intellectual style': 'Neumann made his own rococo brass instruments, using the boyhood skills he had learned as an apprentice bronze founder.' The compass Neumann made and used to generate the ground-plan of a church becomes the tool to express and affirm the autonomy of the technical class to which he belonged. His inventive technique, in its combination of general procedures and accommodation of contingency, shows, under an artistic form, his awareness

of being an intellectual who 'had been trained as a bronze-founder, and who had 'made his way to architecture by way of artillery science and military engineering'.

Baxandall and Alpers suggest a similar genealogy for Tiepolo. The painter, they write, was 'an early-modern technician' and 'the hegemony his picture affirms, and the class to which he is acting as pictorial intellectual' is 'less that of Prince-Bishops than of early-modern provincial technicians'. The presence of the term *hegemony* clearly signals a dependence on Gramsci, and a note to this passage explicitly indicates that 'the sense of pictorial intellectual used here derives from Antonio Gramsci's account of "organic intellectuals"'.[74] This statement does not just hint at a vague analogy but allows for a very detailed characterization of Tiepolo's art. Baxandall and Alpers tell us, first, that Tiepolo is an organic intellectual, an individual who, while producing images that 'almost call for dancing', 'gives expression to the consciousness of a class we call provincial technicians'. Secondly, they emphasize the fact that Tiepolo acts as an intellectual by painting: his work offers a *pictorial* expression of the consciousness of early-modern technicians. Finally, they provide a clear example of what Gramsci means when he describes the activities of the intellectuals as '"specialisations" of partial aspects of the primitive activity of the new social type' that are characterized by a different equilibrium of 'intellectual-cerebral elaboration and muscular-nervous effort'. In fact, Tiepolo does not express the aspirations and values of the class he belongs to by painting technicians or craftsmen at work: he is a pictorial intellectual because of *how* he paints, not *what* he paints. 'It is just the *phasing* of operations – first invention with general procedures, then accommodations of contingency – ... that aligns the painter Tiepolo with the technicians.' It allows him to become a pictorial intellectual organic to this class of experts. Tiepolo thinks through painting. Moreover, Baxandall and Alpers add, the stuff of these operations, the kind of painting articulated by these phases, in so far as it is based on 'craft, manual and habitual, experience, tradition and visual instinct', makes visible the strictly provincial character of this class of early-modern technicians. The technical phasing of operations, combined with the non-technical nature of his painting, is the form that Tiepolo chooses in order to perform his function of pictorial intellectual at Würzburg. Being a pictorial intellectual means operating as an intellectual in the form of thought that is characteristic of pictures, that is, the attention to a developing pictorial problem in the course of activity in a pictorial medium. By choosing a specific process of painting, Tiepolo gives expression to the consciousness of a class we call provincial technicians.

Although these final pages of *Tiepolo and the Pictorial Intelligence* could be discussed at greater length, enough has been said to establish the essential point. It would be hard to imagine a more rigorous or more original application of the notion of organic intellectuals. The figure of Tiepolo not only offers a

very coherent example of Gramsci's idea, but also enlarges its application to painting, a subject that Gramsci himself did not address, but one which might be said to allow for an even clearer illustration of what he meant: Tiepolo is an intellectual who is able to supply a conscious synthesis of the ideas and aspirations of the class to which he organically belongs, and to express them with a means – the two-phased process of painting – that is a specialization of the partial aspects of the primitive activity of this new class.

<p style="text-align:center">ᔡ ᔡ ᔡ</p>

If we try to sum up what we have established so far, we might say that Baxandall finds in Gramsci a sophisticated analytical model that approaches societies and cultures as unitary realities characterized by a complex kind of integrity. This integrity finds a partial expression in the common sense to which the intellectuals, especially organic intellectuals, contribute with their technical skills.

Is this result insufficient to justify Baxandall's claim that he was 'content to stay with Gramsci'? Perhaps not. In any case, his is a particular and selective reading of the Italian philosopher – a 'Grasp of Gramsci', so to speak – that many people will find unsatisfying. It leaves out much of Gramsci's thought, perhaps even what is most essential. Gramsci was first and foremost a political philosopher, an intellectual who wanted, above all else, to think politics. He was a politician who became a thinker. His concept of praxis is based on a belief in the practical and political character of every human activity, from knowledge to work to education to the exercise of power. If we reposition what we have said in the overall framework of Gramsci's thought, even the concepts of common sense and the organic intellectual assume another dimension of significance. According to Gramsci, common sense is an obstacle, something to critique and overcome in order to institute a new ideological hegemony based on the work of organic intellectuals. What Gramsci always keeps in mind is not only the analysis of the real, but also and most of all, the task of elaborating a mode of political action that alters power relationships and that challenges existing hegemony, thus transforming common sense.

Reading the title of this essay, one might expect some discussion of issues related to ideology, to the relationship between Marxism and the history of art, or to the tension between structure and superstructure, all issues in which Baxandall was interested.[75] He had been involved in politics since his youth and he remained, as he said 'an old-fashioned European social democrat of not an orthodox Marxist sort, but with Marxian interests'.[76] Like Gramsci, he was critical of overly reductive economic explanations: the

market chapter of *The Limewood Sculptors* can be read as a truly Gramscian argument against simplistic economic determinism. We can imagine that one of the reasons Baxandall found Italian Marxism so attractive is the way in which Gramsci dissolves any externalized relationship between structure and superstructure. 'There is a necessary and vital bond between structures and superstructures', the philosopher writes, 'as there exists between skin and skeleton in the human body'. Their distinction 'has purely didactic value, since the material forces would be inconceivable historically without form and the ideologies would be individual fancies without the material forces'.[77] There is even a passage in which Gramsci seems to anticipate the ideas proposed by Baxandall in *Art, Society and the Bouguer Principle*: Gramsci writes that if 'Philosophy – Politics – Economics' – but we can also add art – 'are the necessary constituent elements of the same conception of the world, there must necessarily be, in their theoretical principles, a convertibility from one to the others and a reciprocal translation into the specific language proper to each constituent element'.[78]

Even if these affinities are suggestive, they can also be seen as indicating the limited, selective nature of Baxandall's engagement with Gramsci in his practice as an art historian. The reason is simple: the centrality of politics characterizes Gramsci as a diachronic thinker. His interest in the history of culture is motivated by a desire to understand the genesis of power relationships that would make possible their critique and the constitution of a new form of society. Each phenomenon is understood in terms of its genealogy, and that understanding is essential to the possibility of creating a new order. Baxandall, on the other hand, is essentially a synchronic thinker. He prefers the unique work to the chronological series, the analysis of the complexity of articulations within a particular object to that of changes within a tradition, *ekphrasis* to narration. This opposition may be schematic but it reveals something essential about the limitations of Baxandall's engagement with Gramsci, a limitation hinted at in a remark made to Langdale on the concept of hegemony: 'Hegemony doesn't appeal to me. That isn't the thing; well, in a sense, O.K., but I don't get much mileage out of that.'[79]

For Baxandall, Gramsci is the thinker of common sense and the inventor of a new intellectual figure, not the theorist of ideological hegemony and of 'historical bloc'. He is a new and not-very-Marxist Gramsci. He is moreover a Gramsci who deals in concentrated and probing fashion with art and who allows us to understand the role of the artist in a new way. The passages on Tiepolo discussed above, for instance, are almost a direct extension of the *Notebooks*, where very limited space is reserved to painting and sculpture. As Baxandall said himself, one of the reasons for Gramsci's appeal is that 'he's not over-explicit. He leaves room for one to think oneself'.[80] The closing pages of *Tiepolo and the Pictorial Intelligence* are a perfect illustration of this truth.

ৡ৵ ৡ৵ ৡ৵

Let us return to the quote from the interview with Obrist with which we began: 'I think I am content to stay with Gramsci.' Baxandall then went on to explain: 'It's a matter of staying in one universe and part of the attraction of Gramsci to me is that there is so much there and if one brings in other universes that are systematically different then one can do damage to one's first intuition.'[81] The result – and also, perhaps the cause – of this long and patient 'staying with Gramsci' is a deep similarity of interests, a community of universes that is apparent to everyone who reads the two authors, but which is difficult to put into words. In addition to what has already been said here, one might add a taste for exotic singularities, a passion for technique, an astute and occasionally acerbic intelligence, a gift for literary expression, a tendency to support historical hypotheses with the evidence of first-hand experience, a curiosity about humanists and an admiration for the constrictive power of rhetoric, and perhaps also the pleasure of adventuring into unknown fields. All things considered, however, the best synthesis of what unites the thought of these two authors is hidden in a sentence that Gramsci quotes more than once in his *Notebooks*[82] and which Baxandall pondered as well. It comes from the incipit of the first book of the *De Pictura* by Leon Battista Alberti: 'Mathematicians measure the shapes and form of things in the mind alone and divorced entirely from matter. We on the other hand, who wish to talk of things that are visible, will use, as they say, a Minerva in Her Fullness, *una più grassa Minerva*.'

Notes

1 Hans Ulrich Obrist, 'Interview with Michael Baxandall', *RES*, 2 (2008): 42–54; 49.

2 *Substance, Sensation, and Perception. Michael Baxandall interviewed by Richard Cándida Smith* (Los Angeles: J. Paul Getty Trust, 1998), 72.

3 Allan Langdale, 'Interview with Michael Baxandall. February 3rd, 1994, Berkeley, CA', *Journal of Art Historiography*, 1 (2009): 11, accessed 12 April 2014, http://arthistoriography.wordpress.com/number-1-december-2009/.

4 Obrist, 'Interview', 49.

5 Langdale, 'Interview', 11.

6 Svetlana Alpers and Michael Baxandall, *Tiepolo and the Pictorial Intelligence* (New Haven and London: Yale University Press, 1994), 182, n.10.

7 Obrist, 'Interview', 49.

8 Michael Baxandall, *Patterns of Intention* (New Haven and London: Yale University Press, 1985), 58–62. For the notions of influence and tradition, see also Svetlana

Alpers, *The Vexations of Art. Velázquez and Others* (New Haven and London: Yale University Press, 2005), 236–8.

9 Michael Baxandall, *Episodes. A Memorybook* (London: Frances Lincoln Limited, 2010), 74.

10 Baxandall, *Episodes*, 76.

11 *Substance, Sensation, and Perception*, 36.

12 Antonio Gramsci, *Il materialismo storico e la filosofia di Benedetto Croce* (Turin: Einaudi, 1948); *Gli intellettuali e l'organizzazione della cultura* (Turin: Einaudi, 1949); *Il Risorgimento* (Turin: Einaudi, 1949); *Note sul Machiavelli sulla politica e sullo stato moderno* (Turin: Einaudi, 1949); *Letteratura e vita nazionale* (Turin: Einaudi, 1950); *Passato e presente* (Turin: Einaudi, 1951). It would be very interesting, as Carlo Ginzburg has suggested, to know whether this thematic organization of the first edition of Gramsci's *Notebooks* influenced Baxandall's reading. Unfortunately, for now we do not know which Italian edition of Gramsci Baxandall used.

13 Baxandall, *Episodes*, 77–8.

14 See Lanfranco Caretti on Gramsci's *Note su Machiavelli, sulla politica e sullo stato moderno*, in *Il Nuovo Corriere*, 11 June 1950.

15 Lanfranco Caretti, 'Debito con Gramsci', in *Sul Novecento* (Pisa: Nistri-Lischi, 1976), 302–6.

16 Baxandall, *Episodes*, 76.

17 Michael Baxandall, *A Grasp of Kaspar* (London: Frances Lincoln, 2010), 90.

18 Baxandall, *A Grasp of Kaspar*, 102.

19 Antonio Gramsci, *Letters from Prison*, ed. Frank Rosengarten, trans. Raymond Rosenthal (New York: Columbia University Press, 2011), letter I, to T. Schucht (19-3-1927), 83–4.

20 Antonio Gramsci, *Selections from the Prison Notebooks*, ed. and trans. Quintin Hoare and Geoffrey Nowell Smith (New York: International Publishers, 1971), 347. This is the edition quoted by Alpers and Baxandall in *Tiepolo and the Pictorial Intelligence*. See also *Selections from Cultural Writings*, ed. David Forgacs and Geoffrey Nowell-Smith, trans. William Boelhower, (Cambridge, MA: Harvard University Press, 1985); *Further Selections from the Prison Notebooks*, ed. and trans. Derek Boothman (Minneapolis: University of Minnesota Press, 1995) and *Prison Notebooks*, vol. 1, ed. Joseph A. Buttigieg, trans. J.A. Buttigieg and Antonio Callari (New York: Columbia University Press, 1992); *Prison Notebooks*, vol. 2, ed. and trans. J.A. Buttigieg (New York: Columbia University Press, 1996); *Prison Notebooks*, vol. 3, ed. and trans. J.A. Buttigieg (New York: Columbia University Press, 2007).

21 Gramsci, *Selections*, 419.

22 This analysis of 'common sense' is borrowed from Fabio Frosini, *Gramsci e la filosofia. Saggio sui* Quaderni del carcere (Rome: Carocci, 2003), 168–82, and Guido Liguori, 'Senso comune', in Guido Liguori and Pasquale Voza (eds), *Dizionario gramsciano 1926–1937* (Rome: Carocci, 2009), 759–61. For a general introduction to Gramsci's thought, see Peter D. Thomas, *The Gramscian Moment. Philosophy,*

Hegemony and Marxism (Leiden: Brill, 2009) and Giuseppe Vacca, *Vita e pensieri di Antonio Gramsci (1926–1937)* (Turin: Einaudi, 2012).

23 Gramsci, *Selections*, 326, n.5.

24 Gramsci, *Selections*, 419.

25 Gramsci, *Selections*, 330, note by Gramsci.

26 Gramsci, *Selections*, 323.

27 Gramsci, *Selections*, 420: 'The principal elements of common sense are provided by religion.'

28 Gramsci, *Selections*, 420.

29 See Gramsci, *Selections*, 52–5.

30 See Kate Crehan, *Gramsci, Culture and Anthropology* (Berkeley and Los Angeles: University of California Press, 2002), chap. 5.

31 Gramsci, *Selections*, 326, n.5.

32 Gramsci, *Selections*, 326.

33 Gramsci, *Selections*, 325.

34 Gramsci, *Selections*, 323.

35 Gramsci, *Selections*, 349.

36 This passage does not appear in the English edition. See *Quaderni del carcere*, ed. Valentino Gerratana (Turin: Einaudi, 2007), vol. III, *Quaderno* 14, § 1, 1655.

37 This passage does not appear in the English edition. See *Quaderni del carcere*, vol. II, *Quaderno* 11, § 18, 1438.

38 This passage does not appear in the English edition. See *Quaderni del carcere*, vol. III, *Quaderno* 29, § 2, 2343.

39 Michael Baxandall, *Giotto and the Orators. Humanist Observers of Painting in Italy and the Discovery of Pictorial Composition 1350–1450* (Oxford: Oxford University Press, 1971), 17; 44.

40 See Langdale, 'Interview', 3; 9; 24–5; *Substance, sensation, and perception*, 65–9; Obrist, 'Interview', 44. See also A. Langdale, 'Linguistic Theories and Intellectual History in Michael Baxandall's *Giotto and the Orators*', *Journal of Art Historiography*, 1 (2009), accessed 12 April 2014, http://arthistoriography. wordpress.com/number-1-december-2009/.

41 This passage does not appear in the English translation. See *Quaderni del carcere*, vol. II, *Quaderno* 11, § 50, 1474.

Lo studio dell'origine linguistico-culturale di una metafora impiegata per indicare un concetto o un rapporto nuovamente scoperto, può aiutare a comprendere meglio il concetto stesso, in quanto esso viene riportato al mondo culturale, storicamente determinato, in cui è sorto, così come è utile per precisare il limite della metafora stessa, cioè ad impedire che essa si materializzi e si meccanicizzi.

42 Michael Baxandall, *Giotto e gli umanisti,* prefazione all'edizione italiana (1993) (Milan: Jaca Book, 1994), 16.

Non è una questione di 'determinismo linguistico' […]. Non si tratta neppure di 'strutture' culturali […]. Il soggetto è invece l'integrità sia delle culture storiche che studiamo sia della nostra psiche individuale; mi pare intollerabile pensare che il Rinascimento italiano, o io stesso (ma soprattutto il Rinascimento italiano), non siamo nient'altro che una casuale agglomerazione di inclinazioni frammentarie.

43 Baxandall, *Patterns of Intention,* 74–5.

44 Michael Baxandall, *Shadows and Enlightenment* (New Haven and London: Yale University Press, 1995), 119.

45 Michael Baxandall, *The Limewood Sculptors of Renaissance Germany* (New Haven and London: Yale University Press, 1980), 160; 163.

46 Gramsci, *Selections,* 339.

47 'But people were very quick to think if one said that people in a culture derive visual skills from that culture that this is a zeitgeist claim. I never persuaded Gombrich.' Obrist, 'Interview', 44–5.

48 Gramsci, *Selections,* 324.

49 Michael Baxandall, *Painting and Experience in Fifteenth Century Italy* (Oxford and New York: Oxford University Press, second edition, 1988), 40.

50 Michael Baxandall, *Words for Pictures* (New Haven and London: Yale University Press, 2003), 34.

51 Baxandall, *Giotto and Orators,* 49; 31.

52 Baxandall, *Words for Pictures,* 34.

53 Baxandall, *The Limewood Sculptors,* 164.

54 Gramsci, *Selections,* 9.

55 Gramsci, *Selections,* 42.

56 Gramsci, *Selections,* 347.

57 Gramsci, *Selections,* 9.

58 Text not translated in the English selection. See *Quaderni del carcere,* vol. II, *Quaderno* 6, § 29, 706–8.

59 Gramsci, *Selections,* 5.

60 Text not translated in the English selection. See *Quaderni del carcere,* vol. II, *Quaderno* 6, § 106, 778–9.

61 Edward W. Said, *Representations of the Intellectual. The 1993 Reith Lectures* (New York: Vintage Books, Random House, 1994), 4.

62 Gramsci, *Selections,* 5 ('Introduction' by the editors).

63 Gramsci, *Selections,* 347.

64 Gramsci, *Selections,* 12.

65 Langdale, 'Interview', 11; Obrist, 'Interview', 49.

66 Baxandall, *The Limewood Sculptors*, vii.

67 Baxandall, *The Limewood Sculptors*, 10. A similar point is made in Baxandall, *Patterns of Intention*, 120: 'Inferior paintings are impenetrable.'

68 Baxandall, *The Limewood Sculptors*, vii.

69 Baxandall, *The Limewood Sculptors*, 190.

70 Baxandall, *Patterns of Intention*, 120. In *Words for Pictures*, for instance (160), Piero della Francesca is described as 'a person of exceptional organisation'.

71 Baxandall, *The Limewood Sculptors*, 164.

72 Gramsci, *Selections*, 16.

73 Alpers and Baxandall, *Tiepolo and the Pictorial Intelligence*, 161–6.

74 Alpers and Baxandall, *Tiepolo and the Pictorial Intelligence*, 182. It is essential to notice that the expression 'used here' refers specifically and only to Part III, section 10, and not to the entire book. In other words, this expression does not apply to the concept of 'pictorial intelligence' in general. I want to thank Svetlana Alpers for having drawn my attention to this point. For a more explicit reformulation, see Baxandall's 'Arbeitsberichte' in *Jahrbuch des Wissenschaftskollegs zu Berlin 1992/93*: 20.

75 See Adrian Rifkin (ed.), *About Michael Baxandall* (Oxford: Blackwell, 1999); Adrian Rifkin, 'Can Gramsci Save Art-History?', *Block*, 3 (1980): 35–40; Anna Wessely, 'Les Cultural Studies et la nouvelle histoire de l'art', *L'Homme et la société*, 149 (2003): 155–65; Andrew Hemingway (ed.), *Marxism and the History of Art. From William Morris to the New Left* (London: Pluto Press, 2006), chap. 3 and 10.

76 *Substance, Sensation, and Perception*, 72.

77 Gramsci, *Selections*, 377.

78 Gramsci, *Selections*, 403.

79 Langdale, 'Interview', 11.

80 Obrist, 'Interview', 49.

81 Obrist, 'Interview', 49.

82 See *Quaderni del carcere*, vol. II, *Quaderno* 8, § 226, 1083–4; *Quaderno* 10, § 13, 1236. I would like to thank Svetlana Alpers, Carlo Ginzburg and Peter Mack for many helpful suggestions and Guendalina Santini and Jessica Jacobson for helping me revise my English text.

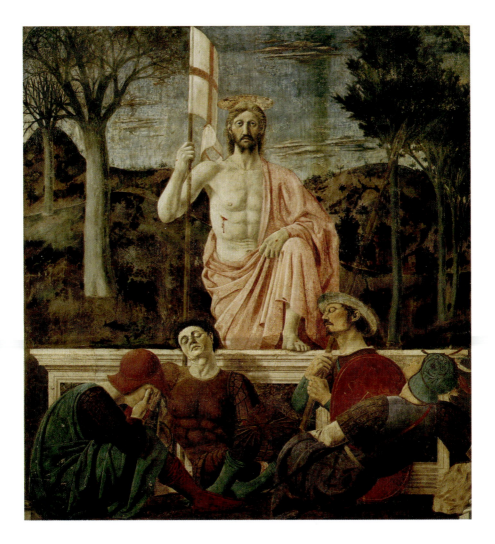

1 Piero della Francesca, *The Resurrection of Christ*, before 1474, fresco and other media, c. 225 x 200 cm, Museo Civico, Sansepolcro

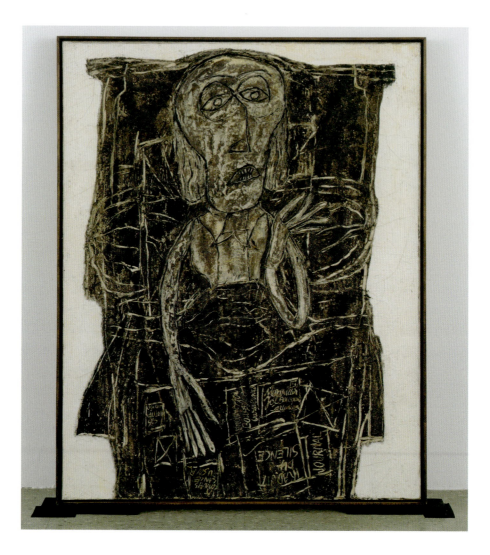

2 Jean Dubuffet, *Joë Bousquet in Bed*, 1947, oil emulsion in water on canvas,
146.3 x 114 cm, Museum of Modern Art, New York.
© 2015 Artists Rights Society (ARS), New York/ADAGP, Paris

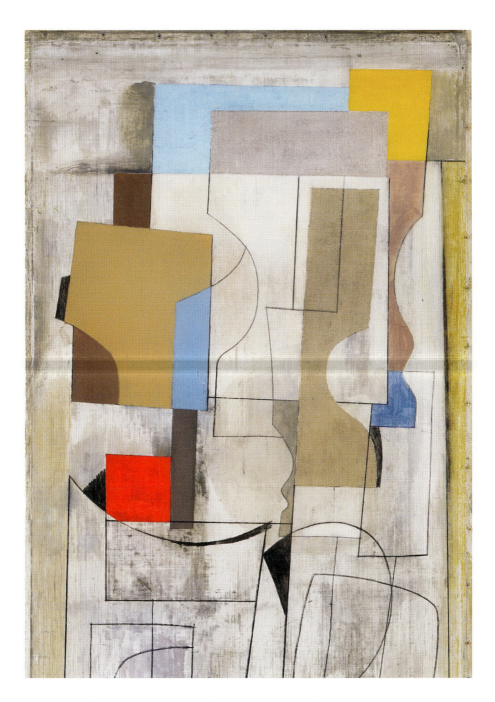

3 Ben Nicholson, *Feb. 28–53 (vertical seconds)*, 1953, oil on canvas, 75.6 x 41.9 cm,
Tate, London.

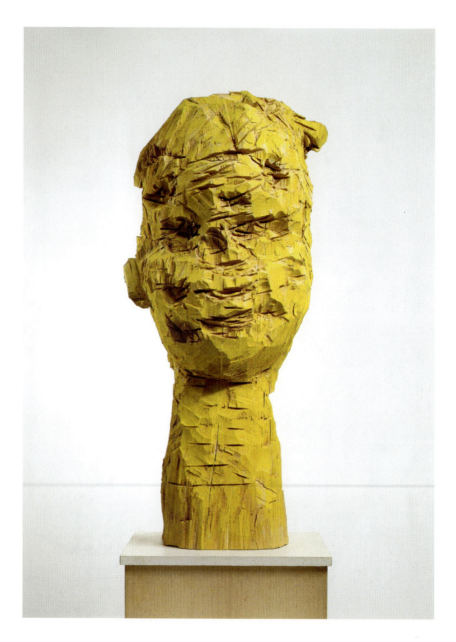

4 Georg Baselitz, *Women of Dresden – The Heath*, 1990, limewood and yellow tempera, 155 x 70 x 56 cm, Louisiana Museum of Modern Art, Humlebaek.
© 2013 Georg Baselitz

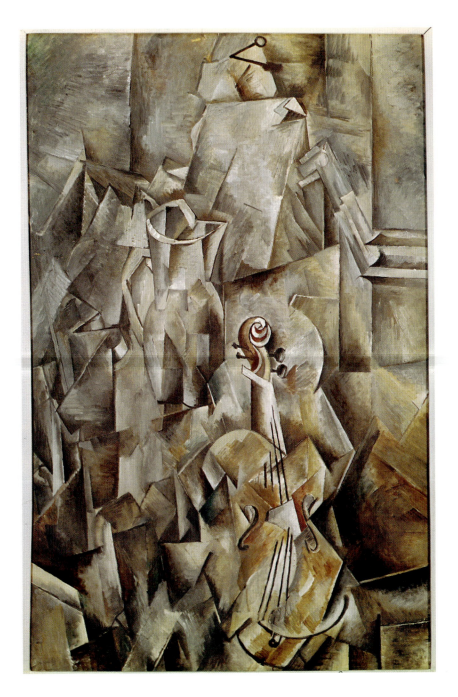

5 Georges Braque, *Violin and Pitcher*, 1910, oil on canvas, 117 x 73 cm, Kunstmuseum, Basel. © 2015 Artists Rights Society (ARS), New York/ADAGP, Paris

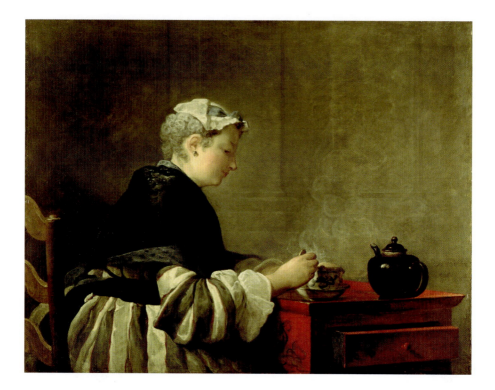

6 Jean-Baptiste-Siméon Chardin, *A Lady Taking Tea*, 1735, oil on canvas,
80 x 101 cm, Hunterian Art Gallery, University of Glasgow.
Courtesy Bridgeman Art Library Ltd.

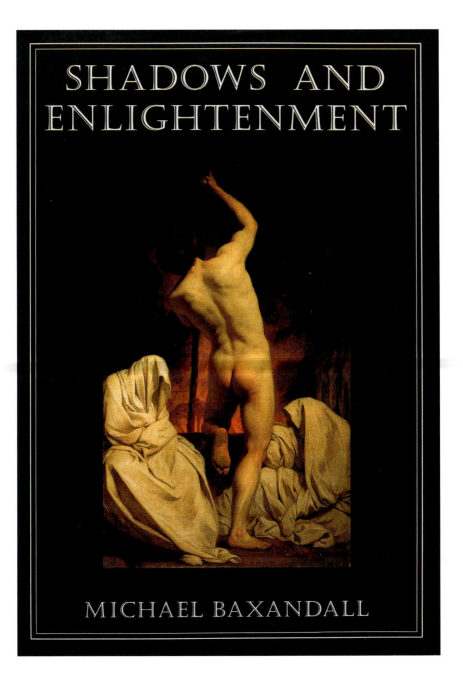

SHADOWS AND ENLIGHTENMENT

MICHAEL BAXANDALL

7 Cover of Michael Baxandall's *Shadows and Enlightenment* (1995), with illustration
of Pierre Subleyras, *Charon*, c. 1735–1740, oil on canvas, 135 x 83 cm,
Musée du Louvre, Paris. Courtesy Yale University Press

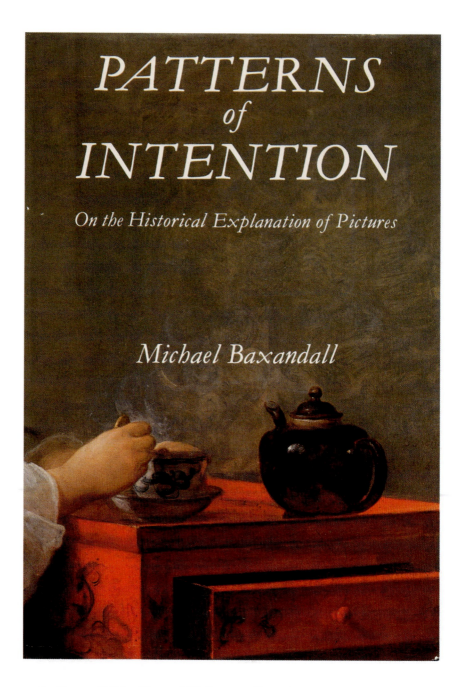

PATTERNS
of
INTENTION

On the Historical Explanation of Pictures

Michael Baxandall

8 Cover of Michael Baxandall's *Patterns of Intention* (1985), with detail from Jean-Baptiste-Siméon Chardin, *Lady Taking Tea*, 1735, oil on canvas, 80 x 101 cm, Hunterian Art Gallery, University of Glasgow. Courtesy Yale University Press

WORDS
FOR PICTURES

MICHAEL BAXANDALL

9 Cover of Michael Baxandall's *Words for Pictures* (2003), with detail from Piero della Francesca, *The Resurrection of Christ, before 1474*, fresco and other media, c. 225 x 200 cm, Museo Civico, Sansepolcro. Courtesy Yale University Press

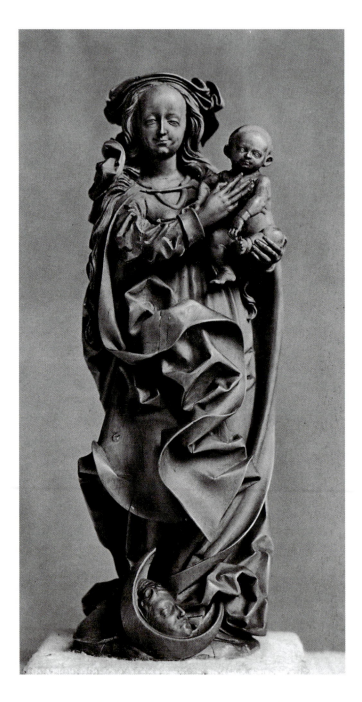

10 Veit Stoss, *Virgin and Child*, c. 1510–1520, © Victoria and Albert Museum, London
(*The Limewood Sculptors of Renaissance Germany*, plate 45)

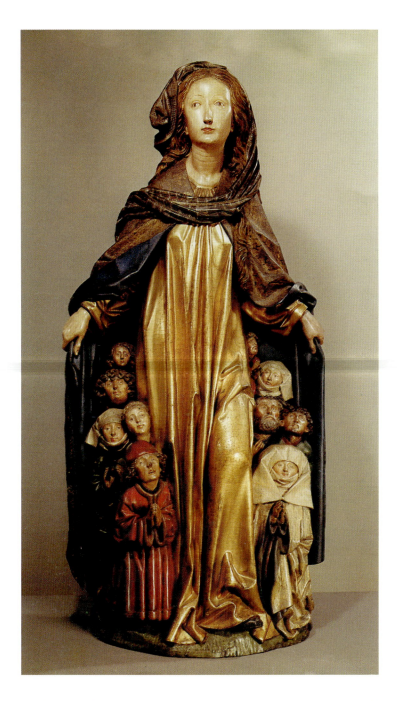

11 Michael Erhart, *Virgin of Mercy*, c. 1480–1490, Staatliche Museen, Berlin
(*The Limewood Sculptors of Renaissance Germany*, colour plate 3)

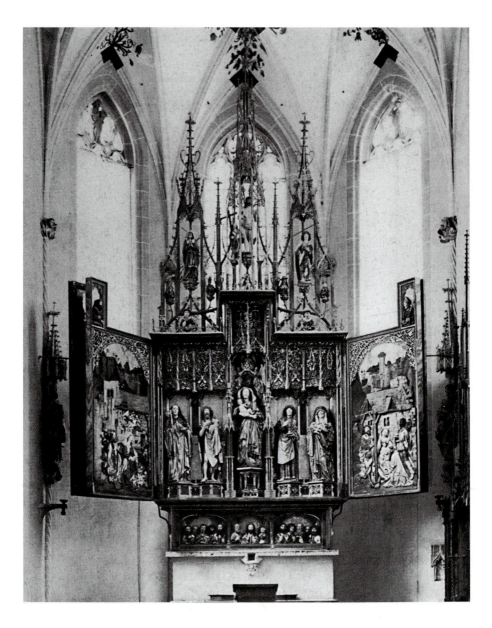

12 Michel Erhart, *Retable of the High Altar*, c. 1493–1494, Klosterkirche, Blaubeuren
(*The Limewood Sculptors of Renaissance Germany*, plate 19)

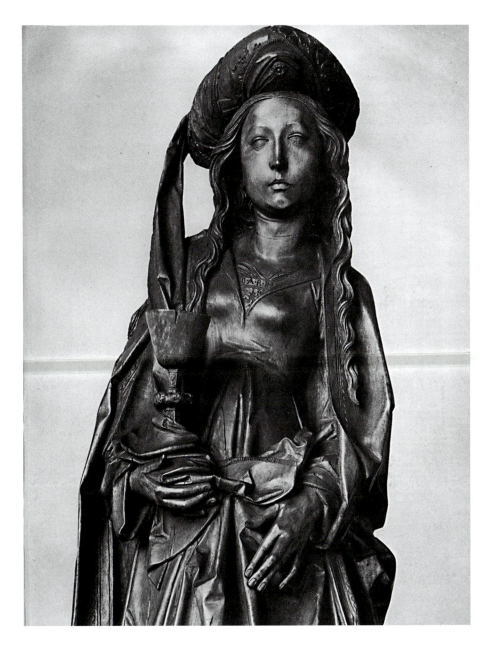

13　Riemenschneider, *St Barbara*, detail, c. 1410–1420, Bayerisches Nationalmuseum, Munich (*The Limewood Sculptors of Renaissance Germany*, plate 23)

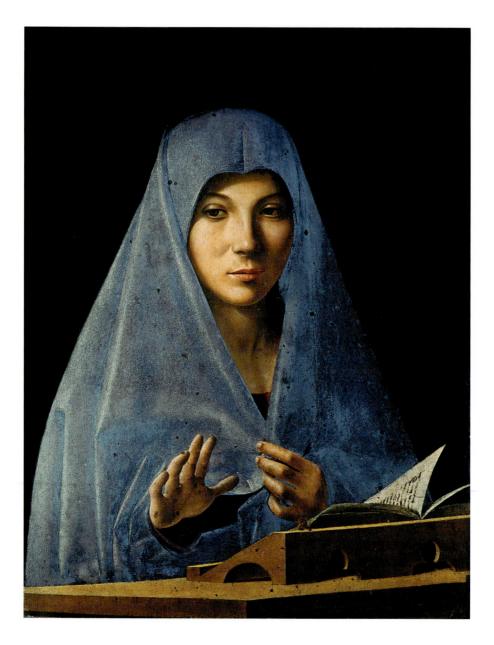

14 Antonello da Messina, *Virgin Annunciate*, oil on panel, 45 x 34.5 cm, mid-1470s,
Palermo, Galleria Regionale della Sicilia di Palazzo Abatellis (inv. 47).
© Archivio fotografico Galleria Regionale della Sicilia di Palazzo Abatellis.
Photo: Gero Cordaro

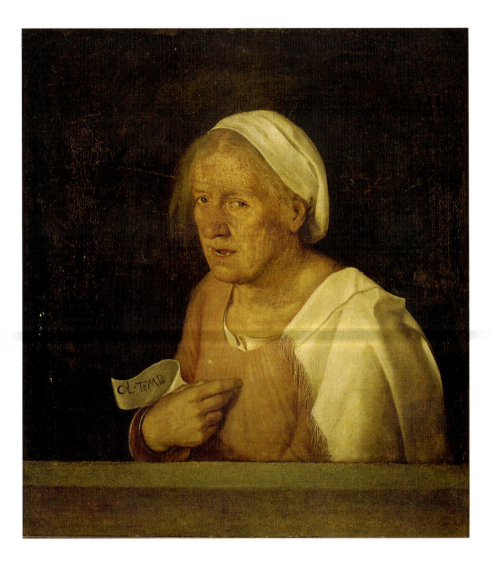

15 Giorgione, *La Vecchia*, tempera and walnut oil on canvas, 68 x 59 cm, Accademia
Gallery, Venice. Photo © Scala, Florence, courtesy of the Ministero Beni e Att. Culturali

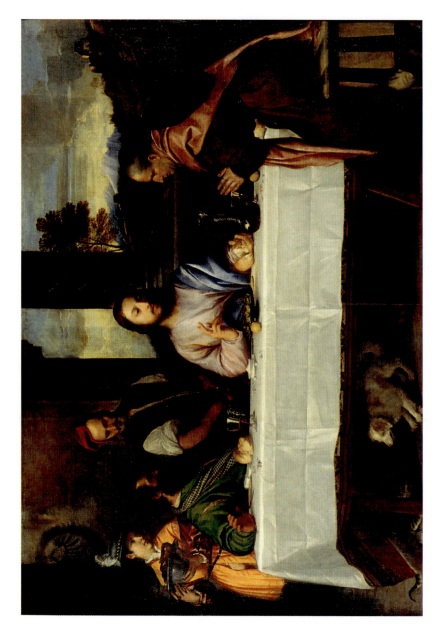

16 Titian, *Supper at Emmaus*, oil on canvas, 169 x 244 cm, Louvre, Paris, INV. 746. © White Images/Scala, Florence

Art History, Re-Enactment, and the Idiographic Stance

Whitney Davis

There has always been an uneasy relation between the practice of art history and the philosophy of historical explanation. Sometimes it has been explicated as the relation between art history as a 'semiautonomous special history', along with the history of literature or the history of science, and the 'general history' we would find in a book on 'France in the Age of Louis XIV'. I use Maurice Mandelbaum's terms in *The Anatomy of Historical Knowledge* because they steered the art historian writing in English who devoted the most sustained attention in the past 40 years to the question of 'the historical explanation of pictures', namely, Michael Baxandall, especially in *Patterns of Intention* (published in 1985). To be sure, Baxandall's earlier book *Painting and Experience in Fifteenth-Century Italy* (published in 1972) had set out some of his key terms.[1] But the 'experience' addressed in the earlier book was redefined in the later one. In *Painting and Experience*, experience belongs to the territory covered by Mandelbaum's general history, namely, the nature and practices of a society existing at a particular time and place, such as fifteenth-century Italy (Medicean Florence in particular). In *Patterns of Intention*, experience also includes the *art historian's* activity in experiencing (and 'explaining') pictures from fifteenth-century Italy.

These two fields are connected. The experience of people who made pictures in the past can be replicated in the experience of people who explain them historically in the present. The replication, Baxandall said, involves 're-enactment': to explain a picture historically, we re-enact something about it. *Patterns of Intention* presented a model of this process – what Baxandall called the 'triangle of re-enactment'.[2] It consists of the 'terms of the problem' confronted by picture makers in the past, which Baxandall called 'the painter's Brief' (one angle of the triangle); the 'culture' in which they addressed the problem (another angle); and our 'description' of the picture that resulted (the remaining angle).[3] One of the puzzles of *Patterns of Intention*, however,

is that Baxandall resisted re-enactment, that is, moving from right to left on the horizontal axis in the diagram, as it were 'back in time' – from the picture described by us in the present to the terms of its cultural production in the past. Baxandall was cautious about re-enactment, and his triangle model was meant to model the reasons why. It not only sets out the difference between general history and art history as a semiautonomous special history with its own objects – art in the past – but also observes a difference between the autonomous history that art has and art history as semiautonomous of that very history.

According to Baxandall, to deploy the triangle appositely is to adopt the 'idiographic stance'.[4] It demands that we 'reconstruct the [historical] actor's purposes on the basis of particular rather than general facts, even while clearly if implicitly using generalizations, soft rather than hard ones, about human nature and so on'.[5] Because this procedure 'decline[s] the model of the physical sciences',[6] it might partly distinguish art history from certain other histories produced in the field of what I will call 'general archaeology', from sciences of art (for example, in physiological aesthetics and more recently in neuroaesthetics), and from natural sciences. These fields of inquiry have been said to be characterized not by idiographic but by 'nomological' concerns: within their frame, as Baxandall put it, it is possible 'to explain historical human actions within quite strictly causal terms as examples covered by general laws, on the same logical pattern as a physical scientist explaining the fall of an apple'.[7]

As we will see, however, the scope of this distinction is debatable when applied to art history. In the end Baxandall backed away from it, even given the qualification about the 'soft generalizations' about 'human nature and so on' – generalizations permitted to art history – with which he had introduced it in *Patterns of Intention*. It turns out that the 'historical explanation of pictures' cannot do without nomological inquiries at well-defined stages in its procedure.

I will go at this in three ways. I begin with historiographical considerations. In addition to its role in much modern aesthetics and art criticism, re-enactment has occupied the philosophy of history since Dilthey, notably in Gadamer's hermeneutic concept of the 'fusion of horizons'. In this arena, Baxandall's *anti*-hermeneutic version was partly tailored to engage re-enactment as it had been conceived both in a preceding special art-historical theory and in a preceding theory of general history, namely Panofsky's and Collingwood's respectively. Then I offer analytic considerations: what are the particular components and claims of Baxandall's triangle of re-enactment and its idiographic stance? Finally, I pursue critical implications and consequences.

A preliminary comment must be made about Baxandall's standing as an art historian – about his representativeness – insofar as I will treat him

as a spokesperson for art history. In one sense, and as the 'lucid' historian and 'subtle' art writer that he was, Baxandall was inimitable – *sui generis*. In another sense, however, it is fair to take his work as a kind of ideal of art history as it has fashioned itself in the past 40 years. There is broad consensus in the worldwide community of art historians that Baxandall's historical scholarship (for example, in *Painting and Experience*) represents one of the high points of art history in his generation of art historians, and perhaps in any generation.[8] Equally important for my purposes, his reflections on the nature of art-historical inquiry in *Patterns of Intention* map out what many art historians (certainly in my acquaintance) think about their practice, and would likely say themselves if they had his 'extraordinary rhetorical alertness'. (The quoted terms in this paragraph derive from a recent perspicuous assessment of *Patterns of Intention* by Margaret Iversen and Stephen Melville.[9]) It is not unreasonable, then, to take Baxandall to stand in for a majority opinion in art history tout court, namely, that art history demands the idiographic stance. The question is whether this is *all* that it demands. To readers in philosophy or the sciences, it might seem self-evident – hardly worth debating – that art history, however idiographic, cannot do without nomological inquiry. It is perhaps a measure of Baxandall's influence, then, that many art historians continue to decline to think that it does, or should.

<p style="text-align:center">∾ ∾ ∾</p>

Before Baxandall's *Patterns of Intention*, one of the most explicit statements that art history involves re-enactment could be found in Erwin Panofsky's 'Art History as a Humanistic Discipline', published in 1938. The relevant passage reads:

> The humanist, dealing as he does with human actions and creations, has to engage in a mental process of a synthetic and subjective character: he has to mentally *re-enact the actions* and to *re-create the creations*. It is in fact by this process that the real objects of the humanities come into being. For it is obvious that historians of philosophy or sculpture are concerned with books and statues not in so far as these books and sculptures exist materially, but in so far as they have a meaning. And it is equally obvious that this meaning can only be apprehended by re-producing, and thereby, quite literally, 'realizing', the thoughts that are expressed in the books and the artistic conceptions that manifest themselves in the statues. Thus the art-historian subjects his 'material' to a rational archaeological analysis at times as meticulously exact, comprehensive and involved as any physical or astronomical research. But he constitutes his 'material' by means of an intuitive aesthetic re-creation, including the perception and appraisal of 'quality', just as any 'ordinary' person does when he or she looks at a picture or listens to a symphony.[10]

I will not dwell on Panofsky's perspective; a great deal has been written about it.[11] But I need to make two points in the present context. First, 'intuitive aesthetic re-creation' is a compound activity. As Panofsky explained,

> it is important to emphasize the prefix 're'. ... In experiencing a work of art aesthetically, we perform two entirely different acts which, however, psychologically merge with each other into one Erlebnis: we build up our aesthetic object both by re-creating the work of art according to the 'intention' of its maker, and by freely creating a set of aesthetic values comparable to those with which we endow a tree or a sunset.[12]

Second, then, this compound intuition needs to be rebalanced. We must move from creating to *re*-creating, to what Panofsky sometimes called the 'reinstatement' of *past* creating, as it were removing our 'sunset' in our object – its aesthetic value specifically for us – when we define it as the creation of aesthetic activity of makers in the past. This is the program of Panofsky's iconology as a 'correction' of our present aesthetic intuition, for, as Panofsky asserted, 'there is nothing less real than the present'.[13] The 'real objects come into being', then, only in our historical work (albeit conducted as a 'humanistic discipline'): this is 'rational archaeological analysis at times as meticulously exact, comprehensive and involved as any physical or astronomical research'. Of course, if to re-enact is to re-create aesthetic values created by agents in the past, what has been taken away by one hand of iconology can sometimes be returned by the other. The two sets of aesthetic values could intersect: after all, their *material* object is often partly shared, though typically it has undergone material transformations over time.

Like Panofsky, Baxandall rigorously distinguishes the circumstances of artistic creation and the circumstances of art-historical re-creation. Indeed, his insistence on the distinction motivates his triangle of re-enactment – the *triangle* specifically as compared to Panofky's *binary* movement from the 'material' present to us and its re-created 'meaning' in the past, a movement that could lead to hermeneutic fusion *or* to historical distance (Panofsky waffled on that point). In Baxandall's triangle, the 'meaning' of the artwork disappears as the historian's object. It is replaced by 'historical circumstances' on the vertical axis, a compound of the 'terms of [an artistic] problem' and the cultural conditions of its solution. (Here there is an echo of Baxandall's teacher E.H. Gombrich and possibly of Gombrich's interlocutor K.R. Popper.) By the same token, in the triangle the 'material' on the horizontal axis is another compound. It is not, however, our 'freely created' aesthetic valuation of the pictorial artwork, but instead our 'description' of the object interacting with the thing itself – 'pictures considered under descriptions'.[14] In re-enactment in the triangle, we can move along *each* axis of the *two distinct sets* of historical circumstances, namely, the axis that relates the maker's problem to culture (a task of 'social history' and its archaeology of culture, developed by

Baxandall in his early writings, notably *Painting and Experience*) and the axis that relates our description to the painting we see (a task of critical writing and of the 'language' of art history, concerns to which Baxandall increasingly addressed himself). But we *cannot* use the *whole of the description* that we can produce to retrieve the *whole of the culture* that produced the picture: the very form of the axes, sitting at right angles to one another, displays the basic discontinuity. Baxandall's triangle of re-enactment, then, could just as well be called the crucifix of detachment.

In this reading I differ somewhat from Iversen and Melville. They argue that Baxandall aspired to 'bridging' (or 'spanning') past cultural situations of making and presenting acts of pictorial description, which they contrast (favourably) with the 'historical distance', 'detachment', and misplaced 'objectivity' supposedly resulting from the methods of Panofsky's iconology.[15] This may be true enough as far as it goes. But it is neither the description of the picture (horizontal axis) nor the account of the maker's culture (vertical axis) that builds the bridge or effects the span. They must do so jointly. And rather than merge (as Iversen and Melville's metaphor might be taken to imply), they diverge, or more exactly, they cross over one another. For Baxandall, the point is to be clear about the shape and scope of the divergence – about the *gaps* in the road as it were, or, to vary the metaphor, about the *crossroad* in which art history is always unavoidably located.

Baxandall's anti-hermeneutic purism, his resistance to attempts to pin down the 'meaning' of pictures, partly flowed from his distaste for what he called 'high iconography'[16] – for art historians' painstaking decipherments of subtle humanist themes or specialized theological symbolisms in such Renaissance pictures as Piero della Francesca's *Baptism of Christ* of c. 1440–1450 (now in the National Gallery in London) and *Resurrection of Christ* of c. 1463–1465 (in the Residenza of Sansepolcro), two paintings to which Baxandall devoted sustained scholarly attention throughout his career. This was not really an argument with Panofsky's theory of re-enactment – reinstatement under correction. It was an argument with latter-day Panofskyans and their 'overelaborate' iconographies – unnecessary and implausible in Baxandall's eyes, however 'learned and ingenious'.[17] In setting out the proper relation between 'pictures and ideas', he wanted to show, for example, how the painter Chardin's culture was broadly 'Lockean' – mediated to the painter by French scientific middle-men[18] – in a way sufficient to account for distinctive pictorial effects in *Lady Taking Tea* of 1735 (now in Glasgow).[19] The historian's tact and judiciousness must here consist in determining how to describe a Lockean scientific culture that was one of the conditions of Chardin's solution to his painterly Brief without supposing that we must follow every twist and turn of Locke's particular thoughts about perception as specifically expressed in Book Two of *An Essay Concerning Human Understanding* – a work that Chardin probably had never read.

(*We* need to read Locke, of course, but mostly 'as a means of getting some sense of the pattern' of eighteenth-century 'Lockeanism'.[20]) Baxandall judged that high iconography (and for that matter high intellectual history) often does not strike the right balance here. In a case like Piero's, it often presupposes that highly literate humanists systematically devised a sophisticated program of theological or allegorical thought which was verbally communicated to the painter who executed the work. In this it too readily loses sight of the *painter's* thought – the 'ideas' that count in the historical explanation of his pictures.

<center>ও ও ও</center>

This brings me to a second (and possibly more important) context of Baxandall's model of re-enactment. At roughly the same time as Panofsky wrote 'Art History as a Humanistic Discipline', R.G. Collingwood wrote the famous pages on 'history as re-enactment of past experience' folded into *The Idea of History*, posthumously published in 1946. Though Baxandall claimed that he adopted a 'sub-theoretical' view of Collingwood's account of re-enactment,[21] that is, that he did not aim to explicate and dispute it directly, it is plain that he studied Collingwood's formulations carefully. *Patterns of Intention* repeatedly addresses them head-on, though not by name except in one footnote.[22]

We should certainly not be surprised by Baxandall's interest in Collingwood. He knew Collingwood's philosophical aesthetics in *The Principles of Art* of 1938. And Collingwood was partly an archaeologist (Lecturer in Philosophy and Roman History at Oxford before becoming Waynflete Professor of Metaphysical Philosophy) whose 'logic of question and answer' (analogous to Baxandall's question-'Brief' and picture-'solution') had steered his own frequent forays in art history. Indeed, before he framed his logic of question-and-answer as a general philosophy Collingwood had developed it in order to address the problem of aesthetic intuition specifically in relation to the history of art. As he recounted in his autobiography, the issue dawned on him when working in Whitehall during the First World War; walking through Hyde Park every day, he became obsessed by Gilbert Scott's Gothic-Revival *Albert Memorial* of 1875:

> Everything about it was visibly mis-shapen, corrupt, crawling, verminous; for a time I could not bear to look at it, and passed with averted eyes; recovering from this weakness, I forced myself to look, and to face day by day the question: a thing so obviously, so incontrovertibly, so indefensibly bad, why had Scott done it? If I found the monument merely loathsome, was that perhaps my fault? ... Was I looking in it for qualities it did not possess, and either ignoring or despising those it did?[23]

Collingwood did not actually give us his answer about Scott. But the same question recurred in his archaeology of 'Classical' art made in Britain under the Romans, often presumably by native Britons: why was it almost always so *bad*? Correlatively, why was a lively 'revival' of (better) Celtic art historically possible at all after the Roman withdrawal from Britain?[24] To answer these questions – Collingwood the Romanist said proudly that he *did* answer them – one must re-enact, that is, re-enact Scott's questions and answers, or those of the Roman Britons.

I will be shamefully brief about this matter, and stick to Collingwood's own well-known words. Collingwood asserted that 'all history is the history of thought', and to write history – or to *do* it in archaeological excavation – is to 're-think' the thoughts, as he put it.[25] When I understand a proof in Euclid's *Elements* (say, the fifth theorem – the *pons asinorum* – that the angles at the base of an isosceles triangle are equal) it is because I think it myself. It is 'revived after an interval' in the sense *not only* that if I return to my thought that 'the angles in that triangle are equal' after five seconds I repeat that act of thought. It is also revived in the sense that if I return to Euclid's thought 'the angles are equal' I repeat *his* thought: it is the thought I must have if it is Euclid's proof, which it is if I am thinking *his* proof. Of course, if 'I want to be sure that twenty years ago a certain thought was really in my mind, I must have evidence of it … a book or letter or the like that I then wrote, or a picture I painted.' As Collingwood went on,

> Only by having some such evidence before me, and interpreting it fairly and squarely, can I prove to myself that I did think thus. Having done so, I rediscover my past self, and re-enact these thoughts as my thoughts. There is nothing which the autobiographer does [in interpreting the evidence of his past] that the historian could not do for another.[26]

On this account, then, I do not so much reprove the fifth theorem (a thinking that I am probably incapable of) as re-enact the fifth theorem's proof (on evidence).

There are many misinterpretations of this striking thesis. I mention two. First, as the historical series of me-thinking-now, me-20-years-ago, and Euclid-2,300-years-ago would suggest, a certain metaphysics of personal identity – 'me' versus 'Euclid' – might lead one to wonder whether such actions as thinking Euclid's proof can jump between discrete personal identities in time and space to attain the requisite identification of thoughts. But if, like Collingwood, we take thought to be a public and social affair, discrete personal identities in history and chains of discrete particular thoughts in history would seem to be cross-wired.

Second, if we take thoughts to be brain-states (even neurochemical events) one might suppose that my brain-states and your brain-states in thinking Euclid's proof, which is Euclid's proof, only Euclid's proof, and nothing

but Euclid's proof, might not be the same brain-states – certainly not *one* brain state. But nothing in Collingwood's thesis requires that they be the same, let alone one. Indeed, they are different. They stand to one another as the post-Roman Celtic Revival stands to the pre-Roman La Tène style it re-thought.[27] This is because every thought (Collingwood said) is an answer to a question; propositions that seem the same might answer different questions, and propositions that seem different might answer the same question. The Albert Memorial could *be* a Gothic ciborium. But it might still be a Victorian monument. It would answer Scott's question how to memorialize Victoria's consort. By the same token, the Albert Memorial could be just as it was in 1875 and answer a certain same question as the ciborium of San Giovanni in Laterano erected by Giovanni di Stefano in 1367: how to cover a holy object or image. Thought answers a question – a *certain* question. To 're-think', then, is to ask the same question (on the evidence for it) and get the same answer as the historical actor who asked a question and produced an answer. In general, re-enactment is not physiological duplication of a thought in the past but its logical archaeology. More exactly, it is the possibility of the 'survival' of the past thought for me – its 'revival after an interval' in the way that an ancient tool could be excavated and reused by me in the very same fashion in which it was first used, given the evidences for that use which can be assembled and assessed by the historian who seeks to identify it. The virtue of Collingwood's approach is obvious. We need to know the question answered by the tool – its purpose. Knowing it, 're-thinking' the tool is simply to use it to do just what it did when the maker produced it to answer that very question, that is, accomplish the task for which it was made.

But now I note that Baxandall – as the very mission of *Patterns of Intention* – vehemently resisted what he took to be re-enactment, despite his own stated commitment to the idiographic history of human purposes in the past. This is partly because he can be read to make both misinterpretations of Collingwood, believing that Collingwoodian re-enactment requires coalescence of persons and/or equivalence of brain-states between past and present, as if I do not just think a certain thought of Giovanni or Scott, a Celtic Briton or a Romanized Briton, or Piero or Chardin, but somehow *become* these people or brain-states (at least with respect to the thought in question). For Baxandall, this would be to collapse the historical 'distance' and cultural 'difference' between the historian and people in the past or in 'other cultures' in which we do not act, or think, as 'participants'.[28]

More important, Baxandall's objection to Collingwoodian 're-enactment' as he interpreted it rests partly on his conclusion that 're-thinking' must be impossible for the art historian in view of the special kind of thought that is *art*-thought. For the thinking done in art is such that there is no enaction that could re-think it.

Things might now seem a bit tangled, but let us press on. As Baxandall took care to note,[29] Collingwood had said that art of the past cannot be re-enacted – and in this, for Baxandall, historically 'explained' – because art is not thought; 'the genuine artist', Collingwood wrote, 'does not think at all'. Art is the expression of emotion defined in a special way – as feeling raised to self-consciousness in working a medium.[30]

But Collingwood's aesthetics need not detain us. For Baxandall claimed that art is indeed thought. This is a decisive thesis in Baxandall's art history – the very basis of his 'historical explanation of pictures'. Later he and Svetlana Alpers gave art-thought the name 'pictorial intelligence', a phraseology taken up by other art historians.[31] But in *Patterns of Intention* Baxandall proceeded simply by calling art-thought the maker's 'style' as constituted in a 'dialectic of process'.[32] Style is the painter's thought in making the picture.

The point needed to be made not only because iconology set style on a lower rung of the ladder of historical re-creation, something to be worked through in the 'material' in order to get to the 'meaning' of the picture.[33] For Baxandall, there is nothing but style – the dialectic of process. The point also needed to be made because as a thought it belongs to very different historical conditions of picture-making than our own. Baxandall credited the recognition of style-as-thought to historians of classical Chinese literati painting, specifically James Cahill,[34] who argued that the classical painters' styles – what Cahill defined as 'individuality with respect to other works' – was the 'ultimate reality' of the humanist strain in art from the Northern Song onward, and its aesthetics as explicitly endorsed and described by the literati painters themselves.[35] The historical explanation of pictures – any picture – is possible in Baxandall's sense only when we treat picturing as these Chinese painters supposedly did. We must enact their aesthetics to *re*-enact works by Piero or Chardin – or a Celtic metalworker or Giovanni di Stefano or Gilbert Scott or any other maker.

Stated another way, the triangle of re-enactment only gets underway when we 'Chinese-ify' a picture – take it to be 'style-thought' (this is my term, not Baxandall's, who mostly said 'pictorial style'). This does not come readily to us because we are tempted (as iconologists) to take it as a *picture*, and to look through its style to its depicted objects and representational significances. But pictoriality inhibits re-enactment in Baxandall's sense precisely because it is replicable thought in Collingwood's: once I have seen what the picture depicts (and maybe what that 'meant' in its culture), I have re-enacted it – I have 'thought' it, I have got it, and I can move on. And if this is the contribution of the special history that is art history to *general* history, it is inadequate, Baxandall believed, to anyone's real experience of certain pictures (or of picture making as an art), past or present.

Now the conundrum of Baxandall's triangle of re-enactment comes into focus. I can re-think a proof of Euclid's fifth theorem in a finite series of well-defined irreducible steps – call them 'thought-emes'.[36] But Piero's *Baptism*

and *Resurrection* involved thousands – millions – of thoughts-in-style, or 'style-emes'. Therefore their re-creation in the present would be interminable even if we could make all the historically appropriate corrections of our aesthetic experience of the object that Panofsky demanded (and which Baxandall doubted could be done anyway). Simply re-painting the picture ourselves is not an option – the version in special art history of 'historical re-enactment' dress-up in general history. Even if we could do this, it would have to be in *our* style, not the painter's.

Are we stuck, then? Yes and no. *Yes*: Because re-enactment – in Panofsky's sense, Collingwood's, the 'historical re-enactors' – is not available to the art historian in Baxandall's sense, an investigator addressing style-thought. *No*: Because we can still play Baxandall's 'conceptual game on the triangle', as Iversen and Melville put it.[37] For the triangle of re-enactment is not re-enactment per se; it is our triangulation of it. As we have seen, we can move on the vertical and horizontal axes – between 'terms of problem' and 'culture'; between description of the picture and the picture itself. When we reorganize these domains in light of one another – standing as it were in the crossroads of art history – we triangulate. This is not re-enactment but 'reconstruction'. In the reconstruction we *infer* what could be re-enacted if we had the evidence for it (Baxandall's preferred name for his procedure in 'historical explanation' was 'inferential criticism'[38]). But we do not have the evidence for it, and we never will: this is precisely what makes art history a definably special history in general history, perhaps definably different from special histories of science or philosophy, which usually work (Baxandall said) in close re-creative proximity to the thoughts they reconstruct.[39] At its best, we might say, art history cannot but be maximally distant from the thought that created its objects.[40]

<p style="text-align:center">❧ ❧ ❧</p>

What are the analytic parameters of art-historical reconstruction? According to Baxandall, it must make three assumptions about style-thought. Style-thought can be most fully explained historically only if all three are warranted.

The first assumption is that the object, a picture, that fossilizes a past maker's style-thought was finished, or, as Baxandall put it, that it was 'relinquished' by the maker – let go, and put into use as cultural fulfilment of its Brief. This is to say that style-thought in the past was actually terminated in the past (in a well-defined material sense open to archaeological research) despite its seeming inexhaustibility – its interminability in any account *we* could give of it.

This assumption resolves a conceptual bind in art history. If style-thought were unbounded in the past, re-enactment would be impossible in principle, and a historical reconstruction would be a mere construct on the historian's

part in the way that a molecular diagram of sodium chloride is a construct of the taste of salt. But because past style-thought was partly self-segmented into discrete things in social use, its bounds or frame can be reconstructed. When we do this, we are not really trying to re-create every single one of the thousands of style-emes making up that stretch of the 'dialectic of [artistic] process' in the past. We are trying to discover the historical conditions under which that group of style-emes belongs to a single set defined by the object relinquished by the maker as a fulfilment of its Brief, and so described by us. Sometimes art historians like to describe this by saying that they focus on objects or even *the* object – *this* picture or *that* picture. Obviously, however, this merely assumes the consequent. Better, art history treats the objects analytically as discrete material things relinquished to have been used and seen as such – a 'pattern' or perhaps more exactly a partition and material deposition of intention. That there are such things is not in doubt, and we have already established that some of them cannot be re-enacted. Hence art history. Of course, there is something fishy about this. But it is only the fishiness of setting up a certain special history in general archaeology – the special history of the relinquishing of style-thought, that is, letting it go in material sediments.

The second assumption is that style-thought was rational. By 'rationality', Baxandall's sources in cross-cultural anthropology denoted practical know-how, local knowledge, and situational judgment – the connecting of answers to questions and means to ends in a way that would be replicable by the people among whom the object was made to be used.[41] Therefore we do not actually have to re-enact at all if we assume rationality. Instead, we reconstruct the historical conditions of said rationality: how people connected answers to questions and means to ends. We find out how we would think their thoughts if we were them, though we aren't. Presupposing rationality, then, historical reconstruction can analytically model enactments in the past without *re*-enacting them in the present. And rationality can be presupposed because if style-thought was relinquished we can fairly assume certain questions were answered and ends realized by means – a rationale. Inversely, if style-thought was rational, we could assume that relinquishing the object *well answered* the question of letting it go specifically in the matter – the sediment – of its style-thought.

This brings me to the third assumption – the trickiest. Reconstruction in the triangle of re-enactment is viable only when we are dealing with what Baxandall called 'good pictures'. Indeed, the *gooder* the picture the more historical we can be about it. I did not say 'the *better* the picture'. The issue is not aesthetic quality for us – what we find better and best in pictures. We have already seen that in re-creation per se we strip out our aesthetic values; it is a rational means of historical reconstruction to assume that aesthetic values in the past (rationally realized in the making of pictures and other things) were

different. The issue is rather that style-thought in the past had to be 'purposeful and reflective', 'orderly and skilled' – well equipped to fulfil its Brief. Style-thought had to answer the question 'How to make a *good* picture?' in a way that when relinquished could be recognized as rational. Paradoxically, this entails that it could not be re-enacted even at the time; only the maker, or makers equivalently equipped as style-thinkers, could produce it. For the very characteristic of good style-thought in making something intended to be used visually (especially to be used visually *as* style-thought – like literati painting) is that it knows how to get started, when to let go, and what to do in between.

Each of the three assumptions of reconstruction requires the others, and reconstruction requires all of them. In the triangle of re-enactment, they are mutually reinforcing. And they frame the special history that is art history – its idiographic stance. Now we can see why Baxandall kept a distance between the triangulations of historical reconstruction and the circularity of hermeneutics. Hermeneutics as he understood it involves re-enactment that tends toward the fusion of historical horizons – *Horizontverschmelzung*. (Despite criticisms, it was not for nothing that Gadamer cited Collingwood as a philosophical ancestor.[42]) But reconstruction in art history eschews fusion because it cannot attain re-enactment in the case of its objects. In Panofsky's view of re-enactment in art-historical re-creation, the art historian develops 'his re-creative experiences so as to conform with the results of his archaeological research, while continually checking the results of his archaeological research against the evidence of his re-creative experiences'. Baxandall agreed; thus far his model of the vertical and horizontal axes of the triangle. But it is not entailed, as Panofsky had claimed, that 'when [the art historian] does all this, his aesthetic perception as such will change accordingly, and will more and more adapt itself to the original "intention" of the work'.[43] To reconstruct the intention is not to re-experience it. It is not 'revived after an interval', to use Collingwood's terms. To the contrary, after the interval it cannot be revived. It can only be reconstructed from what survives. Indeed, style-thought could not be duplicated *even in its own time and place*. As enactment without possibility of *re*-enactment, style-thought has a history but no hermeneutics – an archaeology of survival but no theatre of reanimation. When art historians try to 'bring the past to life', then, they are likely to fail their special history.[44]

❧ ❧ ❧

Two consequences seem to me to follow from accepting Baxandall's model (if we do) of idiography in art history as 'reconstructive' of what I have called 'style-thought'. One follows directly from the assumption of 'good pictures', though it can also follow less directly from the assumptions of relinquishing

and rationality. A lot of visual culture isn't any good in the requisite sense. In many cultures, many social Briefs have been addressed by ready-made pictures – merely efficient 'paint-by-numbers' pictures – and by half-baked pictures and by redundant pictures. These pictures are not open to historical explanation in Baxandall's sense, or at least they are not as fully open to what we attain specifically by adopting the idiographic stance. It seems to follow that visual culture, at least in this register, cannot have a history in Baxandall's sense, or at least an 'art history'.

This seems to be an undesirable result. But it is not incredible. The crucial distinction is between 'reflective' pictures – *good* pictures – with 'high order' (and therefore greater singularity) to their style-thinking and pictures that are less reflective and orderly. 'Reflective order' involves a nonobvious connection between 'terms of problem' and 'culture' on the vertical axis of the triangle of re-enactment and between our description and the picture itself on the horizontal axis. For if it is easy to draw the lines, there cannot be much to the picture's historical explanation per se – to explanation of *that* picture as having its then un-re-enactable style-thought. If our investigations have already canvassed that possibility of picturing in that culture, we already have an explanation.

Analytically, then, in a sense a 'good picture' is a picture that has not yet been historically explained in a reconstruction of *its* style-thoughts. It is a 'good picture' in the sense that an art historian has a 'good topic' for a book in selecting the painting – it needs, it warrants, and it repays historical work. If we attempt the reconstruction, we might find that the picture is even 'gooder' than we had expected because it is hard to reconstruct its style-thoughts in visual-cultural context. But if the picture is not even minimally good, we can never explain its style-thoughts. For such a 'bad' picture is not a product of the visual culture. The lines just do not connect. Maybe the picture belongs to a *different* visual culture, maybe *very* different from the culture we had thought it belonged to. Maybe it does not belong to visual culture at all.[45]

This is circular, of course. But it is an analytic circle, not a vicious circle. The historical explanation of pictures enables us to discover what a visual culture is. But once we have discovered what a visual culture is, the pictures that belong to it do not really need historical explanation. To know they belong to it is already to explain them historically. In this respect art history and visual-culture studies (sometimes said to be quite different and maybe opposed) simply represent different moments of the maturity of historical explanation – of the need for it.

I resolve what seems to be an undesirable consequence of Baxandall's model, then, as the methodological circle enshrined in the triangle of re-enactment: in explaining a picture we move toward understanding its visual culture even as we depend on knowledge of it gained by explaining pictures.

Of course, in philosophy 'understanding' (*Verstehen*) has often been affiliated with the 'idiographic' stance and 'explanation' (*Erklärung*) with the 'nomological' stance, though Baxandall describes both stances as 'traditions of explanation'.[46] This might raise the question why Baxandall would describe 'inferential criticism' in art history as the 'historical explanation of pictures' as opposed to, say, 'understanding pictures historically'. No doubt he was writing 'sub-theoretically', as he often insisted, unperturbed by the contradiction in his insistence that 'explanation' is 'idiographic' in art history. But given the theoretical formulation we have arrived at here, and at risk of terminological gymnastics, it might be said that art historians do not 'explain' a visual culture; they 'understand' it, and in the frame of this understanding attempt to 'explain' pictures that belong to it (an 'idionomological' direction of inquiry as it were). ('Explanation' of a visual culture would be the task of historical sociology, which Baxandall disliked – disdained – *as* or *in* art history as such on his view of it.) Inversely, art historians do not 'understand' a picture; they 'explain' it, and in the frame of this explanation can 'understand' the visual culture to which it belongs (a 'nomoidiographic' direction of inquiry as it were).[47]

What about *un*reflective pictures or the unthought elements *of* pictures? A second consequence of Baxandall's model follows from the claim that we can reconstruct style-thoughts because they are *thoughts*. In turn, and to return to my beginning, this means that art history is a special history (the history of style-thoughts) in a special history (the history of thought) in a general archaeology (or history as such), including the history of things *not* thought – as studied in cosmology or geology. Still, many concerns of general archaeology about history do not show up in our special history (that is, in art history), above all those purely nomological concerns for causation and correlation that help us explain why historical states of affairs are the states they are in certain regular ways we can express in a 'law'. But the reason *why* the nomological concerns of general archaeology do not show up in idiographic art history (at least as Baxandall conceives it in *Patterns of Intention*) is that style-thoughts are purposive in a certain kind of way – supposedly not conformed to general laws though having 'reflective order', whatever that is, so long as it cannot be described under a general law. This definition buys the coherence of art history as a special history (especially a history distinct from sciences in general archaeology) at the price of a circular self-serving claim. As we have seen, the un-re-enactability of the style-thoughts that supposedly concern the art historian is a matter of historical evidence entailing the method of reconstruction. But it has been converted by art history – or by this particular idea of art history – into matters of essence and theory: the style-thoughts are essentially nonreplicable and in principle can never be explained by appealing to any 'law' that accounts for them as instances of the general history it covers. Each 'good picture' is a law unto itself as it were.

The consequence of Baxandall's model is that art history as special history belongs to a branch of general archaeology – perhaps defines a branch – in which nomological explanation has no place. Indeed, this is its stated starting-point.[48] But as a thesis about style-thought, its own central and unique topic, it must be partly wrong. We only need to recall that a good part of what must be investigated in the history of style is simply *not thought*. Unthought style has causes, but it has no purposes. It has no 'reflective' identity. Its status in art-historical archaeology is defined by this very fact. It is identified as sub- or nonintentional habit, for example, in order to effect historical attributions. In describing the style-thought relinquished in paintings by great literati masters in the Chinese tradition, Cahill had to attribute the paintings. And in some cases the very paintings he cited as displays of the style-thought of a master were later copies – presumably style-thoughts *of the copyists*.[49] Of course, if a copyist's purpose was to copy a past master, one might look through his style-thoughts to those of the master, or alternatively accept the copyist's re-enactment as the master's style-thought. But Baxandall firmly teaches in *Patterns of Intention* that style-thought, especially a great master's, cannot be re-enacted, though perhaps some kind of unreflective duplication is possible in certain cases. And Cahill's treatment of this ubiquitous art-historical problem shows that he knew that a copyist's style – *any* style – needs to be investigated forensically in so-called scientific connoisseurship.[50] Here we require special nomological explanations *framed by* the idiographic history – a special history (of neurophysiological reflexes of the eyes and hands, and perhaps of mechanisms of reproduction and of the physicochemical characteristics of materials and media) in the special history (of style-thought) in the special history (of history of thought) in general archaeology.

Cutting to the chase, the seeming consequence of Baxandall's model that art history is *wholly* idiographic – that nomological explanation has no place in it – must be abandoned. Indeed, Baxandall's model can suggest exactly why and just where art history involves nomological inquiry pursued in other areas of general archaeology, such as the cognitive psychology of pictorial representation and the neurophysiology of visual perception. In the later years of his career (and in his last book) Baxandall increasingly turned to nomologically organized inquiries in visual psychology in order to help reconstruct pictures historically, for example, in describing how we visually scan pictures, focus and fix on certain features, and resolve disparities and distortions. What he called 'patterns of attention' can be enacted again and again just because they are lawful and replicable, even if the pattern of intention cannot be re-enacted because our evidence falls short.[51]

It turns out, then, that the Baxandallian art-historical object – good pictures – is not a special object because it belongs to a branch of general archaeology in which nomological inquiry has no place: though ubiquitous in some quarters of art history, such exceptionalism would be fallacious and self-serving. It is

a special object because it wholly incarnates the whole problematic of general archaeology – from geology to geometry, from cosmology to connoisseurship – as it must be able to comprehend all possible objects historically. The art-historical object is not all possible objects, of course. But it is the only object for which historical explanation of *any possible object* could always be relevant – where we need geology as much as geometry and connoisseurship as much as cosmology. If we can know *this* object historically, it is as if we can know *any* object historically.

Appendix

The following is a very lightly edited transcript of the syllabus for Baxandall's seminar on 'Visual Attention' in the Department of History of Art at the University of California at Berkeley in spring, 1996. I have not striven for consistency in the bibliographical references (Baxandall's specification of the 'readings'); rather, I have preserved Baxandall's citations, which are sufficient for readers to locate the publications. My thanks to Robert Williams for drawing this document to my attention, and to the Department of History of Art at Berkeley for permission to publish a transcription.

History of Art 262. Spring Semester, 1996. Baxandall. ATTENTION TO PICTURES: THREE LEVELS OF INQUIETUDE

1. Preliminary meeting.
2. Introduction: Visual 'Attention'. Reading: Marc-Antoine Laugier, *Manière de bien juger des ouvrages de peinture* (Paris, 1771; repr. Geneva, 1972), 236-47; Glyn Humphreys and Vicki Bruce, *Visual Cognition* (Hove/Hillsdale, NJ, 1989), chapter 5 ('Visual Attention'); and see note on background reading.
3. First level: The ocular registration of pictures. Reading: Alfred L. Yarbus, *Eye Movements and Vision* (New York, 1967), chapter 7 ('Eye Movement During Perception of Complex Objects'); Robert Solso, *Cognition and the Visual Arts* (MIT, 1994), chapter 6 ('Eye Movements and the Perception of Art'); Keith Rayner (ed.), *Eye Movements and Visual Cognition* (New York, 1992), Introduction (1–7) and try papers 4 (Klein et al., 'Orienting of Visual Attention') and 15 (Henderson, 'Visual Attention and Eye Movement Control …').
4. Second level: The construction of representations. Reading: Alan Baddeley, *Human Memory: Theory and Practice* (Needham Heights, MA, 1990), chapter 5 ('Visual Imagery and the Visio-Spatial Sketchpad'); Stephen Palmer and Irvin Rock, 'Rethinking Perceptual Organization', *Psychonomic Bulletin and Review* 1994, 1, 29–55; Anne Treisman, 'Features

and Objects in Visual Processing', in Irvin Rock (ed.), *The Perceptual World* (New York, 1990), 97–110.

5. No meeting.

6. Third level: The higher inquietude. Reading: Roger De Piles, *Cours de peinture* [1708], ed. T. Puttfarken (Paris, 1989), 69–78 ('De tout ensemble'); Jean-Baptiste Dubos, *Refléxions critiques sur la poésie et la peinture* [1719] (Paris, post-1740 eds.), Bk. I, chapter 1; William Hogarth, *Analysis of Beauty*, ed. J. Burke (Oxford, 1955), chapter V ('Of intricacy'); Jonathan Crary, 'Unbinding Vision', *October*, 68, Spring 1994, 21–44.

7. Review and slides.

8. Discussion: What is to be done? (agenda and additional readings will be set in the light of what has emerged in meetings 2–6).

9. Individual project meetings (office).

10. 10-minute statements on provisional projects.

11–14. Office hours.

15. Papers (15–20 pp.) in.

16. Final meeting.

Assumed background reading: Denis Diderot, *Oeuvres esthétiques*, ed. P. Vernière (Paris, 1976), deep-browse, particularly in Salon criticism; James J. Gibson, *The Senses Considered as Perceptual Systems* (Boston, 1966), chapter XII; E.H. Gombrich, *The Image and the Eye* (Oxford, 1982), 40–62 and 244–77; Ian E. Gordon, *Theories of Visual Perception* (New York, 1989), complete; William J. Mitchell, *The Reconfigured Eye* (MIT, 1992), browse for stimulation; Nicholas Pastore, *Selective History of Theories of Visual Perception* (New York, 1971), try chapters 4-6. There are a number of suitable introductions to recent ideas on visual perception in general, for example V. Bruce and P. Green, Visual Perception (1990); N. Wade and M. Swanston, *Introduction to Visual Perception* (1991); (S. Palmer, [forthcoming] [Davis: possibly material released in Stephen E. Palmer, *Vision Science: Photons to Phenomenology* (MIT, 1999)].

Notes

1 Maurice Mandelbaum, *The Anatomy of Historical Knowledge* (Baltimore: Johns Hopkins University Press, 1977), 33–9; Michael Baxandall, *Painting and Experience in Fifteenth-Century Italy: A Primer in the Social History of Pictorial Style* (Oxford: Oxford University Press, 1972), and *Patterns of Intention: On the Historical Explanation of Pictures* (New Haven and London: Yale University Press, 1985).

2 Baxandall, *Patterns of Intention*, 34.

3 Baxandall, *Patterns of Intention*, 32–6.

4 Baxandall, *Patterns of Intention*, 12–15.

5 Baxandall, *Patterns of Intention*, 12.

6 Baxandall, *Patterns of Intention*, 12.

7 Baxandall, *Patterns of Intention*, 12. For the well-known distinction between idiographic (or 'teleological') and nomological (or 'nomothetic') traditions of explanation, Baxandall cited Georg Henrik von Wright's *Explanation and Understanding* (Ithaca, NY: Cornell University Press, 1971), and mentioned several editorial collections of sundry writings by philosophers and historians in which it could be pursued. The 'classic formulation' of the distinction, as Mandelbaum puts it (*Anatomy of Historical Knowledge*, 5), is due to Wilhelm Windelband's address 'Geschichte und Naturwissenschaft' of 1894 (see *Präludien*, 5th ed. [Tübingen: J.C.B. Mohr, 1915], 2:136–60). But the modern discussion has been shaped – virtually determined – by Carl G. Hempel's famous essay 'The Function of General Laws in History' (*Journal of Philosophy*, 39 [1942]: 35–48), reprinted in collections cited by Baxandall and echoed by him.

8 For discussion of Baxandall's professional stature and influence, see John Onians, 'Michael David Kighley Baxandall, 1933–2008', *Proceedings of the British Academy*, 166 (2010): 27–48.

9 Margaret Iversen and Stephen Melville, *Writing Art History: Disciplinary Departures* (Chicago: University of Chicago Press, 2010), 26. In some ways their entire book can be read as an endorsement of Baxandall's approach and what they call his 'complex refusal of "method"'.

10 Erwin Panofsky, 'Art History as a Humanistic Discipline', in Theodore M. Greene (ed.), *The Meaning of the Humanities* (Princeton: Princeton University Press, 1938), 105–6.

11 See Iversen and Melville, *Writing Art History*, 16–26, 46–50, which explicitly contrasts Panofsky's art history with Baxandall's, and Whitney Davis, *A General Theory of Visual Culture* (Princeton: Princeton University Press, 2011), 187–229, which offers an analytic reconstruction of Panofsky's humanistic hermeneutics. Of course, the present-day beholder's 're-creation' of aesthetic experience and artistic activity in the past was a leitmotif of Crocean aesthetics, and English critics – Roger Fry, Herbert Read, I.A. Richards, F.R. Leavis, and others – had developed their own terms and practices for it, which Baxandall certainly knew; a full and fine account of this ramified discourse has been developed by Sam Rose, 'Formalism, Aestheticism, and Art Writing in England' (PhD diss., Courtauld Institute of Art, 2014), from which I have learned a great deal. But Panofsky's version, a specifically historical approach, best suits my purposes here, not least because it generated substantive art-historical propositions that Baxandall engaged.

12 Panofsky, 'Art History as a Humanistic Discipline', 106 n.11.

13 Panofsky, 'Art History as a Humanistic Discipline', 115; for 'reinstatement', see (for example) Panofsky, 'Art History as a Humanistic Discipline', 94. The 'correction' of our aesthetic experience of works of art by the methods of historical iconology – history of style, history of types, and history of culture – was expounded by Panofsky in *Studies in Iconology: Humanistic Themes in the Art of the Renaissance* (Oxford: Oxford University Press, 1939), 3–17, a rewriting of a major earlier statement, 'Zur Problem der Beschreibung und Inhaltsdeutung von Werken der bildenden Kunst', *Logos*, 21 (1932): 103–19; see 'On the Problem of Describing and Interpreting Works of the Visual Arts', trans. Jas Elsner and Katherine Lorenz, *Critical Inquiry*, 38 (2012): 467–82.

14 Baxandall, *Patterns of Intention*, 1–11. Baxandall (138 n.1) credited 'the point that it is only phenomena as covered by descriptions that are susceptible of explanation' to Arthur C. Danto, *Analytical Philosophy of History* (Cambridge: Cambridge University Press, 1965), 218–20. But he made it very much his own; see 'The Language of Art History', *New Literary History*, 10 (1979): 453–65; *Patterns of Intention*, 1–11; and *Words for Pictures: Seven Papers on Renaissance Art and Criticism* (New Haven: Yale University Press, 2003).

15 Iversen and Melville, *Writing Art History*, 25, 36. All the quoted terms are theirs – not Panofsky's or Baxandall's.

16 Baxandall, *Patterns of Intention*, 122.

17 Baxandall, *Patterns of Intention*, 121–3. His examples were Marie Tanner, 'Concordia in Piero della Francesca's Baptism of Christ', *Art Quarterly*, 35 (1972): 1–21, and Marilyn Aronsberg Lavin, *Piero della Francesca's 'Baptism of Christ'* (New Haven: Yale University Press, 1972). He was careful to say that 'neither should be judged on [his] summary' of their conclusions (147 n.6). Still, his 'low iconography' (123) abandoned most of their intricacies.

18 Baxandall, *Patterns of Intention*, 89–93.

19 Baxandall, *Patterns of Intention*, 74–104.

20 Baxandall, *Patterns of Intention*, 103.

21 Baxandall, *Patterns of Intention*, 14.

22 Baxandall, *Patterns of Intention*, 139 n.1. R.G. Collingwood, *The Idea of History*, ed. T.M. Knox (Oxford: Oxford University Press, 1946), quoted here. See now *The Idea of History: With Lectures 1926–1928*, ed. W.J. van der Dussen (Oxford: Clarendon Press, 1993) (this edition clarifies the status and order of the texts collated by Knox in the 1946 edition, but it was not, of course, available to Baxandall) and *The Principles of History*, ed. William H. Dray and W.J. van der Dussen (Oxford: Clarendon Press, 1999). Baxandall cited Rex Martin's exegesis in *Historical Explanation: Re-Enactment and Practical Inference* (Ithaca, NY: Cornell University Press, 1977); see now William H. Dray, *History as Re-Enactment: R. G. Collingwood's Idea of History* (Oxford: Clarendon Press, 1995).

23 R.G. Collingwood, *An Autobiography* (Oxford: Oxford University Press, 1939), 29–30.

24 R.G. Collingwood and J.N.L. Myres, *Roman Britain and the English Settlements* (Oxford: Oxford University Press, 1936), 252–60.

25 Collingwood, *Idea of History*, 282–302; 'all history is the history of thought … and therefore all history is the re-enactment of past thought in the historian's own mind' (Collingwood, *Idea of History*, 215). Collingwood said that he learned the proper method of history in learning how (and why) to identify and excavate an informative site under the tutelage of the archaeologist-historian F.J. Haverfield and his co-workers (see *An Autobiography*, 120–46).

26 Collingwood, *Idea of History*, 296.

27 See Collingwood and Myres, *Roman Britain*, 258–61. Collingwood considered his solution to the question of the post-Roman Celtic Revival – of the 'survival' of Celtic art – to be his most notable achievement as a historian (see Collingwood, *An Autobiography*, 137–45).

28 Baxandall, *Patterns of Intention*, 105–37. In his resistance to Collingwoodian re-enactment, Baxandall shadowed Karl Popper's criticism of Collingwood: a 'problem situation' (a 'logic of situations') can be reconstructed, but it does not need re-enactment, which is sometimes impossible and often superfluous (see *Objective Knowledge: An Evolutionary Approach* [Oxford: Clarendon Press, 1972], 186–90). Still, it seems to me that Baxandall's model of question-Brief and picture-answer is closer to Colllingwood's model of thought as 'question and answer' than to Popper's logical-falsificationist 'conjectures and refutations'.

29 Baxandall, *Patterns of Intention*, 139 n.1.

30 R.G. Collingwood, *The Principles of Art* (Oxford: Oxford University Press, 1938), esp. 157–60; the quotation is from *The Idea of History*, 313. In earlier writing, however, and in line with a broad swathe of English critics of art and literature, Collingwood had recommended a present-day 're-expressing' of artistic activity in the past ('Aesthetic', in *The Mind*, ed. R.J.S. MacDowall [London: Longmans, 1927], 214–44).

31 Svetlana Alpers and Michael Baxandall, *Tiepolo and the Pictorial Intelligence* (New Haven and London: Yale University Press, 1994); compare Thomas Crow, *The Intelligence of Art* (Chapel Hill: University of North Carolina Press, 1999).

32 Baxandall, *Patterns of Intention*, 38–40.

33 See Davis, *A General Theory of Visual Culture*, 196–203.

34 Baxandall, *Patterns of Intention*, 142 n.1.

35 See James Cahill, 'Style as Idea in Ming Ch'ing Painting', in Maurice Meisner and Rhoads Murphey (eds.), *The Mozartian Historian: Essays on the Works of Joseph R. Levenson* (Berkeley: University of California Press), 137–56 (quotations from 152, 149); *Chinese Painting* (New York: Skira, 1977), 5–6. In turn Cahill credited the arguments of his teacher Max Loehr in 'The Question of Individualism in Chinese Art', *Journal of the History of Ideas*, 22 (1961): 147–58. To be sure, literati painting was a 'humanistic discipline' – an 'art blended with learning', a 'painting about painting' whose 'content was thought' (Max Loehr, 'Some Fundamental Issues in the Study of Chinese Painting', *Journal of the Asia Society*, 23 [1964]: 193). Perhaps, then, the question of non-painterly 'thought' in painting cannot be ducked entirely.

36 In the classic statement of Euclid's proof of the fifth theorem in the commentary by Proclus as edited by Thomas Taylor, there are 10 'sentences', though many of them embed two or more operations – at least a couple of dozen 'thought-emes' in all, but not much more (*The Philosophical and Mathematical Commentaries of Proclus on the First Book of Euclid's Elements*, ed. Thomas Taylor [London, 1798], 2:53). Some might call the entire proof a 'meme'.

37 Iversen and Melville, *Writing Art History*, 34.

38 Baxandall, *Patterns of Intention*, 34.

39 Baxandall, *Patterns of Intention*, 14.

40 Some rhetorics of 'close looking' and 'object-centered' writing in art history miss this boat – maybe the only ferry there is. For lively commentary, see James Elkins, *Our Beautiful, Dry, and Distant Texts: Art History as Writing* (University Park: Pennsylvania State University Press, 1997), and *On Pictures and the Words that Fail Them* (Cambridge: Cambridge University Press, 1998).

41 For Baxandall's sources, see especially Bryan R. Wilson (ed.), *Rationality* (Oxford: Oxford University Press, 1970), acknowledged by Baxandall (146 n.2) in the context of distinguishing 'participant's' and 'observer's' knowledge.

42 Hans Georg Gadamer, *Truth and Method*, rev. ed., trans. Joel Weinsheimer and Donald G. Marshall (New York: Crossroad), 333–41, 467–9; to be sure, Gadamer worried that Collingwood tended toward 'merely recreating' of the past (or 'mere reconstruction') without a hermeneutic dimension (374).

43 Panofsky, 'Art History as a Humanistic Discipline', 109. Panofsky later recanted this particular claim, likening it to 'astrology' as distinct from 'astrography'.

44 Needless to say, I reconstruct the view of some art historians, such as Baxandall, about art history. Other art historians – even some 'social' art historians ostensibly indebted to Baxandall's work – would seem to be committed to strong re-enactment in art history as a theatre of reanimation. See Whitney Davis, *Replications: Archaeology, Art History, Psychoanalysis* (University Park: Pennsylvania State University Press, 1996).

45 Some art historians would deny that the latter is possible; all pictures and visual artworks supposedly belong to a visual culture. But it might be argued that pictures and visual artworks must 'succeed' to visual culture (as I have put it), that they remain visible outside it, and that they can be used in other visual cultures, though having different aspects there (Davis, *A General Theory of Visual Culture*, 322–41).

46 Baxandall, *Patterns of Intention*, 139 n.1.

47 Baxandall differentiated between 'internal' and 'external' understanding, that is, the kind of awareness that 'participants' in a culture have as distinct from 'observers' of it (*Patterns of Intention*, 109–11). On this view, it is the participants who understand their pictures historically – how they are to be used, what they 'mean', in their tradition of making them. Historian-observers 'explain' this understanding by understanding the visual culture – a horizon the participants couldn't 'explain'.

48 Baxandall, *Patterns of Intention*, 12–15.

49 For example, 'the paintings attributed to Li [Ch'eng] himself all appear to be by lesser artists of later ages, but a few of them retain some trace of that stupendous creative power' (Cahill, *Chinese Painting*, 32; he illustrates a copy of Li's *Solitary Temple in the Mountains*, painted in the mid-tenth century, that is 'probably eleventh century in actual date' according to his attribution).

50 For discussion of this procedure (devised by Giovanni Morelli and his followers) and its psychological assumptions about habit, intention, and so on, see Davis, *A General Theory of Visual Culture*, 75–119.

51 Michael Baxandall, 'Fixation and Distraction: The Nail in Braque's *Violin and Pitcher* (1910)', in John Onians (ed.), *Sight and Insight: Essays on Art and Culture in Honour of E. H. Gombrich at 85*, (London: Phaidon, 1994), 398–415; *Words for Pictures*, esp. 136–7. In the appendix to this chapter, I publish a transcript of the plan for one of Baxandall's seminars on this topic, taught in 1996; it well exemplifies his synthesis of 'classic' (eighteenth-century) considerations of (attending to) paintings and later twentieth-century perspectives in perceptual and cognitive psychology. A helpful exposition of this dimension of Baxandall's work can be found in John Onians, *Neuroarthistory: From Aristotle and Pliny to Baxandall and Zeki* (New Haven and London: Yale University Press, 2007), 178–88.

Inferential Criticism and *Kunstwissenschaft*

Robert Williams

Finding himself celebrated as a leading representative of forward-looking art history at a time when – so it seemed – the discipline was in the throes of epochal self-transformation, Michael Baxandall devoted two unusually polemical essays to clarifying his approach. Their combative tone struck many of his admirers as disappointing, even reactionary: the author of *Painting and Experience in Fifteenth-Century Italy* now seemed to undermine the possibility of the social history of art that his book had done so much to encourage. The first essay, 'The Language of Art History', of 1979, begins by ridiculing the methodological self-searching and dogmatic posturing of his colleagues, then provides a drily pointed explanation of his own concerns: 'The issues I most worry about in art history fall into two main groups', he writes. 'One group is connected with the pretty gratuitous act of matching language with the visual interest of works of art … The other … is connected with how one can and cannot state the relationships between the character of works of art and their historical circumstances.'[1] In the remainder of the essay, he goes on to offer his response to the challenges posed by these issues, laying out the analysis of art historical language – its demonstrative quality or 'ostensivity' and its indirectness or 'obliqueness'[2] – and outlining the basic premises of the 'inferential criticism' that he would elaborate at greater length a few years later in *Patterns of Intention*.

Despite the stubbornly commonplace association of Baxandall with the social history of art, it is inferential criticism that remains his principal contribution to art-historical method. He liked to disclaim any special authority for his own practice or its results,[3] even to insist that he was not an art historian at all.[4] He had decidedly mixed feelings about what he called the 'academicizing-up' of the discipline,[5] the way in which, in the wake of the Second World War and the influx of émigré scholars from German-speaking lands, the English traditions of antiquarianism and connoisseurship had been overlaid with a

highly developed methodological structure – *Kunstwissenschaft* – that they were ill-equipped to support.[6] He would teasingly describe himself as 'Roger Fry trying to do a Warburg',[7] or as wanting 'to do a Leavis on art'.[8] Yet his approach was carefully meditated and profoundly original, a contribution to *Kunstwissenschaft* while also a critique of it, and it may still serve as a point of departure for productive reflection upon the essential challenges of our field.

Language

Baxandall's effort in 'The Language of Art History' to redirect the discussion of art historical method to the centrality of language extends the project begun in his earliest work, the essays on the writings about art by Renaissance humanists that culminated in the early 1970s, not in *Painting and Experience* but in *Giotto and the Orators*. In these studies, language is the primary object of interest, even if the purpose of attending to it so carefully is ultimately to enable us to engage works of art more insightfully. Art historians in the tradition of Warburg and Panofsky had customarily made use of literary sources to enhance their understanding and interpretation of images, usually by establishing a connection between the content of the texts and the representational content of the images. In *Gothic Architecture and Scholasticism*, of 1951, Panofsky had tried to do something more subtle and ambitious: to relate the *form* of scholastic argument to the *formal* logic of Gothic architectural style.[9] In *Giotto and the Orators*, Baxandall analyzes the way in which the rigorously classicizing linguistic and literary forms cultivated by the early Renaissance humanists led them to an emphasis on pictorial values readily susceptible to articulation in those terms, whether motifs frequently remarked in classical and Byzantine ekphrases such as are found in the pictures of Pisanello, or a notion of composition based on the model of Ciceronian sentence structure advocated in Alberti's *De Pictura*.

The innovative force of Baxandall's approach lies in the sheer perversity of undertaking an art-historical inquiry not by direct engagement with the works themselves, but indirectly, through the language used by period writers.[10] Such a method can only be construed as a deliberate assault on the English tradition of connoisseurship as represented, say, by John Pope-Hennessy, under whom he had worked at the Victoria and Albert Museum only a few years before. Its effect, as has often been noted, is to defamiliarize the works we take for granted, to force us to reckon with a complex world structured by mental habits unlike our own.[11] On a deeper level, however, it also undermines our confidence in any assumptions that we, as art historians, may make about pictures based upon our direct experience of them. Period language does not necessarily offer a more accurate or satisfactory account of the objects, but it does expose the limitations of our

own terms and categories. Rather than allowing us to superimpose a familiar analytic vocabulary that assimilates the objects to our interests, Baxandall's approach demands that we recognize the historically contingent nature of those interests. The distancing and defamiliarizing effect is thus intended to have a constructive function: to establish a new, more self-conscious, more critically circumspect strategy for the historical interpretation of images.

Although Baxandall's preoccupation with language in *Giotto and the Orators* seems to be a response to the specific historical circumstances of the early fifteenth century and the author's commitment, as an historian, to render those circumstances as accurately as possible, it is also motivated by the conviction that language is crucial to our engagement with images of all kinds. In the book's preface, he says that he has 'tried to identify a linguistic component in visual taste: that is, to show that the grammar and rhetoric of a language may substantially affect our manner of describing and, then, of attending to pictures and some other visual experiences'.[12] The production and consumption of art – which includes our activity as critics and historians – are inextricably embedded in language: language is not just the essential medium through which the results of art-historical inquiry are communicated; it is also an essential object of such inquiry. This insight receives definitive formulation in the first sentence of *Patterns of Intention*: 'We do not explain pictures: we explain remarks about pictures – or rather, we explain pictures only in so far as we have considered them under some verbal description or specification.'[13]

By the time he wrote *Giotto and the Orators*, Baxandall's reading in anthropological linguistics had led him to a well-informed and critically nuanced position in the debate over linguistic relativism.[14] His sensitivity to the role of language had begun to develop years earlier, at Cambridge, nurtured by the teaching of F.R. Leavis, but also by the pervasive presence of the linguistic or 'plain language' philosophy derived from Wittgenstein.[15] Baxandall disavowed any direct study of Wittgenstein, saying that most of what he learned about him came through the 'osmotic' absorption of ideas that were 'in the air', and, somewhat later, through conversation with Michael Podro.[16] He must have known that concepts like 'ostensivity' were in widespread use among Wittgenstein's followers, yet he expressed surprise when, decades later, Allan Langdale pointed out to him that the phrase 'meaning is use', which appears in *Giotto and the Orators*, is strikingly similar to a passage in the *Philosophical Investigations*: 'the meaning of a word is in its use in the language'.[17] In fact, Baxandall would not have had to read very much Wittgenstein at all in order to pick up some fundamental points: the philosopher's comparison of words that do different kinds of work to the different tools one might find in a toolbox, in the opening pages of *Philosophical Investigations*, would seem to be the ultimate source for the categorization of descriptive terms in 'The Language of Art History' and the

beginning of *Patterns of Intention*.[18] And one might argue that Baxandall's acute sense of the limits of language, and of the need for a rigorously critical approach to it, is in perfect sympathy with one of Wittgenstein's most well-known statements – further on in the *Philosophical Investigations* – that 'philosophy is a battle against the bewitchment of our intelligence by means of [our] language'.[19]

Even more explicitly than does *Giotto and the Orators*, the 'Language of Art History' essay emphasizes the fact that, for Baxandall, language provides the basis of any specifically *historical* engagement with art. The history of art has its origin in a particular category of words we use when, as critics, we describe an object: 'Words inferential as to cause are the main vehicle of demonstrative precision in art criticism.'[20] He then goes on to explain:

> Inferring causes I take to entail being historical: equally one cannot conceive of either history or inference being accurate without critical acuteness. Clearly history and criticism are different inflections of attention – inquiry against judgment, then as against now, how as against what, and so on – but I have no purpose in drawing a line between them, and without a purpose it is hard to know where the line is to be drawn.[21]

Insisting upon the interdependence of criticism and historical inquiry, he sees the latter as a special category of the former. Inferential criticism 'entails the imaginative reconstruction of causes, particularly voluntary causes or intentions within situations'.[22] Inferring causes is a natural tendency of the mind:

> Just as we all ambulate, we all infer causes and intentions: it is a disposition much too deep and diffused in us to be excised … What we are going to do anyway, one could say, we really are entitled to enjoy trying to do as well as we can, while well aware we cannot do it completely.[23]

In the end it is not the period vintage of the terms used that constitutes the historical nature of Baxandall's approach but their critical exercise.[24]

Even more fundamental to Baxandall's method than the emphasis on language – and thus even more significant than its relation to the 'linguistic turn' – is its strategic indirectness. Challenging the traditional assumption that our access to images is somehow self-evidently immediate and unproblematic, it offers itself as a *via negativa*, necessitated by concern with the validity of descriptive assertions and interpretative claims, as well as reverence for that ultimate object beyond the reach of our verbal tools. While emphasizing the provisional, empirical – 'sub-theoretical'[25] – nature of his approach, he thus does aspire to a kind of procedural rigor and purity.[26] And in as much as tactical indirectness is also a feature of Wittgenstein's thought and of the work of those philosophers influenced by him, we are justified in thinking of Baxandall as the Wittgenstein of art history.

Society

Painting and Experience puts the preoccupation with language in a larger context. The third and final chapter, which deals with the language of art criticism and rehearses some material from the earlier book, is preceded by a first chapter, which discusses the economic conditions within which artistic activity occurred in fifteenth-century Italy, primarily the relationship between painter and patron. The second and longest chapter, 'The Period Eye', offers examples of the ways in which pictures register the mental and social skills of their intended viewers. Language is thus presented last but also as the most nuanced of the social conditions with which any art historian must contend. Again, the most noticeable effect of this strategy is one of distancing and defamiliarizing, but it also builds upon the constructive model advanced in *Giotto and the Orators*. The Warburgian method of adducing period texts to help with interpretation is here extended in virtuoso fashion to a whole new range of sources: contracts, letters, sermons, arithmetic textbooks, and treatises on dancing. This expanded repertoire also goes beyond the emphasis of then recent work on patronage by scholars such as Francis Haskell and D.S. Chambers, to explore the more pervasive and deeply embedded assumptions, values, and practices that structure culture: it might well be understood to point beyond 'social' history to 'cultural' history, and even to provide the basis for a sociological or anthropological approach to art, as was soon recognized by Pierre Bourdieu and Clifford Geertz.[27] This wide-ranging yet selective use of literary evidence would find further virtuoso elaboration in the chapter on Chardin's *Lady Taking Tea* in *Patterns of Intention* and in the book *Shadows and Enlightenment*, in which Baxandall deliberately dismisses the kinds of period writing one might most naturally use to document artistic intentions and turns instead to more remote sources in science and philosophy.

Baxandall seems to have been genuinely surprised and puzzled by the reaction to *Painting and Experience*. The notion of 'period eye', like that of 'cognitive style', had been based upon his reading of recent anthropology,[28] but older scholars such as Gombrich saw it as a dangerous reversion to collectivism and the idea of zeitgeist, while a leading younger scholar, T.J. Clark, found the book altogether insufficiently pointed in its analysis of social realities.[29] Baxandall later admitted that part of his intention had been to irritate people: he had succeeded in doing so, 'but not always the people I intended to irritate'.[30] He probably did not expect to irritate Gombrich or forward-looking younger scholars like Clark: he probably expected – and wanted – to irritate Pope-Hennessy and colleagues at the Courtauld Institute.[31] He was thus surprised by how readily art historians 'picked it up'.[32] By the time he wrote 'The Language of Art History', however, he was certainly targeting social historians of art: not Clark specifically, perhaps, so much as other ambitious agenda-setters like Kurt Forster, whom he mentions by name.

He later admitted that though 'very bad tempered', it was 'an enjoyable essay to write'.[33] Indeed, he confessed that 'I've always written to irritate partly, sometimes specific people sometimes not'.[34]

The second of the polemical statements mentioned at the beginning of this essay is 'Art, Society, and the Bouguer Principle', published in 1985. Baxandall describes it as 'the account of a failure', an article about an article that he never wrote, in which he was to have offered a social-historical interpretation of Ambrogio Lorenzetti's frescoes in the Sala dei Nove of the Palazzo Pubblico in Siena. The frescoes had seemed to provide an ideal opportunity to show a work of art 'directly and explicitly addressing society'. He began, he says, by making lists of those features of the picture that attracted his attention: they included the ring of dancing girls in the foreground of *The Effects of Good Government*. Then he set about studying the history and society of Siena, looking for circumstances that might help to explain those features. He presents a rapid overview of the points he planned to make, sketching out the kind of essay that any young social historian of art would have been happy to publish: the dancing girls, for example, would have been related to 'the city's urgent need for social cohesion'.[35] He was prevented from finishing the article by a number of misgivings, however, of which the most important was the 'terribly simple fact' that art and society are 'analytical concepts from two different kinds of categorization of human experience'.[36] Each is a construct and refers to a system, and 'the systems are not compatible'; art and society are 'unhomologous systematic constructions put upon interpenetrating subject matters'.[37] In order to relate them as social historians of art customarily do, we shift the sense in which we use the words, we do not use them properly or consistently.

Asked whether he felt he must 'choose' between art and society, he said yes: art has its own sources of interest: 'Art points to a class of objects that take their meaning from their structure and organization; to treat Lorenzetti's picture for an unstructured collection of represented objects would be to ignore the kinds of organization that make it art and the special kind of information art carries.'[38] He introduces the term 'pictorialization' to explain the particular challenge he feels he must address: 'By pictorialization I mean the deployment of the resources of the medium – the ordering of color, tone, edge, and figure – not just the bare registration of a subject matter.'[39] This concept allows him to avoid any dependence on the old notion that 'formal' concerns are somehow essentially distinct from representation, the syntactic from the semantic dimensions of painting.

Baxandall's belief that art of the highest quality provided the richest material, not only for the critic but also for the historian, was another effect of the teaching of Leavis:

> I mean it's not that I disapprove of attention to popular art or that sort of thing but I suppose what I do believe is that superior art at any rate – and one of the things that I got from Leavis is the notion that one cannot exclude evaluation from art criticism or art history – that high quality things are richer historical documents.[40]

The 'best organized' works of art make 'the best historical documents' because 'they carry more information ... Low art is obviously informative, but I think it's mainly informative in the light it throws on high art.'[41] Such convictions also put him at odds with developing trends in the social history of art, but they were essential to the mutually enhancing effect of the 'critical' and 'historical' operations necessary for inferential criticism. He had already expressed them insistently in *The Limewood Sculptors of Renaissance Germany,*[42] but put the point most forcefully in *Patterns of Intention*: 'That positing an intentional unity and cogency entails a value judgement and hypothesizes a high degree of organization in the actor and the object will not worry us. Only superior paintings will sustain explanation of the kind we are attempting: inferior paintings are impenetrable.'[43]

The 'Bouguer Principle' was Baxandall's contribution to a conference and special issue of the journal *Representations* entitled 'Art and Society: Must We Choose?' The journal was a principal site for the articulation and development of what came to be known as the 'new historicism', a phenomenon with which Baxandall later admitted to having little sympathy, and from which he attempted to distinguish his own approach as follows:

> I'm interested in using art as a historical document and using knowledge of historical circumstances to improve one's reading of the art; these two things seem to me to go together. But I don't feel that what one does is purely, historically relative. I think of myself as trying to find out what really happened.[44]

Associating new historicism with relativism, he offers the same critique of it as of social history.[45] Although he does not say so explicitly, the new historicist emphasis on deconstructing the opposition between 'text' and 'context', historical foreground and background, must have struck him as another effort to undermine the specific interest of art.[46]

Visuality

Despite the ways in which his early work had problematized our engagement with it, visual experience remained the focus of Baxandall's attention throughout his career. Even in *Painting and Experience* he had written: 'The social practices most immediately relevant to the perception of art are visual practices.'[47] In 'The Language of Art History', preoccupied as it is with the

relevant linguistic problems, he could still say 'The specific interest of the visual arts is visual'.[48] He recognized that his interest in the psychology of vision had gotten stronger over the years,[49] and he justified his desire to 'to get back to the visual' as an effort to 'balance' the overemphasis on social context that his own early work might be thought to have inspired and that had since become commonplace in art history.[50] Inferential criticism had always involved working within a 'triangle of re-enactment', carefully playing the description and historical account of the object off against the object itself so that 'concepts and object reciprocally sharpen each other'.[51] When asked, toward the end of his career, how much of our response to pictures is 'physiologically determined' and thus 'independent of culture', he offered an estimate of 97 per cent: 'I don't think that looking at pictures is a purely cultural thing.'[52]

The attempt to recover those aspects of 'the visual' that seem to lie beyond the reach of language and to retrieve them for art history should be seen as another kind of virtuoso performance. The results include two important books, produced – as were *Giotto and the Orators* and *Painting and Experience* – almost simultaneously: *Tiepolo and the Pictorial Intelligence*, jointly authored with Svetlana Alpers and published in 1994, and *Shadows and Enlightenment*, of 1995. While both discuss eighteenth-century painting, they complement one another more than they overlap. *Tiepolo* offers a refreshing treatment of monumental decoration and the complex problems of visual organization that it involves. There is little discussion of optical theory; the emphasis is rather on the artist's practical intelligence in dealing with problems such as the coordination of natural and fictive lighting. It represents a sustained effort to address 'the absolutely pictorial'[53] and to model a kind of art-historical inquiry based upon the primacy of pictorial considerations.[54] To anyone looking for some explicit discussion of cultural context, the most interesting passages are likely to be the brief but suggestive remarks about the relation of Tiepolo's painting to music.[55]

Shadows and Enlightenment, on the other hand, is a study of the interest in shadows and related visual phenomena among eighteenth-century philosophers, scientists, and artists. Much of the book is taken up with unpacking the relevant aspects of eighteenth-century optical theory, as well as with explaining how contemporary science approaches the same phenomena: part of its project is to fashion an analytical vocabulary that can, in theory, be applied to other images than are addressed in the book itself. Evidence for the interest in shadow is drawn from a range of sources: one of the figures most often cited is Charles-Nicolas Cochin, a friend of Chardin's, whom Baxandall characterizes as an 'obsessional observer of shadow'.[56] When it comes to painting, however, the author's interest is concentrated on what turns out to be a very small group of 'contemplative painters',[57] representative of an 'optically self-conscious new painting':[58] the whole argument comes to a

climax in, and hinges upon, a discussion of a single picture by Chardin.[59] There is surprisingly little engagement with the metaphorical or expressive quality of shadow, even of how it how it functions in Chardin's visual poetics as a whole.[60] One finds oneself wondering whether Baxandall's approach, with its 'obsessional' interest in shadows, has not begun to yield diminishing returns. Fascinating and revealing as it is, the selectivity of the emphasis seems more like a function of the author's own interests and preoccupations than of their relevance to the artistic culture of the eighteenth century.

In the essay on Piero della Francesca's *Resurrection* in *Words for Pictures*, published in 2003, Baxandall returns to the work of an artist whose pictorial intelligence had always attracted and challenged him. His account is marvellously sensitive to the expressive content of the picture: he observes that with one foot propped on the edge of the sarcophagus, the figure of Christ seems to combine both a standing pose, as would be appropriate in a Resurrection, and a seated one, evocative rather of a Last Judgment, and links the pink robe to the biblical image of the Lord in the winepress trampling out the grapes of wrath.[61]

It also addresses the visual peculiarities that seem to require attention, such as the fact that one of the guards is apparently missing the lower half of his body. Yet the emphasis that Baxandall places on the relationship between the head of Christ and the banner beside it – which he characterizes as 'distracting'[62] – seems arbitrary: the two forms can just as easily be seen as mutually enhancing, as combining to create a unity-in-complementarity, a single motif or pictorial event emblematic of defeat over death. Following Baxandall's approach to this passage, one might as readily maintain that in Botticelli's *Birth of Venus*, the left side of the goddess's body, with its cascading hair, is a distraction from the right.

When one remembers, moreover, that in his treatment of Braque's still-life, *Violin and Pitcher*, in an essay published in 1994,[63] he had attempted to sustain a similar argument about the essential role of peripheral vision by drawing attention to a zig-zag motif – strikingly like Piero's banner – on the left side of the composition,[64] one cannot help but feel that he is again projecting an interpretation onto the images that has more to do with his own visual habits and preoccupations than with the objective importance of the feature in question, and that his determination to tarry with the formal properties of pictures has begun to expose its methodological limitations.[65]

Baxandall's claim that 'the specific interest of the visual arts is visual' is offered as if self-evident, and may not give pause to many art-historians, even today, yet it is open – urgently so – to contestation. The very designation 'visual arts', after all, can only have the effect of directing our attention to specifically visual qualities. There is nothing natural or inevitable about the category 'visual arts': it is an historical product designed to validate and reproduce a certain limited kind of curiosity and engagement. Providing what

seems to be an objective, scientific way of thinking about art by referring it to the natural sensory modality we use to perceive it, the category 'visual art' might as easily be seen as a pseudo-scientific objectification that substitutes the incidental for the essential. If a picture is 'the deposit of a social relationship',[66] or a richly deliberated act of meaning making, or a distinctively complex and valuable kind of cultural work, then its visual qualities are far from the most interesting things about it, and far from being the necessary ground of our relation to it.

A less determined investment in visuality might have made it easier for Baxandall to reconcile art and society without absorbing art completely into society or dissolving it as a source of independent interest; it might have made it possible for him to establish their connection on the basis of something like signification or representation. As it is, his conviction that the primary interest of the visual arts lies in their specifically visual properties, the ways in which they say what can only be said with the tools uniquely available to them, links him to an old-fashioned form of modernism, a critical tradition extending back from Michael Fried to Clement Greenberg to Fry and even to Zola. The boldly innovative gesture of his early work was to distance himself from that tradition, yet in his later years he succumbed to its gravitational pull. He is not the only radical art historian who emerged in the 1970s to do so.[67]

Conclusion

The tactical indirectness observed in *Giotto and the Orators* is a pervasive feature of Baxandall's scholarship. In *Patterns of Intention*, for instance, he compares his approach to that of astronomers who train their telescopes 'off' a star in order to see it better.[68] It also manifests itself in a preoccupation with peripheral vision in Chardin's *Lady Taking Tea*, Braque's *Violin and Pitcher*, and Piero's *Resurrection*. A similar principle is evident in his insistence that shadows are fundamentally constitutive of optical experience, and in the way in which, in his late work, the focus of his interest shifted from 'attention' to 'inattention', and then – because even inattention proved too limiting – to 'restlessness'. The working title of his last project, never completed, was *Three Levels of Inquietude*.[69] This trajectory of increasing attenuation and rarefaction should be seen as another virtuoso performance, another instance of his *via negativa*, in which something fundamental to his methodological orientation becomes perceptible – even as it withdraws from realization.

Baxandall's personal perspective on his trajectory emerges in a poignant way in the interviews he gave toward the end of his career. A recurrent motif is his sense of the necessity of keeping his distance from the various

personalities and forces he encountered: Sedlmayr,[70] Elias,[71] linguistic relativism,[72] the social history of art,[73] psychoanalysis, semiotics, film studies, and cognitive science.[74] He speaks repeatedly of the effort involved in 'trying to keep my independence',[75] even at the price of being regarded as a 'butterfly'.[76] One senses that his mode of being involved an elaborately managed tension between receptivity and detachment, and that the result was an isolation no less uncomfortable for being the product of sovereign intellectual self-confidence. It seems relevant to his own experience, too, that the epigraph to his chapter on Picasso's *Portrait of Kahnweiler* in *Patterns of Intention* is the artist's remark to his colleague Metzinger: 'Don't talk to the driver!'[77]

Baxandall's tactical indirectness may be a symptom of methodological rigor, but it is certainly not 'scientific' in Gombrich's sense: he often seems to distance himself from any semblance of *Kunstwissenschaft*, especially when, as at the end of *Patterns of Intention*, he insists that the approach he has just spent the entire book elaborating 'has no authority', that inferential criticism is 'scientific' precisely by virtue of the fact that its results do not depend for validation on any special expertise, and that art history begins and ends in civil conversation.[78] Gombrich's effort to ground the discussion of art in perceptual theory, to establish the significance of art in terms of its relation to scientific knowledge, may strike us as misguided, or at least overstated, yet we may be able to recognize that it also exposed the *critical* content of art, and that his approach might thus be reclaimed for our purposes, even if they differ from his. So it is with Baxandall. Those of us who cannot follow him in his commitment to the visual, who have reservations about his preoccupation with the 'absolutely pictorial', might yet be able to see them as grounded in a recognition of the fact that the technical challenges faced by artists were an important part of their work, that it is not the intrinsic visuality of pictures that grounds their interest but the work – the human labour – that the resulting product makes visible.

As with Gombrich, the ultimate value of Baxandall's example may be its rigor, even if rigor of a different kind: for all that it is unlike earlier *Kunstwissenschaft*, it yet offers to re-establish and to model the systematic study of art in a new, more sophisticated, more satisfying way. If Gombrich's notion of rigor was shaped by Popper, and Baxandall's, even at a remove, by Wittgenstein, then the paradigm shift that is Baxandall's achievement might be described as the transition from a Popperian to a Wittgensteinian model. Even as it avoids the usual posturing of scientific discourse, inferential criticism attempts to contend with the groundlessness of art history as a form of knowledge. As long as that groundlessness continues to concern us, we are likely to keep re-reading Baxandall.

Notes

1 Michael Baxandall, 'The Language of Art History', *New Literary History*, 11 (1979) 455.

2 Baxandall, 'The Language of Art History', 454.

3 See especially the last pages of Michael Baxandall, *Patterns of Intention: On the Historical Explanation of Pictures* (New Haven: Yale University Press, 1985), 135–7.

4 A. Langdale, 'Interview with Michael Baxandall', *Journal of Art Historiography*, 2009 (http://arthistoriography.wordpress.com/number-1-december-2009/1-AL/1; hereafter Langdale, 'Interview'), 21: 'I still think of what I do and what a lot of the art historians I like do as being art criticism rather than art history'; and 'I don't see myself quite as an art historian. I see myself as a cultural historian who works with visual things' (30). See also 'Substance, Sensation, and Perception: Michael Baxandall interviewed by Richard Cándida Smith', Getty Research Institute, 1998 (http://archives.getty.edu:30008/getty_images/digitalresources/ spcoll/gri_940109_baxandall_transcript.pdf; hereafter Smith, 'Interview'): 'I'm not a methodical worker' (65–6); 'I liked to think of myself as being outside of art history' (128); and 'I suppose what I've done is tried to keep my independence and my amateur status' (134). A. Rifkin, 'Brief Encounters of the Cultural Kind', *Art History*, 9 (1986): esp. 275, takes Baxandall to task for the 'characteristic tendency to refuse any kind of canonical theoretical debate, while none the less mapping out a sufficiently theoretical basis for his own enterprise'; and in another place gives emphasis to 'the repeated resistance to canonicity that lies at the heart' of Baxandall's writing: 'Editor's Introduction', in A. Rifkin (ed.), *About Michael Baxandall* (Oxford: Blackwell, 1999), 2. M.A. Holly, 'Pattern in the Shadows: Attention in/to the Writings of Michael Baxandall', in Rifkin (ed.), *About Michael Baxandall*, 5–15, esp. 5 and n.1, invokes Baxandall's characterization of his own project, in *Patterns of Intention*, as 'sub-theoretical;' while M. Iversen and S. Melville, *Writing Art History: Disciplinary Departures* (Chicago: University of Chicago Press, 2010), 26–37, esp. 26, emphasize Baxandall's 'complex refusal of 'method' as part of a larger argument for the rejection of 'method' in art-historical practice.

5 Baxandall, 'The Language of Art History', 454.

6 See esp. Langdale, 'Interview', 20–21; Smith, 'Interview', 110–11.

7 Smith, 'Interview',127: 'I would dramatize myself as "Roger Fry trying to do a Warburg".' Also: 'I want to do Roger Fry over again after nature', quoted in M. Nesbit, 'Last Words (Rilke, Wittgenstein) (Duchamp)', in Rifkin (ed.), *About Michael Baxandall*, 84; a remark that he later said was a 'joke': H.U. Obrist, 'Interview with Michael Baxandall', *RES* (not to be confused with *Res*) 2, (2008): 45 (hereafter Obrist, 'Interview').

8 Langdale, 'Interview', 7: 'I wanted to do a Leavis on art and Sedlmayr honestly.' Also: 'I mean I still think of myself as doing Roger Fry, you know, in a different way' (19); and 'I suppose I come back to the sense of trying to do Leavis and Roger Fry – who are an odd pair in the first instance – with enrichment from central Europe, rather than trying to do central Europe in England' (21).

9 Langdale, 'Interview', 4; See also A. Langdale, 'Aspects of the Critical Reception
 and Intellectual History of Baxandall's Concept of the Period Eye', in Rifkin
 (ed.), *About Michael Baxandall*, 24–5; also A. Langdale, 'Linguistic Theories and
 Intellectual History in Michael Baxandall's *Giotto and the Orators*', *Journal of Art
 Historiography*, 1 (2009): esp. 2, 9–12. The relation of Baxandall to Panofsky is
 also discussed by Iversen and Melville, *Writing Art History*, and W. Davis, 'Art
 History, Re-Enactment, and the Idiographic Stance', in this volume.

10 The counter-intuitive nature of this strategy, its relation to the 'linguistic turn', in
 the humanities, and its exemplification of a 'paradigm shift' in the history of art
 are emphasized in Langdale, 'Linguistic Theories', esp. 1–3.

11 See, for instance, the excellent review by S. Campbell of *Words for Pictures: Seven
 Papers on Renaissance Art and Criticism*, *Art Bulletin*, 88 (2006): 178–81, esp. 179.

12 Michael Baxandall, *Giotto and the Orators: Humanist Observers of Painting in Italy
 and the Discovery of Pictorial Composition* (Oxford: Clarendon Press, 1971), vii.

13 Baxandall, *Patterns of Intention*, 1.

14 Baxandall, *Giotto and the Orators*, esp. 47–8; Langdale, 'Interview', 3, 24–5;
 Smith, 'Interview', 64–7; Obrist, 'Interview', 43–4; and esp. Langdale, 'Linguistic
 Theories'.

15 On the influence of Leavis, see Langdale, 'Interview', 13; Smith, 'Interview', 19;
 and esp. J. Lubbock, 'To Do a Leavis on Visual Art', in this volume.

16 Langdale, 'Interview', 2: 'I've never really sat down and read Wittgenstein … I've
 read odd bits of Wittgenstein, very vaguely.' On the conversations with Podro,
 Langdale, 'Interview', 9–10. Baxandall later told Smith that he had read no
 Wittgenstein at all (Smith, 'Interview', 18): 'I'd certainly never read him.' In both
 cases, however, he refused to deny the possibility of unconscious influence.

17 Langdale, 'Interview', 3. He also told both Langdale (3) and Smith ('Interview',
 67) that when *Giotto and the Orators* was described as 'structuralist', he had to
 look up what the word meant.

18 Ludwig Wittgenstein, *Philosophical Investigations* (Oxford: Blackwell, 1967), no. 11
 ff. (pp. 6–6e ff.); Baxandall, 'Language of Art History', 455–9; Baxandall, *Patterns
 of Intention*, 5–10, 25–32.

19 Wittgenstein, *Philosophical Investigations.*, no. 109 (pp. 47–47e): 'Die Philosophie
 ist ein Kampf gegen die Verhexung unsres Verstandes durch die Mittel unserer
 Sprache.'

20 Baxandall, 'The Language of Art History', 461.

21 Baxandall, 'The Language of Art History', 463.

22 Baxandall, 'The Language of Art History', 463.

23 Baxandall, 'The Language of Art History', 463–4. See also Baxandall, *Patterns of
 Intention*, 11: 'that such a process penetrates our language so deeply does suggest
 that causal explanation cannot be avoided and so bears thinking about … [T]he
 description which, seen schematically, will be part of the object of explanation
 already embodies preemptively explanatory elements.' On the other hand, cause
 and intention are not just effects of critical language but facts of history (40):

'One of the deep subject matters of good pictures is the tissue of human intention, in general.'

24 See esp. the discussion of *commensurazione* in the essay on Piero's *Baptism of Christ* in Baxandall, *Patterns of Intention*, 111–16, esp. 115–16.

25 Baxandall, *Patterns of Intention*, 12, 13, 15.

26 On the limits of Baxandall's empiricism, see W. Davis, 'Art History, Re-Enactment, and the Idiographic Stance', in this volume.

27 See esp. Langdale, 'Aspects'; also J. Tanner, 'Michael Baxandall and the Sociological Interpretation of Art', *Cultural Sociology*, 4 (2010): 231–56. For Baxandall's thoughts on Haskell and Chambers, see Langdale, 'Interview', 22–3.

28 Langdale, 'Interview', 8; Langdale, 'Aspects', 19–20; Smith, 'Interview', 80–81.

29 Langdale, 'Aspects', 21, 29–30; also Smith, 'Interview', 85, 118.

30 Smith, 'Interview', 80: Commenting on the opening sentence of *Painting and Experience* – 'A fifteenth-century painting is the deposit of a social relationship' – he said 'Yes, it was written with a little bit of exasperation, maybe, and to irritate people. It did irritate people, but not always the people I intended to irritate.' Also: 'I didn't get under people's skin in the way I was aiming to. But I did in a way it didn't occur to me I would' (85). He said that he expected 'to be considered philistine, and wild, or speculative' (84), but that 'people didn't seem to find it very philistine' (85).

31 Smith, 'Interview', 58: 'One began writing to irritate the Courtauld Institute.'

32 Smith, 'Interview', 85.

33 Smith, 'Interview', 114–16; see also Langdale, 'Interview', 13.

34 Langdale, 'Interview', 14.

35 Michael Baxandall, 'Art, Society, and the Bouguer Principle', *Representations*, 3 (1985): 36.

36 Baxandall, 'Art, Society, and the Bouguer Principle', 40.

37 Baxandall, 'Art, Society, and the Bouguer Principle', 40.

38 Baxandall, 'Art, Society, and the Bouguer Principle', 42.

39 Baxandall, 'Art, Society, and the Bouguer Principle', 33.

40 Langdale, 'Interview', 13.

41 Smith, 'Interview', 104–5. Also: 'I suppose really I've always felt, and I've said this off and on, that the better the art, the richer the document, in a historical way. Well-organized art carries more historical meaning, I think' (123).

42 Michael Baxandall, *The Limewood Sculptors of Renaissance Germany* (New Haven: Yale University Press, 1980), 10, and esp. 164:

Forms may manifest circumstances, but circumstances do not coerce forms. Precisely this gives the best works of art their curious authority as historical documents: the superior craftsman, and only the superior one, is so organized

that he can register within his medium an individual awareness of a period predicament, but his meaning lies as much in how he has formulated the challenge of circumstances as in how he responds to it.

43 Baxandall, *Patterns of Intention*, 120.

44 Smith, 'Interview', 137.

45 Compare, for instance, his remarks on Haskell and Richard Goldthwaite in Langdale, 'Interview', 22.

46 In a sternly worded postscript ('Art, Society, and the Bouguer Principle', 42–3), prompted by the negative reactions of other participants in the conference to the original paper, Baxandall insisted that he did not mean to discourage 'reference to social matter in art history (or to works of art in social history)'.

47 Baxandall, *Painting and Experience*, 109.

48 Baxandall, 'The Language of Art History', 455.

49 Smith, 'Interview', 54.

50 Langdale, 'Interview', 13.

51 Baxandall, *Patterns of Intention*, 34.

52 Smith, 'Interview', 125.

53 Michael Baxandall, *Tiepolo and the Pictorial Intelligence* (New Haven: Yale University Press, 1994), 106.

54 The approach could be seen as an attempt to follow through on the implications of a claim made at the beginning of the chapter on Watteau in *Patterns of Intention* (75): '[T]he typical form of thought in a picture is something more like 'process', the attention to a developing pictorial problem in the course of activity in a pictorial medium. Neither the painter nor we plot it closely on a conceptual level.'

55 Baxandall, *Tiepolo and the Pictorial Intelligence*, esp. 44–5.

56 Michael Baxandall, *Shadows and Enlightenment* (New Haven: Yale University Press, 1995) 78.

57 Baxandall, *Shadows and Enlightenment*, 9.

58 Baxandall, *Shadows and Enlightenment*, 137.

59 Baxandall, *Shadows and Enlightenment*, 139–43.

60 Almost as if it were too obvious to have been considered at greater length, some mention of it is made at the very end of the book: 143–5. The strategy recalls the moment, when, at the end of the essay on Chardin's *Woman Taking Tea* in *Patterns of Intention* (103), the possibility that the figure represents Chardin's wife is added as if it were an afterthought.

61 Michael Baxandall, *Words for Pictures* (New Haven: Yale University Press, 2003), 117–61.

62 Baxandall, *Words for Pictures*, 118, 135–9.

63 Michael Baxandall, 'Fixation and Distraction: The Nail in Braque's *Violin and Pitcher* (1910)', in J. Onians (ed.), *Sight & Insight: Essays on Art and Architecture in Honour of E.H. Gombrich at 85* (London: Phaidon, 1994), 398–415.

64 Baxandall, 'Fixation and Distraction', 409–13.

65 A passage from Baxandall's novel, *A Grasp of Kaspar* (London: Frances Lincoln, 2010), 114, suggests the degree to which the kind of peripheral vision effect emphasized in relation to the Piero and the Picasso was an object of special personal fascination: 'Across the river was a great plantation of larches set in a quincunx so rigorous that there always seemed to be some avenue receding over there; as he walked, Briggs was aware of it as something like a regular slow flashing in the corner of his right eye.'

66 Baxandall, *Painting and Experience*, 1.

67 See, for instance, the discussion of T.J. Clark's *The Sight of Death* (New Haven: Yale University Press, 2006) in R. Williams, 'Notes from the Field: Detail', *Art Bulletin*, 94 (2012): 513–14.

68 Baxandall, *Patterns of Intention*, 6.

69 The progressive redefinition of this last project is explained in Smith, 'Interview', 122–4, 135–6.

70 Langdale, 'Interview', 6–7, 26–7; Smith, 'Interview', 35.

71 Langdale, 'Interview', 6; Smith, 'Interview', 53.

72 Langdale 'Interview', 3; Smith, 'Interview', 65–7; Obrist, 'Interview', 44.

73 Langdale, 'Interview', 15, 22–3; Smith, 'Interview', 95; Obrist, 'Interview', 50.

74 Smith, 'Interview', 55–6, 102, 134, 138–9.

75 Smith, 'Interview', 134; see also Obrist, 'Interview', 50, esp.: 'I had to be careful not to give in to the pressures of the new art history.'

76 Smith, 'Interview', 139.

77 Baxandall, *Patterns of Intention*, 41.

78 Baxandall, *Patterns of Intention*, 135–7. The same might be inferred from his emphasis on 'tact': see esp. Smith, 'Interview', 65–6: 'It seems to me that tact is more important than method.' Also: 'I don't believe in extremely explicit and very determinate readings of pictures: I much prefer the sort of criticism which establishes something from which people can move on themselves' (112).

The Presence of Light

Paul Hills

> I feel I can clearly see two things in my bedroom: parts of the fine world-landscape frieze my father had painted all round; and an occasional light effect on the ceiling, elongated shadow-figures of passers-by bobbing on the spot, reflected summer-evening light diffracted through a gap in the curtains.[1]

In this recalling of his bedroom in what he calls 'a version of infancy' in *Episodes*, Michael Baxandall points to a recurring fascination. The play of light and shadow on the ceiling is a form of depiction, a changing pattern rich in ambiguity, from which inferences may be drawn. And there is more. The comparative stability of a world represented by his father's painted frieze, frames the transient, harder to grasp, shadow-play projected on the ceiling by the 'reflected summer-evening light diffracted through a gap in the curtains'. Reflected, diffracted, lights as well as shadows become present in the room – as they will in memory.

Distinctive qualities of light as the vehicles of memory are evoked in several later passages of *Episodes*. When Baxandall lists five qualities of cities he likes, one is 'noticeable light'. Of Munich in 1957–1958, he recalls 'the white subalpine light, the gamut of light brown and middle brown colours presented by the buildings'. His images of Milan, the Italian city for which he retained the most personal feeling, 'are in bright morning or in a dusk of early evening, lamps just lit but the sky still participating; I do not recall the frequently oppressive Lombard afternoons'.[2]

'Noticeable light' characterizes a city. It is also light that changes, that elicits awareness of the temporal, and prompts shifts of mood. Baxandall's novel, *A Grasp of Kaspar*, unfolds within a tight timeframe of less than a fortnight. The historian turned reluctant detective, Briggs, is immersed in a flux of light that changes hour by hour from the clarity of sunlight to the obscurity of night or a blanket of fog. Alternation between clear light and situations where the

indeterminacy of mist or darkness elicits conjectures is central to the enigmas of the plot.[3]

In the central chapters, the location moves from Switzerland to Pavia, the Lombard city that Baxandall knew well from his time at the university there in 1955–1956. Briggs's arrival in Pavia is described in terms of this shift from seeing clearly to uncertain vision, eliciting conjecture. He comes first to the brightly lit Strada Nuova, then cuts down a side street

> back into the dark old world. And here was the Cathedral, with its oddly unfinished look. A great cupola, the ugliest cupola in all Italy, went up in the mist. One could not make out at what point, quite, it disappeared. The dark brick of the church faded imperceptibly into the lesser darkness of night. He stood and worked on this allegory ….[4]

In the novel, the Lombard fog or murky twilight repeatedly descends after only the briefest interludes of hazy sunlight. The author's understanding of optics sometimes intrudes:

> In this twilight he saw more dimly, but more widely than two or three hours before. Then he had seen sharp and narrow: now the field of vision was becoming soft, broad and even. Rods and cones – they are differently distributed in the eye: the widespread dim-light rods were beginning to take over from the focussed bright-light cones.[5]

Changes in external light levels in the world are related to the physiology of the eye and hence to the internal processes of cognition. The fog that blurs the spy's spying, signals bafflement. Significantly, the loss of certain vision in mist recurs near the conclusion in a search set on Lake Constance. And finally, on the very last page, as Briggs looks out on the lake at dusk there is a strange reversal: 'the gruesome clarity of day was gone. Points and smudges of light were coming out below around the lake, signs of distant things, begging interpretation, flattering the mind.'[6]

'Points and smudges of light … begging interpretation, flattering the mind.' We are back with another version of the shadow-play on the child's bedroom ceiling. Alertness to light and shadow as depictions that stimulate thought characterizes the strong sensory substrate underlying Michael Baxandall's visual interests.

Judging by the sequence and character of Baxandall's publications, one might suppose that attention to light and shadow developed late in his life. It is more obvious in *Shadows and Enlightenment*, published in 1995, and in the book co-authored with Svetlana Alpers published the year before, *Tiepolo and the Pictorial Intelligence*, than in either *Painting and Experience* or *Giotto and the Orators* of a quarter of a century earlier. But this is to overlook the crucial importance of his time as a curator of sculpture at the Victoria and Albert

in the 1960s. Alberti recommended that painters should learn by copying from sculpture because it taught them 'to learn to recognize and portray the lights'; and any curator working day-by-day with sculpture comes to know intimately how the shapes and materials of the objects in his care respond to the light, how they live and change according to the light in which they are seen and displayed.[7] In his memoir, Baxandall writes of the V&A, '… the National Art Library was a hundred yards from my office, and I could have Veit Stoss's boxwood *Virgin and Child* on my desk while I worked on it. It was the perfect position for getting a grasp of a new field.'[8]

When *The Limewood Sculptors of Renaissance Germany* was published in 1980, it included three views (Plate 10) of Stoss's small sculpture – it's just 20 cm high – and one can imagine how years earlier Baxandall might have turned it on his desk, observing the shadows caught in the folds, and the salient convexities of smooth boxwood taking on sheen, and this sheen slipping over the surface as he moved his head to peer round the sculpture or as he rotated it on its base.

We recall here, as an aside, that Baxandall's father David was both a museum curator and keen photographer, at one time with his own dark-room in the home. Michael grew up familiar with the processes of black-and-white photography, he watched a professional photographer friend of the family at work, and learnt how photographers enlist the co-operation of light – whether the distinct projected shadows of 'On the farm, in Radnorshire' or the moody penumbras, the reflections and sheen on water, in the photograph 'With Renate', two of his father's photographs reproduced in *Episodes*.[9] No surprise then that Baxandall chose the photographs that are such an essential accompaniment to the text of *The Limewood Sculptors of Renaissance Germany* with discrimination. Indeed, when illustrating sculpture in the V&A he often sought out alternatives to the standard museum photograph.[10] Many of the finest photographs in the book, including one view of Veit Stoss's Madonna, were commissioned from Helga Schmidt-Glassner of Stuttgart, whose skill Baxandall praises in his preface.[11]

Together, text and photographs demonstrate how the German woodcarvers and the painters who applied the polychromy played 'in elaborate ways with the changing fall of light', and created sculpture that was 'as much multi-textured as multi-coloured'. Baxandall refers the reader here to this colour plate of Erhart's *Virgin of Mercy* (Plate 11) then goes on to enumerate what he calls 'a spectrum of textures: matt, glossy, metallic, translucent and patterned'.[12] Phenomenologically this spectrum of textures is perceived through variations of light on the surface, from mobile lustre and sheen to a more stable microstructure of shadow and light in the matt areas.

Turning to the high altarpiece retables with original polychromy, he writes:

> Seen at their best, which is on a day of mixed sun and cloud, they become a sort of figured organ. Their instability becomes hallucinatory, contradicting any normal mental mechanism of size and colour constancy. They impose illusions of movement and reverse depth: a light on a dark can suddenly become a dark on a light. Because one's usual perceptual skills are invalidated for a time, they effectively deny the mundane and become religious images of a singular kind.[13]

What Baxandall recalls here is an experience over time, cumulative, changing, and one that no photograph can capture, not just because of the essential temporality of viewing but because of how the sculpture plays with the viewer's perceptual skills. Perhaps deliberately, there are no colour photographs of the great retables in *The Limewood Sculptors* and the black-and-white ones, even as fine a photograph as Schmidt-Glassner's of Erhart's retable at Blaubeuren (Plate 12), do not elicit the experience the author describes. Instead a footnote directs the reader how to find retables in situ and when best to view them: for example in the Cathedral at Chur, 'lit from the south only and best in the middle of the day'.[14] Now that so much art historical discourse either evades close engagement with the work of art or is based on photographs, Baxandall's reminder of the necessary temporality of embodied viewing is salutary.

The response of surface to light is just as important in the limewood sculptures that renounced polychromy. Baxandall observes of Riemenschneider's *St Barbara* (Plate 13) that the drapery has 'a generally consistent smoothness, out of which the flesh of the face, neck and hands glows with slightly more reflectiveness'. A few lines later, he remarks that 'the figure as a whole is articulated in a medium of strong highlights and shadows offered by the raised folds of polished wood within the edges of the cloak'.[15] Notice how his choice of words here – 'a *medium* of strong highlights and shadows' – acknowledges that highlight and shadow are integral to the work, guiding the maker in its fashioning or production and equally engaging the viewer in its reception.

Alex Potts has noted, 'Baxandall impels us "to look and think" about shadows in art', and that the value of this is that it 'makes us attend to an aspect of visual experience which affects our response to any work of art, but which we are rarely conscious of except as secondary adjunct or minor interference'.[16] Since the publication of *Shadows and Enlightenment* this is undoubtedly true, but looked at more broadly Baxandall's work also prompts us to think about 'noticeable light' and its relation to presence.

જ જ જ

In the second part of this paper, I will move away from direct consideration of Baxandall's work, though I believe his discriminations have shaped my response. I will look at three paintings, made in Italy within the span of

about 60 years from about 1470 to 1530, which elicit slightly different modes of engagement and rather different ways of imagining presence. These years broadly coincide with the working life of Leonardo, as well as the span of time discussed in *Limewood Sculptors*. It is a period when light and shadow exercised pictorial intelligence in a manner that would shape the distinctive visual grammar of later European art. That these decades were so formative in this respect may be due to the attention that was given to both monochrome and polychrome forms of depiction and to the interplay between them. Baxandall's analysis shows how in Germany, the shift between sculpture with polychromy to sculpture which renounced it heightened awareness of the relative roles of colour, light, and surface texture. North and south of the Alps the rise of engraving as a self-sufficient artistic medium sharpened awareness of how modelling might compensate for the absence of differences of colour. Over time, this self-sufficiency of light and dark in the medium of engraving stimulated painters such as Titian to re-envisage the role of colour as embodied in the medium of oil paint.[17]

Antonello's *Virgin Annunciate* in Palermo (Plate 14) is painted in a mixture of oil and tempera on a panel 45 cm high. Nineteenth-century cleaning removed some of the finer modelling, particularly on the raised hand, and recent conservation has perhaps left the painting hardened in appearance.[18] The presence of light in Antonello's masterpiece is made noticeable through its interruption – interruption by the hand held out and tilted upwards to reveal the shadowed palm, and above all by the emphatic key-hole aperture of the cloak, modestly held together by the Virgin's left hand as if to minimize exposure to this light falling upon her flesh. But the light, falling from in front, above and to the left, enters this aperture and touches her face. On the left where the cloak is held close against her cheek it casts a shadow in an arc across the cheek toward the eye socket, then as the cloak hangs free in space, the cast shadow is more blurred as it cuts across the arch of the eyebrow and on over the forehead. Antonello deploys projected or cast shadow, self- or attached-shadow and the more conceptual slant or tilt modelling.[19] To sample one passage, moving from left to right across the face: on the left side of the nose just a hint of slant modelling articulates its receding wall; the salient ridge is picked out with sheen; projected shadow overlaps the self-shadow of the right side of the nose, falling blurred across the highlight of the cheek before deepening as attached shadow leads us round the turn of the cheek until finally a reflected light picks out the regular arc of the contour running down to the jaw line.

In a masterly stroke that rhymes large and small units of composition, the fall of light through the great keyhole opening of the cloak is miniaturized and duplicated in the pair of trefoil cusps that pierce the front of her slanting lectern. The front of the lectern is shaded yet it casts no shadow; on the contrary, a raking light enters the twin apertures, illuminating their cusped soffits.

Antonello has manipulated the lighting here to replicate its penetration into the larger aperture above. Throughout the picture Antonello's manipulations are bold: another is the fine highlight dissecting the Virgin's hood, its shallow groove inverting the ridge of her nose. That vertical division between light and shadow is taken up again in the projecting corner of the lectern on a scale that duplicates the length of her nose. In this manner the fall of light, which is potentially so meaningful in the context of an Annunciation when 'the power of the most high' overshadowed the Virgin (Luke 1:35), is reified within the picture. To this end, the distraction of projected shadow is minimized, save for where it serves imaginative purpose.

Antonello's *Annunciate*, with her slightly mundane, almost slyly pensive air, has an extraordinary hold over the viewer. I remember in Palermo how difficult it was to tear myself away from the room in which it is displayed and how the image lived on in the memory. We might explain this in the light of the hypothesis put forward by Sixten Ringbom and John Shearman (both scholars that Baxandall admired) that the viewer takes the place of the angel Gabriel, and therefore the fall of light in the painting is shared with the viewer, and so becomes worldly as much as divine.[20] But we could recast this in terms closer to those advanced by Baxandall in *Patterns of Intention* where he writes of 'descriptions of pictures as representations of thought about having seen pictures'.[21] More recently, the philosophers Kendall Walton and Patrick Maynard have proposed a similar line. Maynard summarizes Walton's argument as follows: 'representations are things we imagine with functions we imagine in certain ways … The requirement is that we imagine in our very act of seeing the picture, that it *is* the seeing of what we are imagining.'[22] Antonello, in his painting of the Annunciate, has fulfilled this condition of potent representation: that it *is* the seeing of what we are imagining.

The *Annunciate* is datable to the 1470s. In 1475 Antonello was recorded in Venice, and it is to the presence of light in Venetian painting that I turn, for it is in Venice that exchange between religious images and portraits as vehicles for imaginative seeing is strikingly played out.

Giorgione's depiction of an Old Woman, *La Vecchia* (Plate 15) is painted in oil on a canvas 68 cm high; that is considerably larger than the norm for quattrocento portraits, and only a little below life size. Standing before *La Vecchia* in the Accademia we have powerful sense of face-to-face encounter. Since the painting was once protected by a *timpano* or cover, that viewing encounter would originally have been heightened by the act of removing of the cover.[23] Once uncovered, the white cloth so artfully arranged on the woman's shoulder and so brilliantly catching the light, invites the viewer to stretch out and touch it. Recently it has been argued that this is the kind of napkin used by wet-nurses to protect themselves from the dribbles of the baby; it is an accessory, temporary, readily removed, and we sense how Giorgione might have arranged and studied such a cloth in his studio.[24] The lighting

he has chosen for the picture is from the left, relatively frontal and angled so low it illuminates her eye sockets. It contrasts absolutely with the steep and generalized lighting from above favoured by Leonardo. Such lighting recalls that in Venetian palaces where the deep, flat-beamed *porteghi*, the principle room of the *piano nobile*, are lit by rather horizontal illumination from the bank of windows on the canal façade. But Giorgione manipulates his lighting, drawing it round to catch the right side of her white cap so the cap is pulled towards the plane of the picture. This device renders apprehension of the rear of her head more vivid.

What makes Giorgione's *La Vecchia* such an affecting image of age depends upon manifold insinuations of how with time the woman succumbs to the law of gravity: the tassels of the napkin hang down as filaments of brightness, stroked in with white lead on a loaded brush, and that downward fall of the tassels is repeated in the straggling hair to the left of her face and the weight of her cap sagging to the right. Throughout the painting, subtle congruences between micro-structure and macro-structure, underscored by lighting, sustain attention. What we register here accords with Michael Podro's discussion of portrayal: 'We see the painting procedure in the subject, and the subject in the painting procedure.'[25]

Giorgione's *La Vecchia* was painted towards 1510; my final example, Titian's *Supper at Emmaus* (Plate 16), dates from some 20 years later. It is large, 169 cm high. Although the subject matter is religious, it was probably painted for a domestic setting, most likely the palace of Count Nicola Maffei, chief minister of Federico Gonzaga.[26] I am reminded here that in the preface to his last book, *Words for Pictures*, Baxandall mentions among the conditions that stimulated the fashion for discursive dialogue about art, the accumulation of art in newly large houses and the legitimation of display.[27] Titian's *Supper at Emmaus* may be understood in terms of its display in a large house, probably in the company of other paintings as well as the coming and going of the owners of the house, their guests, and their servants. Its size is important in this regard: the near-life scale of Christ, of the two disciples and the servants, as well of the table, of the bread broken open and the glass vessels on the table, establishes an easy if elevated sense of equivalence between what is depicted and the dining and social gatherings that would have taken place in the room of the palace where the painting hung. Light and shadow play a role in this equivalence.

The expanse of white tablecloth, hanging parallel to the picture plane, but set back from it by the projected shadow of the fold that hangs forward on the left, is a virtuoso display of tonal mastery, the damask shimmering with modulations of self-shadow and sheen. Titian's mastery of highly refractive lead-white suspended in oil makes this possible. And the impalpable shimmer of the evening sky complements this gleaming palpable surface of tablecloth – where pale drifts of cloud veil mountains and sky.

Very deliberately, Titian has brought this pearly whiteness down through the silver sheen of Christ's robes to join the damask white of the table-cloth. The grain of these pale tones over slightly darker grounds, scumbled and dragged over the weave of the canvas, builds pictorial unity. Cast shadows, such as that of Christ's hand raised to bless the bread, are generalized so that they do not interrupt this unity. In this substantial gallery picture, the presence of light, and of shadowy masses envisaged in *contre-jour*, is absorbed into the *matière* and subject of painting. Its varying focus, its points and smudges of light, its elusive passages of shadow, may be understood in terms of the new kinds of sociability and discursive viewing that Michael Baxandall has pointed to. In Titian's *Supper at Emmaus* the presence of light and shadow enters the grain of the picture in a manner that will become central to the European tradition of painting in oil on canvas.

Notes

1 Michael Baxandall, *Episodes: A Memorybook* (London: Frances Lincoln, 2010), 27.

2 Baxandall, *Episodes*: for preferred characteristics of cities, 85; Munich, 99; Milan, 85.

3 Michael Baxandall, *A Grasp of Kaspar* (London: Frances Lincoln, 2010), especially chapter 8 (49–54), and the last sentence of chapter 2 (21): 'Briggs sat and let the light fade.'

4 Baxandall, *A Grasp of Kaspar*, 89; see also the account of his time in Pavia in *Episodes*, 75–85.

5 Baxandall, *A Grasp of Kaspar*, 130.

6 Baxandall, *A Grasp of Kaspar*, 235.

7 *De Pictura*, Bk III, para. 58; in the Italian … *impari conoscere e ritrarre i lumi*.

8 Baxandall, *Episodes*, 133.

9 Baxandall, *Episodes*: for David Baxandall as photographer see 28; for the professional photographer friend, 51; the photographs 'With Renate' and 'On the farm, in Radnorshire' are reproduced as plates 1 and 2.

10 I thank Malcolm Baker for this information.

11 Michael Baxandall, *The Limewood Sculptors of Renaissance Germany* (New Haven and London: Yale University Press, 1980), x.

12 Baxandall, *The Limewood Sculptors*, 41 and 42.

13 Baxandall, *The Limewood Sculptors*, 42.

14 Baxandall, *The Limewood Sculptors*, 220, note 35.

15 Baxandall, *The Limewood Sculptors*, 44.

16 Alex Potts, 'Michael Baxandall and the Shadows in Plato's Cave', *Art History*, 21 (1998): 538; the words within double quotation marks are Donald Judd's.

17 I have discussed this in *Venetian Colour: Marble, Mosaic, Painting and Glass 1250–1550* (New Haven and London: Yale University Press), 162–6 and 201–6.

18 Mauro Lucco (ed.), *Antonello da Messina* (Milan: Cisinello Balsamo, 2006), cat. 35, 232–4.

19 For discussion of these types of shadow see Michael Baxandall, *Shadows and Enlightenment* (New Haven and London: Yale University Press, 1995), 2–4.

20 John Shearman, *Only Connect … Art and the Spectator in the Italian Renaissance* (Princeton: Princeton University Press, 1992), 35–6. Sixten Ringbom, *Icon to Narrative* (Doornspijk: Davaco, 1984), 64–5.

21 Michael Baxandall, *Patterns of Intention* (New Haven and London: Yale University Press, 1985), 1.

22 Patrick Maynard, *Drawing Distinctions* (Ithaca, NY: Cornell University Press, 2005), 88.

23 See the entry by Sylvia Ferino-Pagden in David Alan Brown and Sylvia Ferino-Pagden (eds), *Bellini, Giorgione, Titian* (New Haven and London: Yale University Press, 2006), no. 39, 212–15.

24 Ferino-Pagden, *Bellini, Giorgione, Titian*, 213–14.

25 Michael Podro, *Depiction* (New Haven and London: Yale University Press, 1998), chapter 4 (87–106).

26 Peter Humfrey, *Titian: The Complete Paintings* (London: Phaidon, 2007), cat. 90, 139.

27 M. Baxandall, *Words for Pictures* (New Haven and London: Yale University Press, 2003), viii.

Printing and Experience in Eighteenth-Century Italy

Evelyn Lincoln

Teaching and Learning

In the Spring semesters between 1985 and 1996, Michael Baxandall taught in the Department of the History of Art at the University of California, Berkeley. Undergraduates took his lecture course, and graduate students in art history, history, and from his own preferred department, rhetoric, filled his seminars. Generous with undergraduates and graduate students alike, he was open in his admiration of the democratic nature of our sprawling, state university – a good corrective for us Americans who tended to take such things for granted. Camping out in a different office every year, Baxandall taught largely without the apparatus of books and file cabinets that played a prominent role in other people's office hours. Studying with him was conversational and dialogic, with teaching understood in the sense of showing, rather than telling, of providing conditions in which observations could be raised, and information could travel freely. Most importantly, he taught how to ask illuminating questions. The lifelong effect he had on his students was that of learning how to be curious in an educated way.

To discuss Baxandall's legacy from the point of view of an art historian is a daunting task that also seems somewhat redundant today. As a field, art history has endowed Baxandall's work with a particular authority, so that some of his books are standard reading in classes like the ones I teach on the history of art, and the development of the discipline, at Brown University. The success of his publications and the amount of force they have exerted on the field has attracted a certain amount of pushback, although in no way congruent with the pressure his work has exerted on the discipline. None of the criticisms about what his books fail to include have so far diminished the pleasure and opportunities they continue to provide to the students who read them and the faculty who teach them. But especially in this increasingly

pragmatic educational climate, when the importance of humanities teaching turns out to be so difficult to articulate convincingly – and because all teaching, although it lodges in people, is ephemeral in its manifestation – a discussion of its role as part of Baxandall's intellectual legacy may contribute in an important way that might otherwise be overlooked.[1]

The histories of teaching and learning were important subjects to the Renaissance humanists, and the way these involved performances of speaking and writing about art were at the core of much of Baxandall's writing in the 1960s and 1970s, as he looked at modes of linguistic description and communication in *Giotto and the Orators* and articles on humanist educators like Guarino, Gasparino Barzizza, and others.[2] Baxandall's own graduate teaching at Berkeley tended to look more like the congenial one-on-one tutorial pictured in Pietro Cannuzio's music text than the authoritative speech in the crowded lecture room pictured in Cristoforo Landino's rhetorical handbook. Both of these simple woodcut pictures of teaching that formed the title pages of textbooks written by Renaissance teachers were scattered throughout the by now canonical and much-reprinted *Painting and Experience in Fifteenth-Century Italy*.[3] As a graduate student, this was a book that I, assigned to be his teaching assistant for a lecture course he gave at Berkeley in 1989, helped to teach.

The syllabus from that 14-week lecture course is striking today not only for having been written with an antique writing instrument (Figure 7.1), but also for its singular brevity compared to the highly annotated four- and five-page documents that American professors are now regularly obliged to produce. The textbooks ordered for the class were Alberti's *On Painting*, Frederick Hartt's chronologically driven classic tome on Italian Renaissance art, and Baxandall's own slender volume, *Painting and Experience*. Hartt's complete survey of the Renaissance canon ensured student comfort in an unfamiliar era and visual territory, and provided confidence in the form of much factual information that was not to be found elsewhere in those pre-internet days. Baxandall's book, by contrast, ranged around in the brains of Quattrocento viewers of art, pointing out high points of neural activity when pictures came into view.[4] For this book, Hartt became an expanded picture atlas and useful resource for any information that we could not expect to discover stored in Quattrocento minds. No one ever complained about having had to buy it, and a lot of students consulted it regularly. Nothing that they then proceeded to say about Renaissance art was expressly contradicted in that volume, and students learned that more than one book might be necessary to study the history of a century of art.

A paper was assigned at the first class meeting: students were asked to visit the University Art Museum, where there was an exhibit about the art of the Sforza court in Milan.[5] The assignment, with the original emphasis, went:

HISTORY OF ART 162: ITALIAN RENAISSANCE ART AND ITS CIRCUMSTANCES 1400–1527

1. Introduction: 'Italy','Renaissance','Art'
 Materials of painting and sculpture
2. Artists in society 1: the Bellini family
 Artists in society 2: Mantegna
3. Commissioners 1: Corporate — Florentine guilds
 Commissioners 2: Individual — Giovanni Rucellai
4. Commissioners 3: Court — Urbino
 No lecture 16 February
5. Subject matter [3 p. papers 21 February] ✓
 Intellectual techniques 1: perspective, proportion
6. Intellectual techniques 2: color theory
 Discussion
7. Intermediaries 1: Alberti, De pictura
 Intermediaries 2: Alberti, De pictura
8. Revision meeting
 Mid-term exam 16 March · hr 20 min

=

9. Intermediaries 3: Castiglione and behaviour
 Individuals: Botticelli
10. Art criticism 1: Terms
 Art criticism 2: Argument
11. Art criticism 3: Description
 Art criticism 4: History
12. Burckhardt and after 1
 Burckhardt and after 2
13. Intermediaries 4: Leonardo da Vinci
 1527
14. Revision exercises
 Revision exercises

 Final 2 hour

7.1 Michael Baxandall, typewritten syllabus for HA 162, taught at University of California, Berkeley, Spring 1989

Identify an object that intrigues you, and write a 3-page essay about what knowledge about its circumstances, function, or techniques of making, might or might not be useful in the understanding and perception of it. Also think about what sort of information would not help to get things moving.

From the first week, students were put on notice that responses to art in the form of questions to ask were important enough to constitute a formally written essay. They were extremely useful for the development of the students, and very difficult to mark.

The curriculum took off in Week 2 with a discussion of how workshops acted as schools for craftsmen, looking at the usual practices and working conditions of Renaissance artists, as well as the similarly informed choices humanist educators made who lived and worked in cities or courts. Commissioners, either final or efficient causes of art being made, were then discussed in terms of the nature of their relationships with artists. Baxandall greatly preferred the word 'commissioners' to 'patrons', which he said belonged more to social history, especially anthropology, than to art history. He felt that the use of the word in art history short-circuited inquiry by discouraging investigation about the skills and styles of commissioners, which we examined in different embodiments for two weeks. In Weeks 5 and 6 we dealt with colour and space in terms of intellectual activity. Perspective, or as he explained it in lecture, 'the smallering of things in space', was introduced as a special case of proportion that involved a handout about rhetorical terms, and discussion of Polykleitos, Luca Pacioli, Albrecht Dürer, and musical harmonies, before coming to rest at Leon Battista Alberti. There we stayed the entire following week. At that point, instead of having lectures, we read Alberti's *De pictura* together, the way you might read him in a literature class, with the book in hand, paragraph by paragraph, moving from medieval optical theory to Renaissance colour theory. We did this by way of a vocabulary for the perception of colour from our own time but not our own discipline, using words like 'induction', and 'constancy', which were terms Baxandall had borrowed from scientists working in the psychology of vision, and which he would explain further in *Shadows and Enlightenment*.[6]

There were four class sessions that dealt with art criticism, Weeks 10–11 on the syllabus, which might surprise someone who had read his judgment that it was a 'minor literary genre … affected by generic constraints', but that was for the eighteenth century.[7] In these classes we discussed Giorgio Vasari, focusing on classical rhetorical techniques in literature as Vasari might have learned and deployed them, so that we could understand better how to parse his comments and pictorial discriminations. Baxandall dwelled on the education of vernacular writers outside universities, and we followed Vasari's descriptive style with this in mind. We also directly discussed the evaluative nature of vernacular art criticism vs. academic art history, thinking about how Renaissance people assessed the quality of things. This kind of art criticism, of a conversational and dialogic quality itself, proceeded from three main questions that were at one point written up on the board: 'Who's best?', 'What is good, anyway?', and 'What is the relationship of good art to other things?' In graduate seminars, he did not discuss things in this way, but he recommended reading Antonio Gramsci on the Organic Intellectual without further comment about it.[8] If students took both his graduate and undergraduate classes, and read all his books, it

ITALIAN RENAISSANCE ART AND ITS CIRCUMSTANCES/HISTORY OF ART 162

MIDTERM EXAMINATION (75 minutes)

Answer both questions, allowing 30 minutes for No. 1 and
45 minutes for No. 2.

1. How far can a study of 'patrons' and 'patronage' throw light on
 the cultural and social conditions of Renaissance art? Refer
 to particular cases as much as you feel useful. (30 minutes)

2. Taking into account some of Alberti's categories of pictorial
 quality - e.g. perspective, range of hue, tonal modelling,
 'circumscription', 'composition', diligence-with-quickness -
 discuss either slide (a) or slide (b), or (if you prefer)
 slides (a) and (b) in comparison. (45 minutes)

 Slide (a) is Antonio del Pollaiuolo, The Martyrdom of Saint
 Sebastian, National Gallery, London. Panel, 9'7" x 6'8". 1475.

 Slide (b) is Sandro Botticelli, The Adoration of the Magi,
 National Gallery of Art, Washington. Panel, 27" x 41", about 1482.

7.2 Michael Baxandall, typewritten midterm exam questions for HA 162, Spring
1989

was possible to figure out why Baxandall found Gramsci to be an interesting
and useful interlocutor.

On art history exams, Baxandall effectively disabled the usual student
responses by providing all the data they would otherwise have memorized on
the exam sheet itself, much as museums do (Figure 7.2). In this way he made the
slides an opportunity for putting into practice the use of a period eye through
discriminating looking and writing, using the Quattrocento vocabulary he
described in his book. Borrowing a descriptive language for pictures from
literature, rhetoric, mathematics, and geometry by way of Cristoforo Landino,
Alberti, Giovanni Santi, and Francesco Lancilotti, Baxandall helped students
to make the language their own. This required them to understand the part
of speech of each unfamiliar descriptive category and use it perceptively in
their own humanist assessments of Renaissance paintings. By talking the talk,
students found themselves walking the walk, an important by-product of
which was that they came to understand, by embodying it, the importance of
language in art historical analysis.

In an interview in 2006, Baxandall was asked what he thought about the role of museums, and his response rather closely articulated what I think of as his teaching style. He said then:

> My feeling is that what would be useful is if museums fed public curiosity about why people wanted to do these strange things, and not instruct people, but construct an ambience where people actively think about what was intended. My personal feeling is that people, including myself, can't avoid curiosity about the intention behind objects and they can't avoid evaluations. And these two things coming together become very powerful. So I suppose I'm arguing for making intriguing ambiences and leaving people alone.[9]

Seen in this way, *Painting and Experience* was a guide, but not a Method, for learning how to formulate productive questions about pictures. As such, it was a good user's guide for Hartt which, in California – where we were largely without Quattrocento paintings – stood in for Renaissance art.

The importance of developing and controlling our ability to be curious in front of pictures, to make pictures infinitely generative topics of human interaction rather than simply pronouncing about them, meant that you could address larger and more mysterious concepts through engaging one's visual and declamatory functions. But it had to be done with sensitivity. Writing in 1979 expressly as an art historian, Baxandall wilfully used the pronoun 'we' in talking about what art historians do:

> By origin we are rather lightweight people ... but we do have a good natural vulgar streak. In every group of travelers, every bunch of tourists in a bus, there is at least one man who insists on pointing out to the others the beauty or interest of the things they encounter, *even though the others can see the things too*: we are that man, I am afraid, *au fond* ...[10]

It remains a constant source of amazement, and I think it also did to Baxandall, that what we see when we look at things is not what anyone else sees. In that sense looking at a picture with someone else, or talking about a picture, or comparing responses to pictures is an act of sociability, and like interrupting the reverie of fellow riders on the bus with proprietary observations, it can be done intrusively or it can be done with welcome tact. Just because people, even very smart people, can see things is no guarantee that they know how to be interested in them, nor that they want to be interested in them. But to teach art history means that you are teaching people who are already well-disposed to *wanting* to become interested in pictures, and to mount a museum exhibition similarly presupposes that your audience would like to see things in a new way.

The Case of the Chinea

With those caveats in mind, I had an opportunity to test Baxandall's teaching mode against a particularly daunting and impenetrable-seeming example in an undergraduate class on early modern Festival and Carnival. The class was to culminate in an exhibition of prints of urban festival decorations at an art museum.[11] Baxandall's ideal museum was an anthropological museum, but the Museum of the Rhode Island School of Design comes close, with an in-house specialist audience of students who care deeply about cities, and are particularly agile practitioners of *disegno* for fields ranging from the fine arts to architecture, glass-blowing, and industrial design. Although the exhibition also included festival books, it was centred on a rare collection of indifferently printed etchings in depressing condition that had appeared in pairs, usually on the 28th and 29th of June, almost every year from 1722 to 1785.[12] They were made in Rome as part of the celebration of a solemn festival that also had some carnivalesque qualities, called the Chinea. We spread a representative selection of 15 of the prints out on a table, and began a speculative conversation aimed at figuring out what it was that people saw in them. I am curious about all prints, but experience shows that inspiring curiosity in others about monochromatic two-dimensional objects that do not move can be challenging. These prints are pictures of things that were designed as platforms for a fiery spectacle of impressive sound and destruction, but there is little on the face of them that would give this away. Our unpromising task, therefore, was to promote curiosity on the part of our students, and communicate it through them to the museum-going public, in the static quality and abundant quantity of eighteenth-century Chinea prints.

Festivals were extraordinary events by definition and staging them required great work and expense, which was usually narrated in written accounts of the proceedings in mind-numbing detail in cheap chapbooks or magnificent festival books. The longer narratives proudly announce the amount of wood used in building temporary scaffolding to seat thousands of viewers, dead for centuries but identified there by name; or they list the hundreds of dishes set out at a feast, as we see in a suggestive diagram of the banquet tables at Westminster celebrating the Coronation of James II (Figure 7.3).[13] Abundant information is available in official printed narratives, as well as from the letters of impressed travellers and the observations of literary locals. Not only does this make it possible for historians to report to readers about the stirring aspects of festivals not immediately available in printed illustrations, but also likely that they will want to do so, because it is interesting.

One of the attractive things about festival books and prints is that they go to great pains to seem to be directly indexical to an occasion that no longer exists.

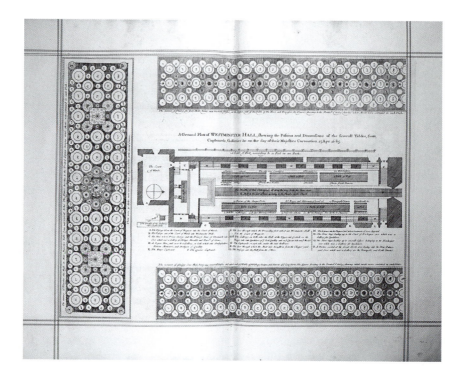

7.3 'A Ground Plott of Westminster Hall, Shewing the Position and Dimensions of the Severall Tables, Seats, Cupboards, Galleries, &s, on the day of their Majesties Coronation 23 April 1685'. In Francis Sandford (1630–1694), *The history of the coronation of … James II … and of his royal consort Queen Mary … 23 of April … 1685. With an exact account of the several preparations in order thereunto … By his Majesties especial command …* (London: In the Savoy: printed by T. Newcomb, 1687), 200. Anne S.K. Brown Military Collection, Brown University Library

The pull through the surface, past the representation to the thing represented, is very strong. The prints, many of them made by unknown artists, do very little to cue a positive, aesthetic response, and there is little precedence in art-historical writing for that kind of response. It is as if at some point we mutually consented to ignore the look of festival prints in order to mine them for information about events. Festival prints are very rich sources, and much of the writing on them is really good cultural history of architecture, history of prints, and book history, as well as theatre and music history. There is also now a huge genre on the history of festivals that owes a lot to Aby Warburg himself, with its own growing bibliography and professional associations, relying heavily on festival prints and books as source material.

The usual response to pictorial representations of festivals, like the print of the second set-piece for the Chinea festival of 1747 (Figure 7.4), is, then, to

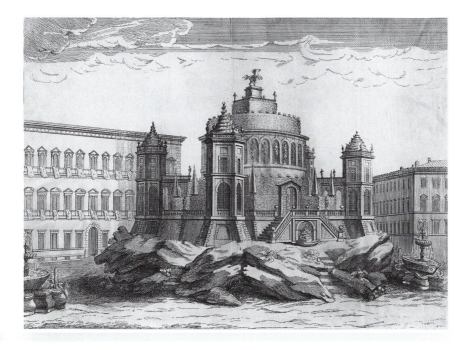

7.4 Michele Sorellò, etcher, after a design by Giuseppe Silici, *Prospettivo della Seconda Macchina con cui vengano rappresentati Orti Pensili …* (Rome, 1747). Collection of Vincent J. Buonanno

discuss the architecture of the palaces in the background, or the *concetto* of the allegorical stage set made of papier-mâché and canvas in the foreground. One may also move past the overwhelmingly inert quality of most of these prints by filling in emotive aspects through a discussion of the sensory experiences that the prints fail to record visually, but which are available elsewhere, such as in accompanying brochures and chapbooks, or festival books. Such information would include the colour of the fake and real greenery that almost imperceptibly cover this fortress-like garden, or the fountain spouting real water at the base of the *rocca*, and the lifelike quality that expert painting lent the papier-mâché rocks and the stucco statues, gleaming with gold and silver paint. In written descriptions it is the *lifelikeness* of the elements in these set-pieces that is insisted on again and again, as much as any other aspect of them.

Chinea prints such as this one differ from the prints in festival books, first in that they are single sheet prints, and therefore the only information we are given about them is inscribed in a formulaic caption engraved at the bottom of the print, or else in news pamphlets published in the weeks of the festival. Festival books with pictures, like the one for James II's coronation, are often elaborate volumes of illustrated text. The second difference about Chinea

prints is that they have been thoroughly investigated as historical documents, primarily by John E. Moore, whose perceptive documentary study of the visual culture of the Chinea festival has made it available to English-speaking undergraduates, among many others.[14] Armed with more information about the role of the prints in the festivals than we would ever have from a festival book alone, it was now our job to say something about these prints, working on the visual register, and this proved to be difficult.

A little background: The word *Chinea* means 'a horse of ambling gait', from which we derive the English word 'hackney'.[15] A horse is also a symbol of the city of Naples. From the eleventh century to 1885, the rulers of Naples and Sicily presented the Pope with an annual tax in return for sovereign rights to Southern Italy. For about a century, the presentation of this tribute took the form of an elaborate ceremony staged as a civic festival by the princes of the Roman Colonna family, acting as ambassadors from the King of Naples to the Papal See. On 28 June, the feast day of saints Peter and Paul, a silver flower was balanced on the back of a richly caparisoned white horse (the Chinea) that was led in procession with enormous pomp, and the noise of many drummers, trumpeters, firecrackers, and cannons, from the Palazzo Colonna at first, and later from the Palazzo Farnese, through the city into the Vatican. There the trained horse would kneel before the Pope, who accepted the tribute – consisting of trained horse, silver flower, embroidered horse-cloth, and a deposit certificate from the King of Naples. The acceptance of the tribute confirmed the sovereignty of the King over Naples and Sicily for another year.

At staggering expense, the Colonna princes commissioned not only the cavalcade itself, but also the construction and dramatic destruction of two grand and elaborate set-pieces, first in the piazza of the Colonna family palace, and later in front of the Palazzo Farnese, which became the seat of the Neapolitan embassy in Rome after 1734.[16] From 1722 to 1788, the Colonna also broadcast the joyful conclusion of this act of tribute throughout the city and to the major courts of Europe by printing well before the event, and distributing before, at, and after the event, a pair of etchings that purported to show the two set-pieces. These constructions were also called *macchine di gioia*, borrowing the term *macchina*, or machine, from theatre sets that were designed to move on a stage. They were fantastic works of ephemeral architecture built out of wire, wood, plaster, papier-mâché, and painted canvas. Their themes were usually allegorical or mythological, praising Naples and Sicily, or expressing the virtues of the king and queen, personal triumphs of the royal family, or Neapolitan advances in commerce, technology, or government.[17] Most were lofty, such as images of Parnassus, or a Temple of the Gods; some evoked explosions and fire in terms of natural or military destruction, such as Mount Vesuvius or the Trojan Horse. These also went well with their function as the base for extravagant fireworks displays after dark. A scene like 'Jove and

Minerva at Vulcan's Forge', which was the subject chosen for the *seconda macchina* of 1733, had the virtue of being both mythological and smoky, allowing for a display of weapons and trumpets that could be noisy as well as providing a spiky, decorative silhouette for fireworks.

On the eve of 28 June for the first *macchina* and again the following evening for the second, fireworks embedded in these set-pieces were activated to provide a fabulous entertainment of 'copious, varied, and vigorous' salvoes that were described as continuous and deafening.[18] Crowds gathered in the piazza throughout the afternoon, admiring the set-piece in its final moments of calm, and drinking wine dispensed by real hunchbacks, perhaps imitating Punchinello figures, presiding at a fountain set up for that purpose.[19] The set-piece was designed to provide an explosive spectacle that selectively fired in successive parts, while leaving the bones of the apparatus intact so that the second *macchina* could be assembled rapidly on top of it before the following evening.[20] The costs and effort related to the army of designers, builders, decorators, and stage managers and the materials they required was formidable. The fireworks and illuminations alone, each listed in payment records by its own wildly descriptive name, numbered in the thousands. Even taking these expenses into account, the payments related solely to the manufacture and distribution of the Chinea etchings were appreciable. Since the prints were made from the same drawings that would then be turned over to the fireworks expert, who was also the head bombardier at the Castel Sant'Angelo, so he could construct the base for his fireworks, the image was designed months before the set-pieces were finished.[21]

In spite of the inclusion in most of the prints of spectators and participants scattered in shadow across the bottom foreground, vignette-like, which gave the scene a sense of scale even when there was no other architectural information, the print showed the plan for the set-piece rather than recording its actual appearance in the piazza at the time of the festival (Figure 7.5 and 7.6). In this way, such prints differed greatly from retrospective accounts of entries or weddings in full-scale festival books. Those books were often organized specifically to show the effort and attention to detail that would eventually result in an experience brought about through artifice that was more marvellous than one could find in nature; a godly experience with cosmic music and Jove-like thunder.

Festival books dwelt on the work and ingenuity, the artifice behind the spectacle. An etching by Jacques Blondel from a French festival book shows the climax of the festivities staged in Paris along the Seine for the celebration of a royal marriage in 1739 (Figure 7.7).[22] Preceding pages contain meticulous diagrams, including measurements of the embankment and ground plans for the ephemeral constructions. The text and images walk the reader through a detailed account of the design and construction of most aspects of the spectacle, from the building of a much-vaunted music pavilion that floated on barges

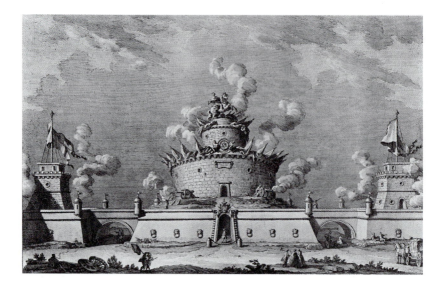

7.5 Giuseppe Vasi, etcher, after Giuseppe Palazzi, draftsman, and Paolo Posi, architect.
Prima macchina, 1759. Castel Sant'Angelo, etching, 1759.
Collection of Vincent J. Buonanno

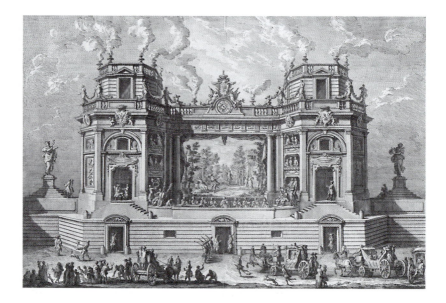

7.6 Giuseppe Vasi, etcher, after Giuseppe Palazzi, draftsman, and Paolo Posi, architect.
Seconda macchina, 1761, Un Magnifico Teatro, etching, 1761.
Collection of Vincent J. Buonanno

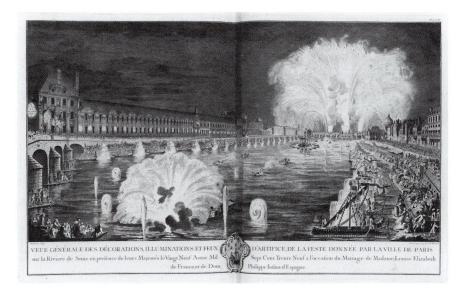

VEUE GÉNÉRALE DES DÉCORATIONS, ILLUMINATIONS, ET FEUX D'ARTIFICE, DE LA FESTE DONNÉE PAR LA VILLE DE PARIS
sur la Rivière de Seine en presence de leurs Majestés le Vingt Neuf Aoust Mil Sept Cent Trente Neuf a l'occasion du Mariage de Madame Louise Elizabeth
de France, et de Dom, Philippe Infant d'Espagne.

7.7 Jacques Blondel, *Veue général des décorations, illuminations, et feux d'artifice …*,
etching, in *Description des festes données par la ville de Paris : à l'occasion du mariage de
madame Louise-Elisabeth de France, et de dom Philippe, infant & grand amiral d'Espagne, les
vingt-neuviéme & trentiéme août mil sept cent trente-neuf* (Paris: P.G. Le Mercier, 1740),
n.p. Anne S.K. Brown Military Collection, Brown University Library

lashed together and covered with false rocks, lit from within through a scrim
of different coloured transparent fabric and containing an entire orchestra that
played all afternoon, to the individual designs for ornamental illumination of
the many boats that lined the river, each different and each kept lit for the
entire night. Even so, the author took care, at the bottom right-hand corner, to
inform readers about the vigilant security measures that robbed the remaining
shreds of darkness of its more sinister aspects (Figure 7.8).

It was said that the many illuminations and the magnificent fireworks
turned night into day for hours on end, reversing the order of nature
(Figure 7.9). This pyrotechnic feat was emphasized in the text by including
the order sheet given to the fireworks experts, listing every device by name.
The effect of the display is registered throughout the print by attention to
the effects of light as shadows and reflections everywhere. The deafening
fireworks are rendered with all the smoke and crackle, explosive force, and
splendour promised in the list of devices in the accompanying text, which
mentions cascades of fire, crazy rockets, and shooting stars among many
others. Presented at the end of a detailed description of all the parts of the
spectacle, the overall view of the city transformed by fireworks shows us

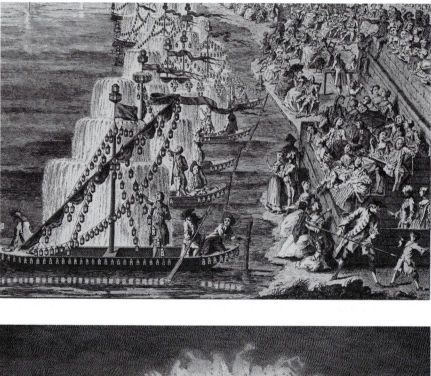

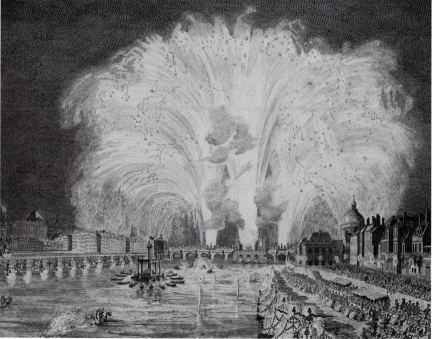

(*top*) 7.8 and (*bottom*) 7.9 Details, Figure 7.7

a perfectly orchestrated sensory symphony on a grand scale, for which the music pavilion floating in the Seine stands as a peaceful metaphor.[23]

The Chinea prints, especially against the background of other contemporary renditions of joyous festivals, look distinctly less joyful, even though reports at the time talked about the roaring explosions that were painstakingly undertaken by crack teams of fireworks experts, which also illuminated the night sky with a continuously unfolding dramatic display.[24] All the events promised free wine, music, fireworks, and a mixture of popular and elite participation that contemporary sources describe in the same appreciative language used in the French festival book. Even given that there was a conventional language for admiring these celebrations, even given that published sources would be written before the event or by people who had not actually attended it, and even understanding that the prints record the clear and instructive plans made by the architect for the set-builders rather than the finished set-piece itself, the distinct reticence on the part of the printmaker to evoke the sound of the exploding fireworks, the sophisticated lighting effects, or any indication of the crowds reported to have filled the piazza, is a matter of wonder.

Some of Giuseppe Vasi's Chinea prints (Figure 7.10) record set-pieces with explosive or carnival themes, and these are among the liveliest of the group. We see a rearing horse in the print from 1759, and an actual rendition of fireworks in the one from 1763 – one of only two such representations out of the 108 known Chinea etchings. The pyrotechnics are displayed here against a cloudy, but not dark, sky. Any potential of fireworks to turn night into day, or to deafen crowds, is visually absent here. Two symmetrical, drooping bouquets of fireworks disrupt Vasi's even-handed screen of sky in such a way that we begin to doubt whether we are looking at a picture of real fireworks or if the whole thing is a painted backdrop, complete with trees in the far distance that were certainly not part of the urban landscape around either the Palazzo Colonna or the Palazzo Farnese. An imaginary, rustic carnival parade works its way towards the foreground.

In 1788, when the Neapolitan King Ferdinand IV definitively put an end to the Chinea spectacles, calling the tribute ceremony 'an indecorous shackle of a chimerical feudalism', the part of the festival that the Roman people seemed to miss the most was the fireworks display.[25] There were over 6,000 of these fireworks embedded in every set-piece, but you would never know it from the Chinea prints.

Giuseppe Vasi's deadpan line work is not an Italian convention – the Venetian printmakers, especially, seemed to care about pressuring their printed lines in novel and signature ways. What in Vasi's work would compare with the short, stippled flecks that distribute light over an array of varied shapes and textured surfaces as we see in Tiepolo (Figure 7.11); or the richly massed, contoured sheaves of line from which Piranesi constituted shadow,

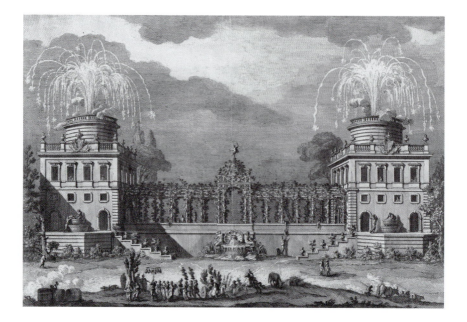

7.10 Giuseppe Vasi, etcher, after Giuseppe Palazzi, draftsman, and Paolo Posi, architect. *Seconda Macchina, 1763: una Vendemmia (a grape harvest)*, etching, 1763. Collection of Vincent J. Buonanno

brick, and bristle (Figure 7.12); or the swashy loops that served Canaletto for the foam, clouds, and reflections that were so necessary to his watery Venetian views (Figure 7.13)? In 1749 the King of Naples needed a festival book made to record a real Cuccagna that he commissioned to celebrate the birth of an heir. Piranesi gave it a try, but the King pronounced it 'truly bad', and gave the job to the Southerner Vasi, a Sicilian from Corleone.[26]

From that year on, Vasi held the title of royal printmaker to the Bourbon court, and an enviable apartment in the Palazzo Farnese where he lived and had a studio.[27] From the balcony of this palace Benedict XIV had spent part of an afternoon in 1745 comparing his impression of a festival etching with the set-piece he could observe at his leisure in the facing piazza, a comparison of the 'real' set-piece with its printed representation that was described as a delightful activity, and something people liked to do with their prints.[28]

The overt, flatfooted fakeness of the Chinea prints signals the conflation of the real and the false on several registers, something that was remarked on as a source of pleasure for viewers. We see it particularly in Vasi's etching of the *Seconda Macchina* for the 1761 Chinea celebrations (Figure 7.6). In printed *relazioni*, and in letters, the lifelikeness of the architecture of the Chinea prints emerged in appreciations of the simulated marble, or the truly stony-looking

stones acknowledged in the same sentence to be made of stucco. The papier-mâché figures on the balustrade of this set, which emulated real statues, were painted to look like marble or bronze. Frame-breaking additions like painted fountains that jetted real water, or real lamps inserted in painted architecture, were also admired.[29] And in pieces like this one, the second structure displayed and ultimately detonated in the Piazza Farnese in 1761, the sound of music that filled the piazza from actual musicians inserted among the stucco ones prompted descriptions in the *Relazioni* of the false musicians and the painted spectators watching them from their boxes as confoundingly real.

The set-piece represented

7.11 Detail, Giovanni Domenico Tiepolo, designer, after Giovanni Battista Tiepolo, painter, *Venice Receiving Neptune's Homage*, etching, after 1750. Museum purchase: gift of Mrs. Murray S. Danforth, Museum of Art, Rhode Island School of Design, Providence

a festive Theater of Music, in no way deformed from real life, neither in its symmetry and proportion, nor in the exquisite pictures of the Scene, where it could easily surpass a real Theater … It wasn't only the Theater itself that formed the Spectacle, the scene had people, who even if mute and of stone, represented nonetheless perfectly, in their clothing, their attitudes, and perhaps also in their likeness, known actors … mute like this they could not be said to be speaking, but they aroused a pleasure in the soul proportionate not only to the memory of something pleasant, but also in the exact correspondence of the fake with the real. Indeed, as regards the Orchestra, when it was finished off with a quantity of Stucco Musicians, nothing was lacking because no other pleasure was given besides this one, that arose just from admiring them: that their inaction was supplemented by as many real players who from time to time could be heard repeating some of the harmonious symphonies that accompany the renowned Opera.[30]

Vasi seems to take care to signal the art in all this confabulation, a constant feature of the Chinea prints that also seems to deflate attempts we make to find them as lifelike as contemporaries claim to have done. Therefore on the left side of the stage the depictions of viewers in their boxes, in shadow, conform to the flat surface of the canvas stretched over the wooden frame of the fireworks base. On the other side the viewers are shown brightly lit, emphasizing the illusion of depth and causing viewers of the print to wonder if on the right side of the image the print represents viewers as flat paintings on canvas or if here they become stucco figures in boxes. It could be either, or

7.12 Giovanni Battista Piranesi, detail of *Del Castello dell'Acqua Giulia*, Tav. IV, etching, from *Le rovine del castello dell'Acqua Giulia* (Rome: Generoso Salomoni, 1761). Collection of Vincent J. Buonanno

they could represent the illusionistic effects of real lamps playing on trompe l'oeil painting, all things that regular festival-goers would expect to see.[31] In the centre a backdrop representing a popular opera as acted by recognizable actors cavorting in a garden was painted in enough detail so as perhaps to be recognizable to the real public, signified in the foreground by the lowest tier of arriving carriages.

At the foot of the painted backdrop the stucco musicians play stucco instruments, painted to look real, which – since we know that they were there from time to time – may include actual human musicians playing real music from the pictured opera, but we can only guess at which ones are real and which ones are fake – something we already know from the descriptions was held to be one of the amazements and pleasures invited by these set pieces. In the audience in the boxes, seen enjoying their last moments of worldly pleasure before being blown up at nightfall, the audience in the piazza can feel an anticipatory, perhaps moralizing thrill signalled in the smoke already beginning to issue from the plaster vases on the balustrades. On the balustrades, too, are the last register of living forms, as stucco or papier-mâché mythological figures such as putti, two-tailed mermaids, and timeless-looking women imitating antique sculpture made of stone.

7.13 Detail, Antonio Canal (Canaletto), *Imaginary View of Padua*, from the series *Vedute Alter Prese da i Luohgi Alter Ideate*, etching, c. 1735–1746. Gift of Mrs. Murray S. Danforth by exchange, Museum of Art, Rhode Island School of Design, Providence

Between 1729 and 1750, the year after Vasi became royal printer, there appeared a subset of the Chinea prints that people have not cared much to talk about. Most of them were designed by pensionnaires of the French Academy in Rome. Rather than emphasizing the set designer's triumph of artifice and ingenuity in constructing elaborate allegorical fireworks bases in the familiar *piazze*, they presented viewers with the allegorical and mythological scenes as if they were actually taking place before them. Leaving out the architectural framework altogether, they concentrated on the fantastic scenes as if they were indeed live actors swarming towering stage sets for an immersive dramatic production, or at least an ambitious tableau vivant, as we see in a Chinea print of 1739 (Figure 7.14). If you were familiar with the genre you would recognize the Chinea himself dressed up as Pegasus, and assume that the craggy Helicon was staged atop a monumental arch – but you needed to

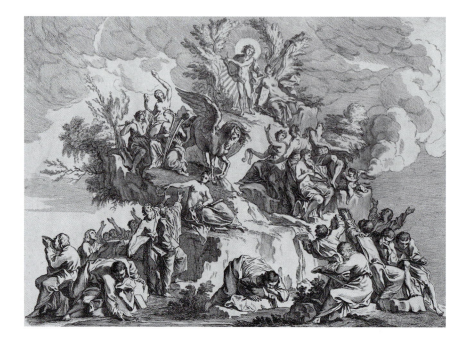

7.14 Michele Sorellò, etcher, after Pietro Parrocel, draftsman, and Michelangelo
Specchi, architect. *Prima Macchina, 1739 (Mount Parnassus with Apollo, the Muses, and
the Horse Pegasus)*, etching, 1739. Collection Vincent J. Buonanno

be in the know. The expense of the Colonna family and the ingenuity of the
bombardiers go by the wayside in favour of activating the fulsome allegories.

In the end, there was a clear preference for the image of the stage set
emphasizing its constructed nature, but without the framework of the
surrounding permanent palace architecture. This is explicit in the fact that
after 1750 and the advent of Vasi, with exactly one single exception in the
Prima Macchina of 1763 that showed a ghostly image of the Farnese Palace in
the background, this was the model for every Chinea print that followed.

Lines of Inquiry

The students in my seminar decided that what they needed here was a better
period eye. Just as Quattrocento viewers would be used to gauging barrels
and assessing ultramarine, Ottocento viewers would be used to trying to
distinguish between what was documentary and what was fabulation: there
were really fireworks, but was there really a carnival parade? They would
look for what was three-dimensional and what was backdrop, which was

the effect of real lighting and which was painted, discriminating among the figures in the festival prints just as they would admire these tricks in a stage set. After 1750 they would be doing this without the inclusion of the distinctive geographies of the set-piece's aristocratic surroundings, or any indication of the known space they occupied. A good deal of the particular structure in the *Seconda Macchina* of 1761, contracts show, was a flat canvas that was painted on both the front and the back, so that the noble viewers inside the palace would have the same version of the view as the crowds in the piazza. But there is no way to know how much was painted canvas. Part of it *purports* to be painted canvas: the backdrop for the popular opera that is represented as being performed on the stage. At the very least, it was a painting of a painting, but it very well could have been a painting of a painting of a stage with its scene and actors and audience, and your guess is as good as mine about whether it was a painting of stucco musicians and papier-mâché statues. It certainly is a print of that.

The evenly calibrated, impassive etchings that give little away about the experience of the magnificent celebration at the expense of the Colonna show us at the same time *il finto e il vero*. Vasi's evenly spaced lines keep those distinctions in tension, depicting the fake and the real without distinguishing too much between them. We have the print because it was given or sent to somebody who saved it, a gift of curiosity filtered through Vasi's even-handed linear screen. The person who turns to look at us from the fine carriage that hurtles towards a blind door made of vertical lines (Figure 7.15) – isn't he worried, like we are, that there might not really be a door there? Where is he going at such breakneck speed? To join his painted companions in the Magnificent Theatre of Music? Through the Looking Glass into the Farnese Palace on the other side?

Folded into albums, as virtually all of these prints once were, to be looked at with friends, these Chinea prints trade in the same visual tricks as those masters of illusion, the *festaiuoli*. If they are lacking as documents of the festival experience, they are interesting documents of viewing experiences: both of stage sets, in public, and of prints, in more private settings. They are not only representations of an act of perception, as Baxandall wrote about Chardin, or in this case, willed misperception, *but a machine in themselves* for re-mobilizing that kind of perception in viewers of the prints.[32] It's no longer a game we really want to play, and it becomes clear that Vasi did not make these prints for us. But if we enter into the Chinea prints not wanting them to be Blondel, or Piranesi, but looking at Vasi's signature lines as effects with which *he* asked riddles in a meaningful visual language, we then gain access to a variety of early modern curiosity on its own deeply unfamiliar terms. We have sharpened our sense of the pictures, and are able to create a dialogue about them.

7.15 Detail, Figure 7.6

Notes

1 Most recently and fully: Andrew Delbanco, *College, What It Was, Is and Should Be* (Princeton: Princeton University Press, 2012); Martha C. Nussbaum, *Not for Profit: Why Democracy Needs the Humanities* (Princeton: Princeton University Press, 2010); and a host of impassioned commentaries on academic websites and public opinion pages.

2 Michael Baxandall, *Giotto and the Orators: Humanist Observers of Painting in Italy and the Discovery of Pictorial Composition, 1350–1450* (Oxford: Clarendon Press, 1971); and, by the same author, 'A Dialogue on Art from the Court of Leonello d'Este', *JWCI*, 26 (1963): 304–26; 'Bartholomaus Facius on Painting: A Fifteenth-Century Manuscript of the *de Viris Illustribus*', *JWCI*, 27 (1964): 90–107; 'Guarino, Pisanello and Manuel Chrysoloras', *JWCI*, 28 (1965): 182–204; and finally, on modern art history: 'The Language of Art History', *New Literary History*, 10, no. 3 (Spring, 1979): 453–65.

3 Michael Baxandall, *Painting and Experience in Fifteenth-Century Italy: A Primer in the Social History of Pictorial Style* (Oxford: Oxford University Press, 1972; 2nd edition, 1988).

4 Frederick Hartt, *The History of Italian Renaissance Art: Painting, Sculpture, Architecture* (Englewood Cliffs, NJ: Prentice-Hall, 2006; New York: H.N. Abrams, 1969), continually updated and republished, most recently by David G. Wilkins.

5 Kendall Curlee, *The Sforza Court: Milan in the Renaissance 1450–1535* (Austin: Archer M. Huntington Art Gallery, 1988). The exhibition was curated by Andrea Norris and travelled to the University Art Museum, Berkeley, 18 January–12 March 1989.

6 Michael Baxandall, *Shadows and Enlightenment* (New Haven: Yale University Press, 1995).

7 Michael Baxandall, *Patterns of Intention* (New Haven: Yale University Press, 1985), 81.

8 See Alberto Frigo's illuminating intervention on Baxandall's interest in Gramsci in this volume.

9 Hans Ulrich Obrist, 'Interview with Michael Baxandall', *Res*, 2 (May 2008): 43.

10 Michael Baxandall, 'The Language of Art History', *The New Literary History*, 10 (Spring 1979): 454.

11 'The Festive City', co-curated by Evelyn Lincoln and Emily Peters, the RISD Museum, 21 December 2012–14 July 2013.

12 The prints are part of the extensive, and otherwise magnificently printed, collection of Vincent J. Buonanno.

13 Francis Sandford (1630–1694), *The history of the coronation of … James II … and of his royal consort Queen Mary … 23 of April … 1685. With an exact account of the several preparations in order thereunto … By his Majesties especial command …* (London: In the Savoy, printed by T. Newcomb, 1687), 200.

14 John E. Moore, 'The Chinea: A Festival in Eighteenth-century Rome' (PhD diss., Department of Fine Arts, Harvard University, 1992); and by the same author, 'Prints, Salami and Cheese', *The Art Bulletin*, 77, no. 4 (December 1995): 584–608; 'Building Set Pieces in Eighteenth-Century Rome: The Case of the Chinea', *Memoirs of the American Academy in Rome*, 43, no. 44 (1998/1999): 183–292; and 'Some Comments on Giuseppe Vasi and the Festival of the Chinea', in James T. Tice and James G. Harper (eds), *Giuseppe Vasi's Rome* (Eugene: University of Oregon Press, 2010), 59–66.

15 Moore, 'Prints, Salami and Cheese', 584. The discussion that follows on the history of the Chinea festival proceeds entirely from Moore's extensive documentary study in his dissertation and articles, as in n.14.

16 Moore, 'Prints, Salami and Cheese', 584.

17 Moore, 'Prints, Salami and Cheese', 586, for the 'ambiguous relation between the prints and the set pieces'.

18 Moore, 'Building Set Pieces', 257–8.

19 Moore, 'Building Set Pieces', 238.

20 Mario Gori Sassoli, *Della chinea e di altre 'macchine di gioia': apparati architettonici per fuochi d'artificio a Roma nel Settecento* (Milan: Charta, 1994), 35.

21 Moore 'Prints, Salami and Cheese', 584, 592.

22 Jacques Blondel, *Description des festes données par la ville de Paris: à l'occasion du mariage de madame Louise-Elisabeth de France, et de dom Philippe, infant & grand amiral d'Espagne, les vingt-neuviéme & trentiéme août mil sept cent trente-neuf*

(Paris: P.G. Le Mercier, 1740). On the illuminations and the festivities for that festival see: Eric Monin, 'The Speculative Challenges of Festival Architecture in Eighteenth-Century France', in Sarah Bonnemaison and Christine Macy (eds), *Festival Architecture* (London and New York: Routledge, 2008), 155–80.

23 Moore, 'Building Set Pieces', 262: 'The arrangement of fireworks displays required a sense of timing and an ability to fashion a satisfying whole from a multiplicity of parts, qualities that could be likened to the direction of musical or theatrical performance.'

24 Moore, 'Building Set Pieces', 257–63.

25 Moore, 'Prints, Salami and Cheese', 584. The Chinea payments continued until the late nineteenth century, at which point the then king paid for the Marian column of the Immaculate Conception in the Piazza di Spagna and had done with it. See also: John Robertson, 'Enlightenment and Revolution: Naples 1799', *Transactions of the Royal Historical Society*, 10 (2000): 31.

26 Tice and Harper, *Giuseppe Vasi's Rome*, 92. The book is: *Narrazione delle solenni reali feste : fatte celebrare in Napoli da Sua Maestà il Re delle Due Sicilie Carlo Infante di Spagna, Duca di Parma, Piacenza &c. &c per la nascita del suo primogenito Filippo Real Principe delle Due Sicilie* (Naples: 1749), with Vasi's etchings after drawings by Vincenzo Rè.

27 For Vasi's ground floor apartment and studio in the west corner of the Palazzo Farnese from 1760–1782, see: Moore, 'Building Set Pieces', 191.

28 Moore, 'Building Set Pieces', 233; and Moore, 'The Chinea', 587, n.20, and 600–601.

29 Moore, 'Building Set Pieces', 247, for applications of real and false greenery: 'Whether flowers, garlands, or the like were used within the palace is not indicated here, but the inclusion of plants, flowers, and waterworks within ephemeral structures was common practice in Roman festivals.'

30 Gori Sassoli, *Della chinea*, 36 and 68; Moore, 'Building Set Pieces', 198: '… e per lo applauso riscosso volgarissima Opera Drammatica, muti così non possono dirsi, che non sembrino parlanti, o non destino almeno proporzionato il piacere nell'animo per eccitamento non solo nella riminiscenza di cosa gradita, ma ancora per il rincontro, e corrispondenza esatta del finto col vero. Anzi se riguardasi l'Orchestra, avvegna che rifinita di quantità di Suonatori di Stucco, nulladimanca però alcun altro compiacemento tramanda oltre quello, che dal solo mirarli proviene: giacchè supplita la loro inazione da altrettanti veri Professori, sentesi tratto tratto ripetere alcuna delle armoniose Sinfonie, che accompagnarono la rinomata Opera.'

31 Moore, 'Building Set Pieces', 231, 233, and 247, on the difficulty of knowing what was three-dimensional and what was not. Page 247: '"Reading" prints or similar visual records of festivals for their political, historical, and symbolic content is a rewarding exercise, but the graphic record bears little immediately or unambiguously discernible relationship to what was constructed. There is no easy distinction between "true" and "false"; at issue are a series of approximate understandings of historical objects that are always difficult to retrieve and were, moreover, designed not to last.'

32 Baxandall, *Patterns of Intention*, 95, on Camper's optical argument on acuity.

Pattern and Individual: *Limewood Sculptors* and *A Grasp of Kaspar*

Peter Mack

Michael Baxandall (1933–2008) was primarily a writer. On leaving Cambridge he hoped to write novels and did eventually publish a fascinating one, but he enjoyed great success as a writer about the relationship between visual art and social history. This essay will focus on two of his books, *The Limewood Sculptors of Renaissance Germany*, perhaps his most distinguished work in the field of art history, and his novel *A Grasp of Kaspar*, begun in the mid-1980s, completed in 2005, and published posthumously.

I shall begin by considering the organization, preoccupations, and achievement of *Limewood Sculptors*; then I shall investigate some ways in which *Kaspar* reworks and builds on ideas expressed in *Limewood Sculptors*; finally I shall address the question of what *Kaspar* adds, what fiction permits Baxandall to write about which he could not express in art historical scholarship.

Michael Baxandall often described his task as 'the historical explanation of pictures', as if he wanted to explain how we could express what we see in paintings by thinking and talking about how they came to be produced. He also called this 'inferential criticism'. In *Limewood Sculptors* he wanted to understand the larger social, commercial, and religious structures and functions governing the trade of limewood sculpture and how individual sculptors worked within them. He tried to develop a historical sense of the sculptures which could also respond to the subjectivity of both the artist and the modern viewer.

The first six chapters of the book are devoted to providing the reader with an array of tools for understanding the production of the sculptures which are then in the final chapter tested and exhibited (one might almost say proved) against the experience of looking at works by four of the sculptors. Wherever possible Baxandall investigates the categories through which contemporaries understood their visual experience, working for example from the theory

of the four temperaments, categories developed by the mastersingers for analyzing poetry and writing stage directions, manuals of dancing and fencing, and Paracelsus's theories about the different ways in which the interior nature of things is revealed by external signs, including chiromancy. Typically he arranges these categories as lists in order to make them available to his readers for their analysis, as well as to enable them to evaluate his own use of them.

Alongside lists and categories, descriptions play a large part in the book. Baxandall described the image before him in order to bring out the effect of polychrome wood sculpture on the viewer[1] or to describe the process of looking at Tilman Riemenschneider's *Altarpiece of the Holy Blood* from Rothenburg through the different lighting conditions of a day.[2] In the way in which they work with (and sometimes against) the systems of categories which the earlier part of the book has built up, the descriptions of the final chapter[3] justify his method by making the reader see and appreciate these sculptures in an entirely new way. The way Baxandall brings out the features of the sculptures gives them a different level of visual interest for his readers. They will never again look as they did before.

Throughout the book Baxandall develops a strong sense of place: the character of the different cities and their different forms of government, the trade-routes of Southern Germany, the local pilgrimages and saints, the location of forests, and the uses of different sculptural media in different places. The book opens with a sketch of three generations of sculptors, explaining the choices they were able to make between different styles, helpfully set out as a historical and geographical diagram on page 17.[4] Baxandall understands both 'the mind's need for patterns' of this kind and the limitations of such patterns.[5] While the book is devoted to giving us a scheme of ideas with which to approach South German sculpture, he tells us that the aim of the final chapter is to 'soften the schematic character of the general account by setting individuals against it'.[6]

The achievement of the book derives from both aspects: the extraordinarily rich ostensive descriptions of particular sculptures and the range of social historical features which are offered to his readers as ways of approaching the sculptures. Baxandall builds up a picture of the constraints operating on the artists, which also becomes a means of understanding their achievement. Through images and direct quotation of primary sources, he invites his readers to interest themselves in the materiality of the wood (and in particular the value and sacredness of limewood); the woodworking tools and the carving motions available to the sculptors; the nature of the commissions, including both their religious implications and the role of the retable as a social statement; the conditions of the workshop; the situation of the guilds and their relation to incipient international market capitalism; the meanings of individual commissions (such as that for Blaubeuren);[7] and the categories

with which contemporaries understood their visual experience and the nature of images. It seems that Baxandall enjoys providing his readers with comprehensible, basic information in a range of fields and showing them how these concerns are reflected in the form of the sculpture.

Baxandall places considerable emphasis on style, as a response to the medium, as a characteristic of an individual sculptor, and as a way for that sculptor to achieve expressiveness. Early on in the book he explains that the Florid style of sculpture is the one he admires in this period.[8] He argues that the properties of limewood and the way that it shrinks with age establish a scale of sculptural performance between 'relaxed stability' and 'flaunted stress'.[9] The sculptors 'use the chiromantic register of limewood, both to establish a personal style – for some sculptors consistently work towards one end or the other of the gamut – and to move up and down their own range, to make particular points of this kind'.[10] He shows how individual artists develop a personality by making choices between different available styles and how awareness of such stylistic mannerisms and choices can help us read the sculpture. A chapter of the book is devoted to the tension between developing an individual style and making expressive choices within developing national styles, here characterized as the 'Welsch' (or Italianate) and the 'Deutsch'.[11] His interest in the implications of style is also expressed in his discussion of the decorum involved in different types of presentation of female bodies in religious sculptures.[12] Baxandall admires the virtuosity of the sculptors' woodcarving but also the elegance of their individual expressive choices.

Baxandall is strongly interested in guilds and the conditions of trade[13] but he manages to connect this with the choices made by the individual sculptor. He writes of the market as 'one medium through which a society can translate both general facts about itself and such preoccupations about art as it possesses into a brief the artist can understand'.[14] He always seeks to intertwine the 'collective facts of the sculptors' circumstance' with the individual choices made by the sculptors. The circumstances offer the artist 'a vast repertory of alternative stimulations and suggestions'.

> He in turn would be seen to respond to some, deny others, draw yet others out of some quite different subjective resource, and combine all into a sum and order peculiar to himself. Forms may manifest circumstances, but circumstances do not coerce forms. Precisely this gives the best works of art their curious authority as historical documents: the superior craftsman, and only the superior one, is so organized that he can register within his medium an individual awareness of a period predicament, but his meaning lies as much in how he has formulated the challenge of circumstances as in how he responds to it.[15]

Knowledge about the circumstances helps us to see new visual interest in individual sculptures; circumstantially read, the sculptures can provide us with insight into the way the sculptor formulated the challenges of his brief and his historical situation.

A Grasp of Kaspar shares many of the preoccupations of *Limewood Sculptors*. Above all, characters in the book offer us schemas for understanding the behaviour of other characters, most often, but not only, the absent Kaspar, whom Briggs and the reader are attempting to grasp. In chapter 8, his friend Klaus offers Briggs a theory of the relationship between excitement (E) and repose (R) in the range of feeling which individuals experience at different times.[16] According to Klaus, Briggs typically moves between values of 3E/1R at high points of excitement and 1E/2R at low points. Klaus believes that Briggs is sometimes attracted to women who prefer a much higher ratio of excitement, in the case of Inka, moving between 9E/1R at high moments and 1E/1R at moments where repose is strongest. According to Klaus a lasting relationship depends on there being some quite approximate sort of match between the curves of the two individuals. His view is that when Briggs and Inka met they were both around 3E/1R (at the top of Briggs's range and near the bottom of Inka's) but that she kept swinging off upwards and he downwards.

> You will allow me, old friend, to say that you are immediately attracted by women on a much steeper *E/R* curve than yourself. For a time they stimulate you, and you depress them, but then later ...[17]

Briggs rejects the model as far too schematic (and also too simple) and Klaus replies that it was only a teaching device, but he presses the point that Briggs should think about it, especially in the light of his developing relationship with Mechtild, Kaspar's wife.

> I was just looking for a colourful analogy – my teaching instinct. And I am struck by the look on your face. I know it: like someone just off a *piste* several degrees too fast for them. But you are right to imply that I am not a tender of souls. Even so, do think about it ... I must go.[18]

My sense is that the reader will reject Klaus's model for much the same reasons that Briggs does, but will also notice the warning. In terms of ordinary prudence Briggs is getting more involved in a thriller plot than is wise for someone of his personality; in terms of the genre of fiction, of course, we require him to become involved, to follow the clues, creep up on the putative villains, sleep with the available woman, and so on. But there also seems to be an overlap (or even a rough approximation) between Klaus's mathematically expressed view of human personality and Baxandall's exposition of the location of individual sculptors in relation to the 'relaxed stability' and 'flaunted stress' of limewood sculpture in the Florid style.

The question of the relationship between the schema and the individual is raised again when Briggs offers his Italian friend Pasquale an outsider's sketch of the predicament of Laura Bragagnolo as 'Italian woman'.[19] Pasquale rejects the sketch and gives Briggs a short description of Laura's life.

As for your curious last point [a supposed resemblance between Pasquale and Laura's son Riccardo], Riccardo and Laura and I are all Lombards. To the ignorant all Chinese look the same.

There are more of my type of Laura Bragagnolo than there are of yours.

Of course. Agreed. But you put the cart before the oxen. You let the type be the origin, and individuality be fallings-away from some first mould. Whereas I, with a livelier sense of life and altogether more generous view, see people as unique in origin. Sure, they later converge into type, but that is because of shared ... *Dio mio*! this is stupid.[20]

Here the Gramscian Pasquale gives Briggs a lesson in the limitations of using general patterns of social life ('the predicament of the Italian woman') as determinant of individual experience. Briggs is an economic historian of medieval Southern Germany and likes to see money and trade as the dominating social development. Both Pasquale and Mechtild accuse Briggs of mis-seeing reality through sentimental stereotypes,[21] but the human need to construct simplifications and schemata is at the heart of many of the inferences all characters draw in the novel. The genre requires that elements of the puzzle be investigated and unravelled, but Baxandall keeps showing us the limitations of the schemes of explanation proposed even by the characters with the largest views and the best intentions. The relationship between general principles and special cases is also a major part of Don Ivo Pavan's reflection on casuistry,[22] which frames one of the key narrated episodes of the novel.

Without losing its character as a novel, *Kaspar* also resembles *Limewood Sculptors* in the range of types of material which can be included. The most striking example is a long and very Baxandallian passage on alpine paths, the production of cloth, and the technology of weaving to a pattern, which Mechtild quotes from Goethe's *Wilhelm Meister* at the end of chapter 7, and which Briggs reads at the end of chapter 8. There is an extract from an awful lecture on Jacopo D'Abbiategrosso which mocks self-satisfied academic mannerisms. Much of the middle section of the book[23] is devoted to narratives of war-time Pavia from the resistance fighter Aldo Guardamagna (a name borrowed from the Pavian experience outlined in *Episodes*[24]) and the Rector of the Collegio Praga, Don Ivo Pavan, who may be connected with Don Cesare Angelini, Rector of the Collegio Borromeo.[25] The novel also includes passages of detailed visual description of landscapes, paintings, and a wooden sculpture of St. Roche and short disquisitions on the human landscape of the Po valley,[26] the geology of the upper Rhine region of Switzerland,[27] and topics of interest to the social historian. Some of these short essays are framed as if they are thought by Briggs;[28] others are unknown to him[29] and serve as scene-setting by the narrator.

These short inset passages have the effect of introducing many of the social historical preoccupations of *Limewood Sculptors* into the novel. The interests in the relations between geography, trade, and social history shine out in many passages.

> The main point about Kempten was that this was where the cotton road had come in over the mountains from the south-east – from the Brenner pass and Venice and the Levant. Briggs's people had needed that Cypriot cotton to weave their fustian. But in the course of getting it they had also got cleverer. Along with the bales of cotton came a bundle of Italian tricks – ideas about partnerships, dry interest, analytical book-keeping, gearing-up, generally how to put florins to work. It was a period of commercial ingenuity out of which operators like Fremont Funds and the Schulte Bank were fairly straightforward developments.[30]

Like *Limewood Sculptors*, *A Grasp of Kaspar* concerns itself with old maps and trade-routes, with the way the passes run over the Alps, and with the chances for medium-sized stretches of water transport along the long pack routes south and east. There is a continuing preoccupation with the relationship between transfers of money and matters of more human significance, introduced by Maria's jocular reference to one of Briggs's articles (or perhaps his thesis) 'Movements of money and movements of mind',[31] which she then wittily develops into an imaginary conversation between William Briggs and Klaus.

> But Willi would reply: of course they are not homologous. One must learn the language of money, the grammar within which a money operation signifies as a declaration of values and perceptions. Money is not a neutral medium, he would say, it has its own formal energies. And he would go on to argue – shifting his ground here, rather – that money is as much an aesthetic medium as words, almost a glass-bead-game. People play with it, enjoying their skill. So that when you know the financial forms of an age you have something like a literature, even like a cathedral – an art that embodies in its forms the mind of that age.[32]

Here Maria seems to be engaged in a playful development, perhaps even in a refutation through over-extension of the implications, of ideas which *Limewood Sculptors* presents seriously. There is also some typically alert discussion of visual response and of different types of light, particularly when Briggs uses very Baxandallian visual knowledge to evade his pursuers in a *piazzetta* in Pavia.

> He was no more than eight feet above the ground and within the line of sight of almost everyone in the *piazzetta*. But several things, he reckoned, should be working for him. First, they would expect him at ground level. Second in the lee of the *colonnette* he was in the deep shadow made by the floodlight behind it. Third, the abrupt brightness of the *piazzetta* was generally disorganising of perception. Rods recoiled, cones were caught unawares: the sensorium was thoroughly put out. He had felt it himself.[33]

Briggs's thinking about the way the light of the piazzetta will help to conceal him is very similar to the way in which Baxandall writes about visual perception, particularly in *Shadows and Enlightenment*. Two of the most important clues about Kaspar are provided by descriptions of his paintings. This is Briggs viewing the painting in Kaspar's rather inexpressive living room ('Matters had not been shaped by interest, or by use'):

> … but on the wall over the fireplace was a big, slightly chunky view of a medieval Italian town with tall brick towers. The painter had left much of the detailed underwork showing through, and this seemed to be in some parallel-perspective convention, like a mechanical drawing. Over this he had sloshed about more freely, playing with effects of light and appearance. There was a signature in the bottom right corner: KL '44.[34]

Later Briggs admits that he likes the painting, which Mechtild thinks that Kaspar keeps 'almost penitentially'.[35] Later we learn that this painting was made at one of the crucial moments of Kaspar's life.[36] Here by contrast is the more developed view of the more inferential Don Ivo on a painting of the bridge over the Ticino, the Borgo and the city of Pavia which Kaspar gave him:

> Strange, no? In one aspect it is an engineer's diagram, a Euclidean reduction of complex things to some scheme of reality beneath. In another it is a child-like exclamation of raw colours. Prudent with lines: vehement, exasperated, I would almost say blustering, with hues. And we see the two aspects clearly because these two artists are clearly not on intimate terms with each other. And then, do we not see this even rather *too* clearly? Perhaps they are knowingly enacting, personating conflict? Kaspar gave me this picture, I think, as a declaration.[37]

Don Ivo sees more in the painting partly because he wants to think about the way it was painted and what the painter might have either revealed about himself or intended to suggest by painting it that way, and partly because the painting is only one illustration in a more general meditation-cum-narrative on the state of Kaspar in 1944. As well as showing us that Don Ivo sees more than Briggs, this ekphrasis forms part of Don Ivo's attempt to help Briggs understand Kaspar, possibly as some sort of recompense for Don Ivo's vaguely guilty feelings about the way in which his casuistry had intervened in Kaspar's thinking about himself. Part of the description of the state of Kaspar's mind involves Don Ivo quoting his comment on the material nature of painting, spoken in shock to Florian Schulte, at the moment of learning of what he took to be the execution of his best friend Peter Vogt after the attempt on Hitler's life.

> 'It is mostly flax, you know', he said. 'When painting, one is playing with flax. Heterogeneous but mainly mineral dye-stuffs are suspended in the oil of flax seeds: linseed. That is what the paints are. And the fibre of flax stalks is spun single-warp – *single*-warp – then bleached and plain-woven. That is the canvas. One smears the first on the second.'[38]

This, the longest direct quotation from Kaspar in the book, gives us a precise, ironic view of human activity. The words were spoken, according to Don Ivo, 'in a neutral but quite good-humoured tone, like a man instructing students'. In comparison with Baxandall's attention to the materiality of limewood and woodworking tools, this comment has less appreciative wonder and more of a witty sense of futility. Kaspar uses it to escape from the questions which Schulte and Don Ivo seem to be about to pose.

There are also some coincidences between *Limewood Sculptors* and *Kaspar* which may signify no more than shared authorship or may perhaps suggest a certain playfulness of the novelist in relation to the historian. First, and I think this must be significant, Baxandall gives Kaspar the surname Leinberger, the surname of the last great master discussed in *Limewood Sculptors*, whom Baxandall perhaps admires more than any of the others and whose Virgin and Child 'largely rebuffs the equipment the book has assembled'.[39] Although he concedes that it would be possible to discuss Leinberger's art in the terms set out in the rest of the book,[40] Baxandall makes it clear that Leinberger's real artistic interest lies elsewhere.

> Leinberger's is very much a phenomenalist sort of art in that it forces us to see it as consisting of an intricate act of serial perception by ourselves rather than in a wooden artefact, as a process and not a thing: to stretch a phrase, a Leinberger sculpture is a permanent possibility of *cumulative* sensation.[41]

I would not want to press the point, but one could come to think of that remark about Leinberger's sculpture as presaging a possible grasp on Kaspar.

A second coincidence arises from the strong and strange use of the verb 'impend', in the opening sentence of chapter 1: '"Just hang around the better bars and impend", Charlie Livingston said, fluttering a hand in the air to show how.'[42] 'Impend' is very rare and striking as a main verb and may even be unprecedented as an imperative.[43] The participle 'impending' is by contrast very frequent, as in such phrases as 'impending disaster' (almost a cliché) and 'impending deadline'. A few pages later Briggs gives us his own view of Livingston's phrase: 'Hang around the bars, the better bars, and impend – Livingston had said, absurdly enough.'[44] But in point of fact, though one only notices this after reading *Kaspar*, 'impend' is also used a couple of times, apparently without absurdity, in *Limewood Sculptors*:

> Regensburg in the north, which had a fine Gothic tradition, did not produce in this period the quality of sculpture one might have expected: perhaps the old cathedral workshop impended too heavily.[45]

Here 'impend' must imply, slightly differently, that the traditions of the cathedral workshop dominated sculptor's practices and clients expectations so as to get in the way of the development of sculpture in the Florid style.

A second sentence employs the more usual participle, but in a sentence which strikingly draws attention to the writer's creating of and commentary on the reader's reaction: 'For some pages now the louring fact of the guilds has been impending; it is an authentic period sensation and should be savoured.'[46] The guilds have been demanding the attention of the art historian and his reader in just the way that they hung over the activities of artist and viewer. Waiting for the guilds is a sensation shared between historical subject and historian and as such should be savoured. The self-referentiality of the sentence both amuses the reader and provokes thought about the way in which history is made or imagined.

A third large coincidence between *Limewood Sculptors* and *Kaspar* concerns the company from Ravensburg. *Limewood Sculptors* has an impressive account of the trading activities and organization of the Great Ravensburg Company, which conducted substantial business in cloth, metal, spices, and 'portable cultural hardware' with Milan, Genoa, Valencia, and Barcelona and which incidentally promoted the sculpture of Jakob Russ through its resident agencies.[47] One page 100 we meet the Humpis family, one of the three families who founded the company. Briggs's entry into the narrative of *Kaspar* is a request from his friend Livingston to investigate the Ravensburger-Humpis Textilindustrie, the company *Kaspar* works for. Kaspar is married to Mechtild, the daughter of the 'chief' or 'patriarch' of the company.

Before addressing the question of what fiction adds, it is only fair to notice that there are one or two moments in *Limewood Sculptors* where Baxandall appears to be using the resources of the novelist to write art history. Near the end of chapter three he tries to imagine what a Florid sculpture which would not be offensive to the reformers might look like.

> What would a chastened image look like? It would not be very magnificent in its material, not *hurisch* or *kupplig* in its characterization, nor distractingly elaborate in its ornament and detail … .[48]

After exploring a number of positive qualities that such a sculpture would have and pitfalls which it would avoid, Baxandall concludes that 'the sculptor who came nearest to conciliating first-class Florid sculpture with such a pattern of piety was Riemenschneider'.[49] Working from the fiction of imagining a possible solution to the problem, Baxandall arrives at a statement about Riemenschneider, which he promises to qualify later since the demands of art and reform cannot entirely be reconciled.

From time to time he also allows himself types of authorial comment which might come more easily to the novelist than to the historian. On the attempts of the guilds to apply their statutes rigorously in order to protect the masters of the craft against both the journeymen and the merchants: 'It was not an elegant posture.'[50] On justifying his attempt to assemble a period approach to Florid sculpture:

> There is no question of fully possessing oneself of another culture's cognitive style, but the profit is real: one tests and modifies one's perception of the art, one enriches one's general visual repertory, and one gets at least some intimation of another culture's visual experience and disposition. Such excursions into alien sensibilities are a main pleasure of art.[51]

And a little later: 'One will coin a few categories authentic at least to the general visual experience of the period, so as to be able to close a little more with the sculpture.'[52]

These passages certainly work very well as history but to comment on the 'elegance' of a historical group, to justify one's historical procedure because of the pleasure it will give, and to announce the intention of coining some new old categories in order to get closer to the sculpture is unusually honest about the aesthetic and imaginative element in the writing of history. To my mind all three comments press concerns characteristic of fiction into the service of history. But fiction and history are more closely related than masters of both crafts usually admit.

So, what, finally, does the fiction of *A Grasp of Kaspar* allow Baxandall to talk about which the virtuoso art history of *Limewood Sculptors* did not permit? In the first place, writing fiction allows him to be more open in providing the pleasure which readers take from fine description, elegant narrative, and beautiful and far-reaching argument. What Baxandall (or perhaps Briggs) says about the different alpine passes may well be true but in the novel it gives the reader the pleasure of observing the process of elegant and wide-ranging thought, rather than asking to be understood as part of a larger argument:

> One way is to go by the St Gotthard, but Briggs disliked the St Gotthard as a forced and parvenu pass. He favoured the Splügen, which had been a going concern since Roman times. Passes, he believed, stand for the accessibility of success in the pursuit of knowledge and many other human endeavours. The last sharp climb to the summit is rarely the problem of a pass; and the immediate terrain of the summit itself tends to be much like that of any other pass, whatever the differences in the outlook. What sets the problem and the character of a pass is the lower approach. It had been the long sullen gorge of the Reuss on the northern side that had kept people from the St Gotthard for so many years, not the St Gotthard itself. Whereas they had been led early to the Splügen by the easy valley of the Upper Rhine on one side and the sparkling availability of Lake Como on the other.[53]

Briggs gives readers some food for thought about the nature of passes. They may or may not agree with his comment on the sameness of all summits (partly softened by his reference to the differences in the views from them). It is also interesting to reflect on the idea that all human endeavours have this same symbolic shape, differences and difficulties in the nature of the problem set and the initial approach taken, but an essential similarity in the process of achievement. The landscape and geographical description of the differences

between the approaches to the two passes offers a plausible explanation of the historical priority of the Splügen. Baxandall is not really trying to convince us of the validity of an argument here, but is giving us the pleasure of thinking about the question from different points of view, as we might in the best conversation. And the tone of Briggs's disdain for the St. Gotthard at the beginning is very amusing. This might be the moment to register that the decorum of fiction allows for more jokes than in art history and that Baxandall enjoys this liberty.

The descriptions of the book are often wonderful in themselves, but the special tone of the book arises from the combination of description and thinking:

> The valley was criss-crossed with lines of white light in various directions and at various angles. Though there was general continuity, there was also constant local change, individual lines of tracer ceasing and being replaced for a time by others, none persisting for more than a few seconds at a time, though they might recur. These lines were like some sorcerer's survey, bearing-lines which, if grasped as a whole and in relation, would give a plot of the shape and extent of the invisible valley. In addition there were occasional much more diffused global flashes of much less intense light, too diffused and brief to illuminate the lie of the land to the point of actual perception but giving rise to intuitions of possibility. It was all like some great act of constructive inference, Keplerian or Newtonian. Or it was a masque of the operations of such an act.[54]

Here the description begins by trying to register what the onlookers observe over time. The streams of light from the tracer bullets both enact some sort of narrative of their own and give clues as to the shape of the valley. They might even be representations of the measurements of angles and triangulations from which a surveyor might construct a map of the valley. The lights give enough information to suggest the possibility of knowing the landforms but too little to allow one to perceive them, like the fragments of knowledge from which great scientists can infer facts about the universe, or like a theatrical representation of the way in which scientific intuition works. The light sensations are interesting in themselves; the description of them is beautiful, but what really gives pleasure to the reader is to think first about the comparison with great science, second about the idea that this might be a masque, a contrived display rather than a reality, and third about the way this image and the comparisons offered relate to what Briggs and other characters have been attempting throughout the novel. Fiction permits such comparisons and speculations to range more freely, to be enjoyed more in themselves, than would be allowable in a history where every such connection needs to be asserted and justified.

A second and related advantage is that fiction allows the writer to scatter fragments of teaching, reflection, and erudition across the work, giving incidental pleasure to the reader and allowing the writer to express a range of

ideas, without the need to relate each element to a larger argument. Narrative of a single completed action gives to a text a kind of unity on which many different kinds of incidental material (not all of which need be central to the thought of the novel) can be draped. In many cases further reflection will suggest that the incidental idea *can* be related to the overall thought of the text, but the novel does not insist on this. Chapter 9 opens with a wonderful economic-historically reasoned explanation of the location of the mills around St. Gallen.[55] In the novel it is scene setting, but it gives the reader the pleasure of thinking and the writer the opportunity to express interesting incidental ideas clearly. It is a paragraph which might have appeared in Baxandall's art-historical writing on the early Renaissance textiles of northern Switzerland if he had transferred to a different department of the Victoria and Albert Museum.

These descriptions and elaborations offer the reader the possibility of making broader connections across the novel. Some of what Don Ivo says about casuistry ('One plots a position and proposes a course from bearings on fixed points in ethical doctrine and in natural law'[56]) looks rather different once the reader reflects on the processes of navigation which Briggs attempts on Lake Constance in chapters 31 and 32. The comparison between casuistry and navigation is itself suggestive and opens up connections with the interest in surveying and old maps elsewhere in the novel.

Thirdly, the form of the novel brings to the fore issues concerning the moral judgement of human actions which often seem out of place in scholarly history. Baxandall wanted to speculate about complex moral judgements, and the form of the novel gave him a forum in which to do so. The form of the thriller produced the expectation that Briggs would insist on investigating puzzling words overheard and anomalies of behaviour. Baxandall can use the novel to invite readers to make moral judgements about the conduct of the principal characters. Briggs is involved in a quest for information about Ravensburger-Humpis and specifically about Kaspar Leinberger which involve a commercial and moral judgement about their soundness. As Briggs 'impends', several characters offer him opinions about Kaspar, starting with René Pfiffner (who terms Kaspar 'a man very capable of having bad dreams or high aspirations even'[57]) and ending with Eberhard Vogt who analyzes Kaspar's lack of authenticity and narrates his own attempt to kick him 'out of the limbo of his everyday'.[58] In chapter 26, very late in the day, 'Briggs began to come to terms with having, somehow, lost all confidence in Kaspar Leinberger as a villain'.[59] Baxandall describes this as a change in Briggs's 'sense of the pattern in things' and invokes his need to allow things 'to settle into a new pattern, with a new centre'.[60] Long before, Mechtild had told him that she considered Kaspar 'a *virtuous* man. A serious man. It's mad to think of him doing something criminal.'[61] After warning Briggs against participating in a witch hunt, Lorenz assures him that Kaspar is incapable of wrongdoing

'almost to the point of a disability'.[62] Hearing and judging Vogt's account of his interference in Kaspar's life in the final chapter sharpens Briggs's sense of his own guilt. Several times in the novel Briggs had resolved to end his enquiries and return to Munich,[63] but each time a combination of his curiosity and his infatuation with Mechtild had brought him back into the mode of investigation until he became one of the surrounding group who precipitate Kaspar's retreat, stumble on the kerb, and fall into the path of the approaching car,[64] one of the 'pack of jackals'.[65] Moral judgement is a serious point of the novel and Baxandall suggests that Briggs's act of indulging his curiosity in this way was a contributory cause to the destruction of the person he was trying to investigate.

Fourthly, and as a consequence of this moral judgement, the novel allows the writer to place in the foreground demonstrations of the deceptiveness of knowledge and interpretation. All or almost all the stories which people in the novel construct as explanations turn out to be false. In several cases this falsity is also dangerous. Where history demands that one present a reasoned and so far as possible truthful narrative, fiction allows one to illustrate the deceptiveness of many kinds of claimed knowledge and to accept the unknowableness of things which the scholar and historian would like to know. One possible point of rest in the novel is Don Ivo's idea of the consolation of bathos.[66] Another is the emergent sense of Kaspar as a sort of hero of resistant non-activity in Pavia in the war,[67] as the author of 'an accelerating series of small acts or non-acts demonstrative of piecemeal principle'.[68] Another would be the idea of the damage done to him by the Eastern Front and the death of his friend Peter.[69] This scattering of ideas from which a new and necessarily still partial version of events could be constructed within a framework of distrust of larger explanations is something a novel can offer a reader. The form of the novel prompts the work of comparison. If Briggs and Kaspar are in some sense 'hollow men',[70] by some lights 'inauthentic',[71] where does that leave the figures who take a more active role: Vogt, Penney, Fritz, and Mechtild? Novels invite readers to speculate in these ways; they do not have to convince us of propositions.

The specific qualities of fiction should not obscure the strong continuity between the preoccupations of A Grasp of Kaspar and Baxandall's work as a historian, above all in the matter of the relations between the schemes which the human mind requires and their relation to individual agency. One of my last letters from Baxandall (13 November 2002) discusses the difficulty of getting the balance between 'rhetoric and dialectic as pervasively conditioning and enabling, and rhetoric and dialectic as plastic and adaptable; it's so difficult to avoid the impression of schematic rigour', and I remember this issue as a concern in his teaching and supervision of the late 1970s at the Warburg Institute.

A Grasp of Kaspar is a fascinating addition to Baxandall's oeuvre. It gives his readers many of the pleasures of elegant and far-reaching thinking which they expect from him, and it allows him to discuss ideas and describe phenomena which would not easily fit within a book of art history. The novel casts a new light on the preoccupations which contributed to the greatness of his historical writing.

Notes

1 Michael Baxandall, *The Limewood Sculptors of Renaissance Germany* (New Haven: Yale University Press, 1980), 41–2.

2 Baxandall, *The Limewood Sculptors*, 188–90.

3 Baxandall, *The Limewood Sculptors*, 159, 170, 189, 206.

4 Baxandall, *The Limewood Sculptors*, 16–26.

5 Baxandall, *The Limewood Sculptors*, 9–10.

6 Baxandall, *The Limewood Sculptors*, vii.

7 Baxandall, *The Limewood Sculptors*, 101.

8 Baxandall, *The Limewood Sculptors*, viii.

9 Baxandall, *The Limewood Sculptors*, 37.

10 Baxandall, *The Limewood Sculptors*, 38.

11 Baxandall, *The Limewood Sculptors*, 123–42.

12 Baxandall, *The Limewood Sculptors*, 88–90.

13 Baxandall, *The Limewood Sculptors*, 95–122.

14 Baxandall, *The Limewood Sculptors*, 95.

15 Baxandall, *The Limewood Sculptors*, 164.

16 Michael Baxandall, *A Grasp of Kaspar* (London: Frances Lincoln, 2010), 51–3.

17 Baxandall, *A Grasp of Kaspar*, 53.

18 Baxandall, *A Grasp of Kaspar*, 53.

19 Baxandall, *A Grasp of Kaspar*, 93.

20 Baxandall, *A Grasp of Kaspar*, 94.

21 Baxandall, *A Grasp of Kaspar*, 80, 93.

22 Baxandall, *A Grasp of Kaspar*, 142–3.

23 Baxandall, *A Grasp of Kaspar*, 116–29, 137–49.

24 Michael Baxandall, *Episodes: A Memorybook* (London: Frances Lincoln, 2010), 76.

25 Baxandall, *Episodes*, 76–80.

26 Baxandall, *A Grasp of Kaspar*, 115.

27 Baxandall, *A Grasp of Kaspar*, 157–8.

28 For example, Baxandall, *A Grasp of Kaspar*, 115.

29 Explicitly so in Baxandall, *A Grasp of Kaspar*, 158.

30 Baxandall, *A Grasp of Kaspar*, 17.

31 Baxandall, *A Grasp of Kaspar*, 23.

32 Baxandall, *A Grasp of Kaspar*, 23–4.

33 Baxandall, *A Grasp of Kaspar*, 133.

34 Baxandall, *A Grasp of Kaspar*, 41.

35 Baxandall, *A Grasp of Kaspar*, 79.

36 Baxandall, *A Grasp of Kaspar*, 145–6.

37 Baxandall, *A Grasp of Kaspar*, 141.

38 Baxandall, *A Grasp of Kaspar*, 146.

39 Baxandall, *The Limewood Sculptors*, vii.

40 Baxandall, *The Limewood Sculptors*, 202.

41 Baxandall, *The Limewood Sculptors*, 206.

42 Baxandall, *A Grasp of Kaspar*, 11.

43 Dickens uses the word twice in two lines at the beginning of chapter 6 of *Our Mutual Friend* to describe the way in which the pub 'The Six Jolly Fellowship-Porters' hangs over the Thames.

44 Baxandall, *A Grasp of Kaspar*, 34.

45 Baxandall, *The Limewood Sculptors*, 25.

46 Baxandall, *The Limewood Sculptors*, 106.

47 Baxandall, *The Limewood Sculptors*, 99–100.

48 Baxandall, *The Limewood Sculptors*, 92.

49 Baxandall, *The Limewood Sculptors*, 92.

50 Baxandall, *The Limewood Sculptors*, 107.

51 Baxandall, *The Limewood Sculptors*, 143.

52 Baxandall, *The Limewood Sculptors*, 145.

53 Baxandall, *A Grasp of Kaspar*, 85.

54 Baxandall, *A Grasp of Kaspar*, 179.

55 Baxandall, *A Grasp of Kaspar*, 55.

56 Baxandall, *A Grasp of Kaspar*, 142.

57 Baxandall, *A Grasp of Kaspar*, 31.

58 Baxandall, *A Grasp of Kaspar*, 232.

59 Baxandall, *A Grasp of Kaspar*, 165.

60 Baxandall, *A Grasp of Kaspar*, 166.

61 Baxandall, *A Grasp of Kaspar*, 79.

62 Baxandall, *A Grasp of Kaspar*, 192.

63 Baxandall, *A Grasp of Kaspar*, 71, 150–51, 186–7, 192–3.

64 Baxandall, *A Grasp of Kaspar*, 212–13.

65 Baxandall, *A Grasp of Kaspar*, 235.

66 Baxandall, *A Grasp of Kaspar*, 149.

67 Baxandall, *A Grasp of Kaspar*, 127–9, 148–9.

68 Baxandall, *A Grasp of Kaspar*, 149.

69 Baxandall, *A Grasp of Kaspar*, 79.

70 Baxandall, *A Grasp of Kaspar*, 234.

71 Baxandall, *A Grasp of Kaspar*, 230.

Michael Baxandall's 'Stationing'

Elizabeth Cook

John Keats on John Milton:

> Milton in every instance pursues his imagination to the utmost – he is
> 'sagacious of his Quarry', he sees Beauty on the wing, pounces upon it and
> gorges it to the producing [of] his essential verse … But in no instance is this
> sort of perseverence more exemplified than in what may be called his *Stationing
> or statuary*: He is not content with simple description, he must station, – thus
> here, we not only see how the Birds *'with clang despised the ground'*, but we see
> them *'under a cloud in prospect'*: So we see Adam *Fair indeed and tall – under a
> plantane –* and so we see Satan *'disfigured – on the Assyrian Mount'*.[1]

I think Michael Baxandall would have liked this term 'stationing'. I remember,
when I was a doctoral student (working at the Warburg Institute under his
supervision, on late Renaissance ways of looking through the medium of
language), the pleasure he took in Thomas Hobbes's use of the word *conatus*
to signify instantaneous motion through minimal space.[2] It was gladly
adopted as a useful, practical, and current term to denote a process we were
jointly exploring to indicate swift, intuitive grasp – quick thinking that speeds
through intermediary stages. The adjective 'conative' was coined to describe
the rapid leaps of association. It could usefully describe the thought process
teased out in this sentence from *A Grasp of Kaspar*: '[Briggs] should have been
trying to work out a way to tell Mechtild what had to be told, but his mind
evasively drifted off: Säntis – Lenardo – René Pfiffner's historical view –
Appenzell = "Abbots' Cell" – Abbots and their officers – Bailiff = Vogt.'[3]

 Milton's stationing was, for Keats, about his ability to situate his imagined
scenes in space: to create a below, an above, a behind, and before. As here,
when Satan sneaks into Eden. The stationing extends as much to the similes
as to the centre of the narrative:

Now to the ascent of that steep savage hill
Satan had journeyed on, pensive and slow;
But further way found none, so thick entwined,
As one continual brake, the undergrowth
Of shrubs and tangling bushes had perplexed
All path of man or beast that passed that way:
One gate there only was, and that looked east
On the other side: which when the arch-felon saw
Due entrance he disdained, and in contempt,
At one slight bound high over leaped all bound
Of hill or highest wall, and sheer within
Lights on his feet. As when a prowling wolf,
Whom hunger drives to seek new haunt for prey,
Watching where shepherds pen their flocks at eve
In hurdled cotes amid the field secure,
Leaps o'er the fence with ease into the fold:
Or as a thief bent to unhoard the cash
Of some rich burgher, whose substantial doors,
Cross-barred and bolted fast, fear no assault,
In at the window climbs, or o'er the tiles;
So clomb this first grand thief into God's fold:[4]

'Over', 'within', 'on', 'in', 'amid', 'into' – all the prepositions come in useful here to map out an imagined space and to get a purchase on its contents.

Michael Baxandall was good at stationing. During this paper I shall focus on the two works of his that were published after his death, *Episodes: A Memory Book* (a book *about* memory rather than a memoir) and *A Grasp of Kaspar*, but the impulse to station – to give an account of spatial situation and place – is of course something that runs through the work for which he is, so far, better known.

In the course of pages devoted to his time working at the Victoria and Albert Museum, Baxandall writes 'I was allotted as my main charges the German objects, which I knew nothing about.' (That 'which I knew nothing about' is promising.) The paragraph continues:

> The most coherent of these objects as a group, I felt, were the late-gothic and renaissance south-German sculptures, a small but good collection, and I set about equipping myself to catalogue them. At that time the Museum considered it one of its functions to enable its staff to become 'authorities', as a public resource: it supported travel for study and contact with museum officials abroad; the National Art Library was a hundred yards from my office, and I could have Veit Stoss's boxwood *Virgin and Child* on my desk while I worked on it. It was a perfect position for getting a grasp of a new field.[5]

The placing here is of various kinds: historical context about ethos and freedoms, topographical location. The crux of the paragraph is 'I could have Veit Stoss's boxwood *Virgin and Child* on my desk while I worked on it' – a passage that anchors the paragraph in the solidity of the figures, a solidity

that extends, almost by sleight of hand, to 'while I worked on it' and 'a perfect position for getting a grasp on a new field'. The 'grasp' of the fictional Kaspar Leinberger (the name so close to that of another German sculptor in wood) is approached in a comparable way.

However, I cannot imagine that Baxandall handled the Veit Stoss piece very much while he worked on it. Rather, that it sat upon his desk, being given space and occupying that space. The attention that would have been paid to it would have avoided any taint of intrusion. It required a way of mapping without interference.

Earlier in *Episodes* Baxandall writes of his student habits of getting to know literature: 'I never developed a mature critical stride at all. What I liked to do was buy a physically compact text – say Kenneth Muir's "Muses Library" Marvell or the "World's Classics" Tennyson or the Penguin Hopkins – and live with it for a time, until the pages became limp and docile and I had the illusion of having got it.'[6] Self-deprecatory though this particular instance is, there is a persistent and almost stubborn assumption that the manner in which something is packed (the grains in a sand-dune, the pages of a bound volume) is integral to its identity. A form of attention that exerts pressure on its object, intrudes upon and alters it. The aim is to grasp without bruising. 'People do act on each other, you know', says Briggs to his old friend Klaus,[7] who has been attempting to plot the range of feeling in an individual 'along a curve that represents a changing balance of satisfaction between two goods'.[8]

The hope, expressed at the outset of *Episodes*, is to 'come to some conclusion about what shaping pressures have been at work in producing the memory-like objects and events I have in my mind'.[9] Those pressures, like the winds that both move the component particles of a sand dune and exert a shaping pressure on the form of the dune as a whole, have differently directed effects depending on the scale and nature of their objects. There is a wonderful drama in this account of the movement of sand:

> It is a defining property of *sand* … that its grains are of a size and weight to jump or hop along in a strong but locally not abnormal wind, rather than soar in suspension like dust particles or roll along a little now and then like pebbles. The single grain on a bed of sand may jump either because it has been caught up by the wind when a sheltering grain took off or because it has been struck by another grain descending from a jump.[10]

This drama, seen with a poet's eye, honours the autonomy of the individual particle and its potential for movement independent of its role as part of a dune. This movement may be compared to the 'independent demands and energy' of those 'pieces of actual reminiscence' that have been selected as exemplary of the workings of memory in *Episodes*.[11] The honouring of those independent demands is what leads to a biographical/narrative interest and may lead some to mis-describe this work as memoir.

An episode that stands out for the strength of response provoked by its recollection – so that 'Even at this moment of writing it up it provokes a physical unease'[12] – is that concerning Andrew, Baxandall's colleague and house-sharer in St Gallen. Like several of the episodes described in this book, as well as those that compose the narrative of *A Grasp of Kaspar*, there is an element of bathos to the arc of the story: the interest is all in the telling, not in any exciting or conclusive event.[13]

The great retrospective unease derives from the sense that the author was too actively directive when Andrew was considering a move from his post at the St. Gallen institute to a 'known boarding school in Germany'.[14] In spite of the recognition that Andrew was 'heading for a mess' at St. Gallen (his preoccupation with an 'appalling boy' at the school being part of this) and that he felt 'a fresh start for Andrew would be good absolutely', '[e]xasperation with him played too big a part in what I said and so did my own disapproval of the Institut. It adds up to a sort of bad faith, I am afraid. Clearly I had invaded another as one has no business to do.'[15]

Invasion is a strong concept for what might be seen by another as a gentle act of steering. In contrast, the description of a typical evening encounter with Andrew is meticulous in its stationing: Andrew has returned to the house on his moped from a session of heavy drinking at the Hotel Hecht with Horst, the reflective barman. During the first phase, while Andrew reported on Horst's views ('full of tips on that bracer called Life'), 'Andrew would … be moving irritatingly about, touching things.'

Then, after five minutes or so of Horst, he would go over to sit on an upright chair next to his index cabinet. This cabinet was a splendid object, matt pale-grey metal with many small drawers to fit his word-slips, or vice versa:

> and I remember the slips as being rather larger and squarer than our three-by-five cards. They carried the words and references of his philological research, in principle still a going concern. The drawers were beautifully contrived to coast very smoothly in and out on some first-class arrangement of ball-bearings. Andrew would put one arm not around, but along the top of the cabinet and with his other hand very gently open and shut drawers, tilting his head to hear better. One sometimes sees musicians doing rather the same as they play a stringed instrument.[16]

The passage – after the early 'irritatingly' – is sparing in judgement, admiration being reserved for the 'splendid' object of the cabinet, the drawers 'beautifully contrived to coast very smoothly' and the 'first-class arrangement of ball-bearings'. But 'irritatingly' has leaked out and extends, subtly, to the meticulously described actions that follow. The comparison of the tilt of Andrew's head to that sometimes performed by musicians of stringed instruments suggests, after all this precision, a quality of the *writer's* attention, rather than the irritating Andrew's.

To pervade might be better than to invade. Keats again: 'it can scarcely be conceived how Milton's Blindness might pervade the magnitude of his conceptions as a bat in a large gothic vault'.[17] The exact observation – almost notation – of stance and gesture is a quality possessed by and required of certain playwrights – Beckett in particular – and of cinematographers. Gestures peculiar to their makers – like those of the irritating Andrew – are carefully rendered by Baxandall: '[Vogt] smiled, and signalled decision by moving one hand lightly up and down to pat the arm of his chair.'[18] '[Bing] could convey a quite subtle qualifying view of what one had just said by the timing and pace with which her hand moved the cigarette to her mouth, her face expressionless and unchanging.'[19]

There is silent physical comedy, as in the description of Briggs and Laura making their way out of Uncle Leonida's shop ('a resonantly clangorous barn with a small glass-fronted office at the back') with all its 'evidently productive clutter smelling of hot oil: whining turret lathes, pitiless grinders, a milling machine and old-fashioned buffer with a big emery band, trolley-trucks and steel bar': 'They worked their way out through the shop, the elderly clerk going before signalling to them as if they were a reversing truck.'[20] British comedy (so an ex-stand-up comedian informed me) is peculiarly *observational* in its nature. But there is also, and always, the comedy and poignancy that come from the encounter with the limitations of the stuff we and the world are made of. 'While he inflated the tyres he replied to her questions about Penney. Her giggling persisted, in spite of the implications he spelled out. He was disadvantaged by the grotesque attitudes of the foot-pump user who is also having to talk.'[21]

The playwright's notation is a set of instructions – a branch of choreography – whereas Baxandall's notation is description, accomplished with an acute consciousness of the way in which the particular tugs and densities of the medium exert their pressures. Is it possible to notate and situate in language in the hands-off way of looking at the Veit Stoss Madonna and Child? There are many fine observations of light and its changes in *A Grasp of Kaspar*. This one, at the start of chapter 28, is an exercise in refinement. The 'tracer ammunition' of the military operation operates as a coarser version of the lines of light it gives rise to and that map out, illuminate, and pervade the valley:

> … though the valley was too dark for its limits or form to be directly seen, the military exercise taking place in it was being conducted with tracer ammunition.

> The valley was criss-crossed with lines of white light in various directions and at various angles. Though there was general continuity, there was also constant local change, individual lines of tracer ceasing and being replaced for a time by others, none persisting for more than a few seconds at a time, though they might recur. These lines were like some sorcerer's survey, bearing-lines which, if grasped as a whole and in relation, would give a plot of the shape and extent

of the invisible valley. In addition, there were occasional much more diffused global flashes of much less intense light, too diffused and brief to illuminate the lie of land to the point of actual perception but giving rise to intuitions of possibility. It was all like some great act of constructive inference, Keplerian or Newtonian. Or it was a masque of the operations of such an act.[22]

The divers' code – designed to communicate gesturally in a situation where speech is precluded – is one of several alternatives to verbal language that appear in *A Grasp of Kaspar*. It is not without ambiguity. When it is watched, by the concealed Briggs, it is presented as an incomprehensible and also comic dumb-show on the part of his pursuers.[23] It is only later that Briggs's friend Laura (with the benefit of her 'professional deformation' that comes from a doctorate in hydraulic engineering[24]) guesses the nature of the gestural language displayed. As on several other occasions in this novel,[25] a vision or a mental grasp is refined, modified, re-framed. Much of *A Grasp of Kaspar* is concerned with correcting the vision that is seen through distorting lenses:

> The first distorting lens was what he had taken as René's rendering of the two men – the one as a farcically cultivated patrician of the old school, the other as an edgy Hun with gritty fingers. ... These were not plausible types. But then, Briggs knew, these caricatures had been further distorted, not corrected, by his own resistance to them. He had reacted to René's images by almost idly imposing over them clichés from a puerile mythology of his own – a smooth smiling master-villain from a John Buchan adventure, and an SS officer on half-pay. Inane. But it would be hard now to dislodge those constructs entirely. That was the trouble with learning about people even from a single informant: you saw them refracted not once but twice.[26]

The decision to go and 'impend' at the bar where Kaspar Leinberger's wife, Mechtild, was known to hang out would provide 'a small advance, a little step towards reality'.[27] On occasions syntax mirrors the movement towards clarification, these small steps towards reality. As Briggs looks around Eberhard Vogt's room he qualifies the account of the room that René Pfiffner had given him: 'What René Pfiffner had described as a medieval statue of St. Martin was certainly not St. Martin. ... René's old music-stand was not a music-stand but a baroque lectern for a standing reader. ... The cello leaning against the window-sill was indeed a cello.'[28] There is a continual revision of grasp.[29] Briggs 'working his way into his coat as he went'[30] is an image of that process. Briggs's gesture is one equally capable of mis-reading. To Mechtild he 'looked like a vampire' – 'All that flapping with your arms. I suppose you were just getting your coat on, but in the mist'[31]

Aldo Guardamagna recounts (in an Italian rendered as transparently into English as is possible, containing a gestural sense of Italian in its idiom) how, as a mechanic during the war, he was unable to restore to function the German trucks he and his co-resisters (were they *in* or *of* the resistance?) had

appropriated: 'What the clever northerners had made so well, this Italian peasant could not understand, only destroy. I was a clown playing with clockwork.' As he lay sleepless he

> began to develop a vision, an image of the manual, a maintenance handbook with wiring diagrams, which would solve my problems. The book of knowledge. It was the sort of image you can feel with the fingers, which you can smell. It was this high, this wide, this thick: dark-blue shiny cover, thick glossy paper. In one part of my mind I must have realised that it would be written in German, but my image was somehow as accessible as a children's book in Italian. With this good book I would be on a footing with the northerners and the trucks would run like Swiss watches again.[32]

This non-existent maintenance handbook is an image of perfect, unmediated, and uncomplicated communication of matter which is of itself purged of the colourings of attitude and personality. The nicely named Don Ivo Pavan (not a Gavotte or a Galliard), Rector of the Collegio Praga, has thoughts on the distortions and colourings of idiom and style. Having quoted a Lombard riddle ('The more there is of it, the less you see. Answer: mist') which he dismisses as a 'verbal trick' he continues, 'but the real paradox … is that popular wisdom should be so shaped by its hunger for verbal trickery and pattern, by a sort of instinct to evade experience through art'.[33] He recalls the conversations he once had with the German Leinberger, each speaking in their own language which the other could understand better than he could speak:

> Each spoke with the real voice of the mind … but at some point contact was thwarted. Concept never quite kissed concept, not on the lips. And the consequence went further. I spoke in Italian – a softened Latin – the language of Cicero and Augustine, one of the most precisely diversified vehicles the human mind has evolved. He spoke German, a quite recently regularized and elaborated Gothic – the tongue of warriors and hunters and other forest-dwellers communicating about … well, woodland matters. From our tongues we took roles – you see?[34]

We see also Don Ivo's condescension as he portrays a nation of trolls!

Briggs, when he looked around the living room of Leinberger's house (to which Mechtild has brought him) noticed how it 'contrived to be both lush and bleak … . Matters had not been shaped by interest, or by use'.[35] Interest and use shape domestic interiors as much as they do languages, rivers, and mountain passes. 'Briggs disliked the St. Gotthard as a forced and parvenu pass. He favoured the Splügen, which had been a going concern since Roman times.'[36]

If the job is simply to provide a means to cross from Pavia to St. Gallen, then the two passes do the same job. But, as with two alternative referents in a metaphor, each carries an autonomous vitality and history of associations. There is no real equivalence.[37] Just as the attempt to use personal memories

in an exemplary way – to demonstrate the action of memory – is frequently confounded or distracted by the independent energies and interest of the material, so in any analogy there is as much a pull away into independence as towards reinforcement and clarification. Even units of measurement have their own associations and back-story. The *tola* was the base unit of measurement in the British Indian system of the nineteenth century. It has associations (never named here) with Kipling, with the 'Great Game' of espionage that threads through *Kim*. When Lorenz elucidates to Briggs what a ten-tola bar is, he describes it has having the volume of 'a very small marron glacé'.[38] The analogy 'places' Lorenz as much as it describes the *tola*. The approximation of these two objects and their independent worlds has the quality of a metaphor in a metaphysical poem!

A great deal of social 'placing' goes on in *A Grasp of Kaspar*, each instance inevitably placing the placer as much as the intended object. René Pfiffner tells Briggs that St. Gallen is 'the Manchester of continental Europe';[39] Mechtild tells Briggs that he looks 'like a Dutchman, perhaps. If a Dutchman had bought some of his clothes in Germany and some in London and perhaps some somewhere else, he could look rather like you.'[40] Pasquale introduces Briggs to the group of Lombard Young Communists as 'a strange type of anarcho-syndicalist from the north, but my friend'.[41] When Briggs meets Guardamagna for the first time he is aware of being sized up, and Briggs returns the compliment:

> He himself was a physically powerful man in his thirties with a shrewd and fluid eye. He was not yet gross, but he was sanguine and the veins in his neck were marked. He was the townsman, hair cut carefully, sharply cut pale grey suit, a silvery Milanese striped tie. He might have been the owner of a small cinema or garage.[42]

They take the measure of each other.

When occurring within the context of a fiction, such social placing communicates the nature of both observer and observed. Charlie Livingstone tells Briggs about his conversations with Florian Schulte, and also about himself: 'Registrations for Buxtehude – that was a topic on Thursday.'[43] When Briggs, whose consciousness pervades *A Grasp of Kaspar* – for he it is who is trying to do the grasping – thinks about the distance between St. Gallen and Ravensburg it is in these terms: 'Westchester to Wall Street, say, or Haywards Heath to the Savoy Grill.'[44] Baxandall here places Briggs with great economy. It becomes a neat characterizing device.

While providing a fictional character with personal referents is a brisk way of placing them in their world and values, the act of fictionalizing – of creating a story – can give body to a reality otherwise ungrasped. In *Episodes* the figure of Godwin, a kind of Wordsworthian solitary, is first depicted in an external

way, as a watched object, rather like Wordsworth's Leech-gatherer. A boy has thrown a stone at him:

> It hit the man harmlessly on the back. But he stopped and half-turned to look round, stooped with one arm raised to shield his head. He stayed twisted in this posture for a moment as if he were performing a mime of fear or abjection, and then shuffled on to the shop.[45]

Baxandall approaches Godwin as close as is possible through disciplined observation and recollection. To move further, fiction is required: '*The next two pages did not happen.*'[46] While to remember may be to alter ('to remember something is likely to modify the memory'[47]), an owned fiction may communicate a quality without denting it.

The next two pages of *Episodes* effectively station what is secret and unspoken. In the encounter with Godwin that did not happen, Godwin gives minute instructions to the young Michael: 'There's a good mulberry tree off the south drive, behind the sloes. To the left as you come, next time ... Tucked away, he said. He turned to leave, halted for a moment, and added: Behind the sloes.'[48] Godwin has also had something to say about the unsaid: 'Things you know about yourself yourself are strong if others don't.' The location of the tucked-away mulberry tree becomes an image of such an unknown thing.

Tristram Shandy's father was convinced that 'there is a North-west passage to the intellectual world ... that the soul of man has shorter ways of going to work, in furnishing itself with knowledge and instruction, than we generally take with it ... The whole entirely depends ... upon the *auxiliary verbs.*'[49] He proceeds to demonstrate how it is possible to discourse, by this means, upon a white bear without ever having seen one:

> A WHITE BEAR! Very well. Have I ever seen one? Might I ever see one? Am I ever to see one? Ought I ever to have seen one? Or can I ever see one?
> Would I had seen a white bear! (for how can I imagine it?)
> If I should see a white bear, what should I say? If I should never see a white bear, what then?
> If I never have, can, must or shall see a white bear alive; have I ever seen the skin of one? Did I ever see one painted? – described? Have I never dreamed of one?[50]

The Coda to *Episodes* (whose 'project' 'was to feel a way to a rhetoric of recall'[51]) begins with a version of the traditional rhetorical questions 'Quis, quid, ubi, quibus auxiliis, cur, quomodo, quando?' (Who, what, where, with what, why, in what manner, when?) These questions, typically part of a medieval *accessus ad auctores*, can, perhaps better than Sterne's auxiliary verbs, be used to interrogate and get a purchase upon material that may be elusive. 'As one deteriorates physically', Baxandall writes at the start of *Episodes*, 'the informal

liaison between mind and body, whatever it and they may have been, comes under strain. The body is detaching itself, becoming a disorderly other, and it must be watched and newly learned as from outside.'[52] The relation between the matter that can be handled and observed and the 'one' that is 'practically distinguishable from the body' is poignant in both absence and presence.

The actual stuff of a book (the source of much play in *Tristram Shandy*) may also exist in an 'informal liaison' with its less material matter. I have already quoted the passage from *Episodes* about a preference for a 'physically compact text' that can be lived with for some time, the pages mollifying as their matter is internalized. Earlier Baxandall writes about his encounter with F.R. Leavis, initially through his *Revaluation*. 'I had liked the leanness of *Revaluation*, as well as the type, roughish paper, rust-brown binding and spare dust-jacket design with their good 1930s Chatto feel – whereas *The Heritage of Symbolism* [Bowra] … I still find repellent, font and text and shiny maroon case.'[53] Notice the '*good* 1930s Chatto feel'. It is striking how often and in some sense gratuitously the word appears in *Episodes* ('the good Australian actor Peter Finch'; Pope-Hennessy's 'good 3-volume book on Italian High Renaissance and Baroque Sculpture'[54]) – there is a frankness about and a willingness towards moral evaluation, a vertical placing. This is an important element of what Leavis offered, among the 'dispositions' that Baxandall acquired through Leavis: 'I am sure it is due to Leavis that I regularly worry about relevance – about whether some thought about an object, veridical though it may be, is likely to sharpen or just encumber its vitality … that I also feel that in art the technical and the moral fuse into one, and that to try and isolate either is likely to be frustrating and may turn destructive.'[55]

Thought may 'sharpen or just encumber' vitality. The detailed commentary that Gertrude Bing wrote ('in the frugal Institute manner on the back of galley-proof of the British Museum Library supplementary catalogue for 1949' – information of a kind to interest Sterne) is valued for its 'sharp edge and … candour – real attention [that] one loved and wanted'.[56] Candour is of course a quality of light as well as of temperament – it illuminates but does not encumber.

Benjamin Baker refused to 'materialise a falsehood' in his design of the Forth Bridge. In the exemplary account of the Bridge, in *Patterns of Intention* (an exemplary account of an exemplary object), having itemized 24 circumstances that had bearing on Benjamin Baker's design of the bridge, Baxandall writes: 'I cannot distribute the different circumstances of the bridge among its different sections – side winds to the left, Siemens steel to the right, expressive functionalism somewhere else. In the form of the Bridge, Baker alloyed circumstances, he did not aggregate or collocate them.'[57] The constituents of alloy are inseparable (in the way that, for Mechtild, her mother's 'voice was in the words' of Lenardo's Diary from *Wilhelm Meister*[58]). What language can do, if it is sufficiently alert and supple, is approach an object, mental or

substantial, from many different directions, idioms, codes and assumptions – any of which may both qualify and reinforce another – and to hold that object, station it, without imprinting it. I think of Michael Baxandall holding the Veit Stoss Madonna and Child in the cradle of his attention.

Keats again, writing to the painter Benjamin Haydon:

> I have ever been too sensible of the labyrinthian path to eminence in Art (judging from Poetry) ever to think I understood the emphasis of Painting. The innumerable compositions and decompositions which take place between the intellect and its thousand materials before it arrives at that trembling delicate and snail-horn perception of Beauty.[59]

The snail-horn he had in mind is the one Shakespeare described in *Venus and Adonis* (ll.1033–8), retractive, tender, and sensitive, ever readjusting. 'Integrity' is another word to describe what is both moral and material ('Is durability not also a moral quality?' asked Bing[60]). What is valued in Leavis and in Bing (as well as in Alberti and Benjamin Baker) is their insistence on the moral quality of structures. *Virtú* and virtue reinforce one another. Baxandall's verbal stationing is one which attends to the integrity of its objects and is concerned that what pressures it applies neither dent nor invade.

Notes

1 John Keats, *The Major Works*, ed. Elizabeth Cook (Oxford: Oxford University Press, 2001), 344.

2 '[M]otion made through the length of a point, and in an instant or point of time'; Thomas Hobbes, *The English Works of Thomas Hobbes*, ed. Sir William Molesworth, 11 vols (London: John Bohn, 1839–1945), I:206.

3 Michael Baxandall, *A Grasp of Kaspar* (London: Yale University Press, 2010), 73.

4 *Paradise Lost*, Book IV, 172–92.

5 Michael Baxandall, *Episodes: A Memory Book* (London: Yale University Press, 2010), 133. Elsewhere Baxandall writes of the 'rhetoric of the edge' in Stoss – the clarity of his line: 'the mental image of a Stoss sculpture can be recalled in the memory with relative ease and precision'. *The Limewood Sculptors of Renaissance Germany* (New Haven and London: Yale University Press, 1980), 192.

6 Baxandall, *Episodes*, 69.

7 Baxandall, *Kaspar*, 53.

8 Baxandall, *Kaspar*, 51.

9 Baxandall, *Episodes*, 16.

10 Baxandall, *Episodes*, 17.

11 Baxandall, *Episodes*, 141.

12 Baxandall, *Episodes*, 98.

13 Stephen Melville has argued that the account of the Forth Bridge is allegorical of the work that follows in *Patterns of Intention*. Margaret Iverson and Stephen Melville, *Writing Art History* (Chicago: University of Chicago Press, 2010), 34; in a comparable way the interest in narrative 'plot' may be allegorical of inner interest.

14 Baxandall, *Episodes*, 97.

15 Baxandall, *Episodes*, 98.

16 Baxandall, *Episodes*, 97.

17 Keats, *Major Works*, 337; see also the passage in *Kaspar*, 179, discussed below in which it is light that pervades.

18 Baxandall, *Kaspar*, 222.

19 Baxandall, *Episodes*, 114.

20 Baxandall, *Episodes*, 110, 111.

21 Baxandall, *Episodes*, 180. See also the physical comedy in Baxandall's account of passing Pope Hennessey in the long corridor of the V&A; *Episodes*, 127, in which the timing of the encounter is perfectly conveyed. Paul Hills has spoken during this conference of Baxandall's awareness of the temporality of light. This sensitivity to temporality extends to a mastery of narrative timing, demonstrated not only in memoir and fiction but also in the late and finely judged placing of personal information about Chardin's *A Lady Taking Tea*. Michael Baxandall, *Patterns of Intention* (New Haven and London: Yale University Press,1985), 103.

22 Baxandall, *Kaspar*, 179.

23 Baxandall, *Kaspar*, 134.

24 Baxandall, *Kaspar*, 151.

25 The death of Kaspar is presented as a sequence of uninterpreted physical events.

26 Baxandall, *Kaspar*, 33–4.

27 Baxandall, *Kaspar*, 34.

28 Baxandall, *Kaspar*, 220.

29 Reality is approached by means of a *via negativa* as in apophatic theology or the *neti neti* (not this … not this) of Jnani Yoga.

30 Baxandall, *Kaspar*, 35; Later Don Ivo invites Briggs to 'try to feel our way a little into the generic plight' (143).

31 Baxandall, *Kaspar*, 36.

32 Baxandall, *Kaspar*, 125.

33 Baxandall, *Kaspar*, 138; also the claim that 'Any language … is a conspiracy against experience in the sense of being a collective attempt to simplify and arrange experience into manageable parcels', in Michael Baxandall, *Giotto and the Orators* (Oxford: Oxford University Press, 1971), 44.

34 Baxandall, *Kaspar*, 142.

35 Baxandall, *Kaspar*, 41.

36 Baxandall, *Kaspar*, 85.

37 Empson writes: 'Any statement of identity between terms already defined ("God is love") is a contradiction because you already know they are not identical … A vague sense that "is" has other uses than the expression of identity makes us ready to find meanings in such sentences.' William Empson, *Some Versions of the Pastoral* (Harmondsworth: Penguin, 1966), 117–18.

38 Baxandall, *Kaspar*, 193.

39 Baxandall, *Kaspar*, 28.

40 Baxandall, *Kaspar*, 39.

41 Baxandall, *Kaspar*, 91.

42 Baxandall, *Kaspar*, 117.

43 Baxandall, *Kaspar*, 12.

44 Baxandall, *Kaspar*, 19.

45 Baxandall, *Episodes*, 33.

46 Baxandall, *Episodes*, 35.

47 Baxandall, *Episodes*, 21. Later he writes of another passage, 'There is something postcard-like about this vignette and I suspect it has been looked at too often' (*Episodes*, 96); the word 'contaminated' is also used to refer to what can occur in re-telling (*Episodes*, 23).

48 Baxandall, *Episodes*, 36.

49 Laurence Sterne, *The Life and Opinions of Tristram Shandy* (Harmondsworth: Penguin, 1967), 394.

50 Sterne, *Tristam Shandy*, 396.

51 Baxandall, *Episodes*, 141.

52 Baxandall, *Episodes*, 15.

53 Baxandall, *Episodes*, 63.

54 Baxandall, *Episodes*, 124 and 128; also the naming of Vasari as 'the best of all art historians', Baxandall, *Limewood Sculptors*, 191.

55 Baxandall, *Episodes*, 70.

56 Baxandall, *Episodes*, 116.

57 Baxandall, *Patterns of Intention*, 33.

58 Baxandall, *Kaspar*, 77.

59 John Keats, letter of 8 April 1818, *Major Works*, 389.

60 Baxandall, *Episodes*, 116.

Index